PISGAH

NATIONAL FOREST

· A HISTORY ·

MARCI SPENCER

Foreword by
James G. Lewis, PhD

THE
History
PRESS

Published by The History Press
Charleston, SC 29403
www.historypress.net

Copyright © 2014 by Marci Spencer
All rights reserved

First published 2014

ISBN 9781540211132

Library of Congress CIP data applied for.

Dedicated to my daughter, Christi Worsham, and my granddaughter, Brooke Lyda, to whom I owe my sincere gratitude for searching for historical materials, filing and typing mounds of library clutter, photographing dozens of exhibits and taking hundreds of notes when my mouth and mind were working faster than my pen.

To Christi and Brooke, I also owe an apology from me and my father, Max Garland Lance, for instilling in them an intense desire for adventure and an addiction to all that moves, or doesn't, in the outdoor world.

CONTENTS

Foreword, by Dr. James G. Lewis 7
Acknowledgements 11
Introduction 17

1. Coming to the Mountains 23
2. A Gentleman Comes 33
3. U.S. Forestry Education: The Beginning 47
4. Establishing Pisgah National Forest 65
5. Moving Forward 77
6. Grandfather Ranger District 101
7. Appalachian Ranger District 129
8. Pisgah Ranger District 159

Bibliography 191
Index 203
About the Author 207

FOREWORD

"Walk the creek," the math teacher said to his students. "Discover your past."

Why is a math teacher instructing his students to delve into the history of a nearby national forest? This is just one of many fun conversations that Marci Spencer shares with us in her history of the Pisgah National Forest, one of the most popular national forests in the United States. With her guiding us through both the landscape and the history of the Pisgah, you will not only walk a creek but also hike a mountain, ride a log flume, plant a tree, build a lodge and tramp through a wilderness area. And when you're done reading this book, you'll probably want to go to the Pisgah and do some of those things. If you do, you'll be visiting one of the crown jewels of the National Forest System for yourself.

You might be asking yourself, "Why should I delve into a history of a national forest? What *is* a national forest?" The Forest Reserve Act of 1891 authorized the president to set aside public lands, but the Forest Management Act of 1897 laid out the purpose: timber production and watershed protection. In the ten years following the passage of the Forest Reserve Act, 40 million acres were set aside, all in the West. If you look at a map of the United States today, you will find national forests and national grasslands throughout the country and even in Puerto Rico, a total of 193 million acres. In a national forest, you'll find all sorts of activities, from the relaxing (hiking, camping, fishing and swimming, to name a few) to the industrial (mining, logging and grazing). Each national forest has been established "for the greatest good for

the greatest number for the long run," in the words of Gifford Pinchot, the first chief of the U.S. Forest Service. The federal government, through the U.S. Forest Service, manages all national forests and national grasslands for multiple uses on a sustainable basis on behalf of the public.

"What is public land?" you might ask. You wouldn't be the first. Verne Rhoades, the first forest supervisor of the Pisgah National Forest, rhetorically asked that when he received the appointment in 1916. His questions continued, Marci tells us. "Whose interest is the most important—the logger's, hunter's, fisherman's, hiker's or the government's? Who decides?" The questions Rhoades asked have been asked by others aloud ever since the idea of setting aside public forestlands was first proposed some 150 years ago. And they should be asked by you because you and every American are the owners of the Pisgah and the other 154 national forests.

Thankfully, for us owners, President Theodore Roosevelt created an agency in 1905 to do the hard work of managing our federal forestlands, for protecting their "natural resources, balancing forest needs with public interest, and improving forest health to ensure a successful future," a mission Rhoades carried out for the next decade as Pisgah's forest supervisor. His successors on the Pisgah, and every man and woman who have put on the green uniform of the U.S. Forest Service since, continue to do it for the benefit of all.

So, why delve into the history of this particular national forest? The Pisgah National Forest is no ordinary national forest. In addition to its breathtaking beauty and proximity to millions of Americans who enjoy its bounty year-round, it is the home of many "firsts" in American forest history. To start, it is home to the Cradle of Forestry in America.

Before the Pisgah National Forest was established in 1916, there was an area called the Pisgah Forest, which was part of the sprawling Biltmore Estate just outside Asheville, North Carolina. There, the first attempt at large-scale forest management in America was conducted by Gifford Pinchot, the first forester born in America (he of the "greatest good" quote.) Using millionaire George Vanderbilt's money and landscape architect Frederick Law Olmsted's idea of introducing this science to America, Pinchot undertook a bold experiment: trying to rehabilitate, reforest and restore the 120,000 acres of badly cutover woodlands that Vanderbilt had purchased in 1895.

Pinchot's efforts eventually led to the establishment of the Biltmore Forest School, the first school of forestry in America. Not by him, though, but by a German forester named Carl Schenck (he was not the first German forester though!). One of his nearly four hundred students was Verne Rhoades,

the first forest supervisor of the Pisgah National Forest—the first national forest established under a 1911 law that allowed the federal government to purchase private lands for the first time. In short, what happened in the Pisgah mattered; it changed America.

This revolutionary idea of buying private lands and managing them as public forests was inspired by what had been going on in Vanderbilt's Pisgah Forest, which itself was revolutionary. The forest restoration efforts carried out by Pinchot and Schenck showed America the benefits of forest conservation and proved that it increased the value of the land. Their work is *why* that land is a national forest today. Now all of that history is preserved as the Cradle of Forestry in America National Historical Site, located in the heart of the Pisgah National Forest. As you will soon read, the list of historical firsts continued after the Pisgah's establishment in 1916.

But the history of the Pisgah National Forest is more than just the history of the "Cradle of Forestry." After all, what I just described is what led to it becoming a national forest. There is, of course, everything that followed its establishment, and those events and places are just as important and fascinating. After all, there is Mount Mitchell, Linville Gorge and Wilson Creek, just to name a few places as rich in nature's offerings as in history. And there are so many more people Marci introduces us to as she brings us up to today—people who have helped to make the Pisgah the special place that it is.

After you meet all those folks in her overview of the Pisgah's history, she'll introduce you to the history of more places—many of them hidden gems—found in each of the Pisgah's three ranger districts: the Appalachian, Grandfather and Pisgah. They are as different as they can be, too, just like their landscapes. As a whole, the Pisgah National Forest offers so much to do, such a *variety* of things to do, year-round, that it's hard to know where to start and what to see.

Lucky for you, then, that you have this book. If some of the places Marci discusses aren't familiar to you, fear not. Marci is an excellent guide. If you're familiar with the Pisgah already, I bet you'll still learn something new, like I did. Either way, it takes a native to know where the hidden gems are. A friend will tell you where those gems are and will share their stories. With Marci, you have someone who is both.

So read this book. Walk a creek. Discover the past.

JAMES G. LEWIS, PhD
Forest History Society
Durham, North Carolina

ACKNOWLEDGEMENTS

Y ou better stop shakin' those trees," my dad warned when he thought I was asking people too many questions. "You never know what might fall out of them. You just might find some bad apples." I've been shakin' a lot of trees, but I've only found fine fruit in my labor.

People are very busy. Schedules are overbooked, and time is short. However, when it came to Pisgah, many of my "trees" offered enthusiastic support. They'd return e-mails, push projects aside, pull up a chair, order another cup of coffee and review chapters as if, at that moment, nothing was more important than Pisgah. Sometimes only a few questions were needed to open up a treasure chest of memories. Their interest, though, was not in me. Most of them didn't even know me. *Pisgah* caught their attention, stirred their sentiments and garnered their support. First and foremost, I must thank Pisgah for getting me in the door.

A number of people helped me build the first few chapters. For their information and support inspiring me to proceed, I offer my sincere appreciation to my dear friend Albert Sorrells, who may believe in me more than I do; to George Vanderbilt's grandson, George Cecil, who offered insight and understanding of the Vanderbilts and the Buck Spring Lodge and then introduced me to Walt Weber; and to Walt himself, an author, historian and active volunteer with Carolina Mountain Club. Walt provided an in-depth, guided tour of the Buck Spring Lodge site and patiently answered my numerous questions. I wish to thank Lou Harshaw, Asheville historian and author, for taking the time to review the chapters on regional history.

ACKNOWLEDGEMENTS

In Hominy Valley, at the foot of Mount Pisgah, Chester (Chet) Hill and Dr. Ken Israel allowed me to possibly overstay my welcome for hours talking about Pisgah. The pair have written numerous articles on the valley's history. Dr. Israel's mother, Mary Mabel Israel, began painting with the Works Progress Administration (renamed Work Projects Administration in 1939) to preserve southern Appalachian culture. Dr. Israel donated her painting of Mount Pisgah for this book. I am most grateful. Poet Alan Reynolds e-mailed me from the Netherlands granting permission to publish his poem about Pisgah. During a weekend stay at Pisgah View Ranch, the Cogburns (especially Cindy and Bruce) graciously interrupted dinner service, hosting guests and evening entertainment at the Barn, to provide historical information. I send thanks, also, to a preacher, Austin Watts, walking his dog along a quiet Hominy Valley road early one morning.

Brothers Jere and Jim Brittain welcomed me into their homes to discuss Pisgah and their Mills River family history. Jim has done extensive regional research, authoring a book and many articles on local history. I offer heartfelt thanks for Jere's meticulous attention to detail in reviewing multiple chapters.

The extensive collections of forestry history resources at the Forest History Society, North Carolina State University and University of North Carolina–Asheville have been invaluable. Many 3:00 a.m. mornings found me deep in their files. Dr. James Lewis, historian at the Forest History Society, editor of *Forest History Today* and author of *The Forest Service and the Greatest Good: A Centennial History* offered his time, encouragement and expertise. His in-depth knowledge helped sharpen the text into a more focused, cohesive history. In long, detailed e-mails attaching recommended resources, Gordon Small, retired director of lands for the U.S. Forest Service, educated me about the Weeks Act and land acquisition. Many thanks to NC State University's Dr. Gary B. Blank of the Department of Forestry and Environmental Resources and to Mark Megalos, PhD, of the NC Cooperative Extension department, for reviewing relevant chapters.

The Biltmore Forest School chapter was a special one to write. Thank you, Cindy Carpenter, Education and Interpretation Program curator at the Cradle of Forestry, for not only providing guidance during the research process and for reviewing several chapters but also for sharing the mutual respect and admiration for the work of Dr. Carl Alwin Schenck. Her keen insight and enthusiasm not only intensified my own interest but also made the learning process downright fun. Thanks also to John Palmer for reviewing Dr. Schenck's chapter and contributing valuable information.

ACKNOWLEDGEMENTS

I shook many trees in the Grandfather Ranger District. Anne Swann of Mountain Gateway Museum, Dee Daughtridge of Old Fort's Marion Davis Memorial Branch Library, Sue Gibbs of Old Fort Visitor Center, James Haney of Carson House and Patti Holda at the McDowell County Library shared regional resources with a warm, genuine support. Bill Nichols sat at my dining room table for longer than he expected sharing stories of Old Fort history; Daniel Adams and his daughter, Binkie; and Catawba Falls. My friend, Ray Morgan, sat in the same chair in the same room longer than Bill, telling tales of local history. His mother, Lucille Morgan, a sketch artist, lived in a cabin between Mortimer and Edgemont in the Grandfather District with her husband, Lyle, a NCWRC wildlife officer, in the 1950s. Choosing which of her illustrations to include in this project was a difficult task. Thank you, Andrew Kota of Foothills Conservancy, for improving the story of Catawba Falls. John Smith stopped loading logs at his sawmill, leaned up against the truck and told me about Curtis Creek lumber operations and the log flume. Bud Hogan also recalled the old flume and Union Tannery history. A special thank-you goes to John Buckner, my Black Mountain "oak tree," for his deep-rooted local history, lifetime wisdom and solid support for my endeavors; most of all, I appreciate his "voice" that's added to the text.

More of my Grandfather District trees included Kevin Massey and Christopher Blake, PhD, of the Friends of Linville Gorge, who reviewed Linville's section. Chris is one of Outward Bound's first rock-climbing students at Tablerock Mountain, a Green Beret A-Team trainee at the gorge and an author/historian of two books on Linville Gorge. On his back deck, Chris generously opened files, scrapbooks, photo albums and a resource library, allowing me to get lost in his huge collection of Linville Gorge history. The hours went by too quickly.

The trees I shook at Wilson Creek will never be forgotten. Wayne Beane, president of the Colletsville Historical Society and author of regional history essays, welcomed me into his home office to become immersed in his vast collection of materials. His antique photos are displayed at the Wilson Creek Visitor Center. At the center, in the museum and in rocking chairs on the front porch, interviews with Glynis James; her father, Joe James; and Frances Crump Walker found my pen hard to keep up.

A sense of pride and commitment to the U.S. Forest Service was recognized through communications with retired fire management officer Gary Greer and C.W. Smith, the first law enforcement officer in the Grandfather District. (Unfortunately, long-distance phone calls with Doug Francis were cut short. Although Doug had retired from Pisgah National Forest as a Forest Service

interagency fire manager, he was fighting forest fires out west during the summer of 2014; his dedication to that service was certainly more important than discussing Pisgah's history.) Their knowledge of the district, as well as their genuine support, encouraged me in my endeavors. C.W Smith and Gary Greer reviewed Grandfather's chapters, offering valuable feedback. If only I had met them earlier. They had many more stories to share, like Gary and Doug's participation in the cutting and transportation of the nation's 35th Capitol Christmas Tree in 1998, a Fraser fir harvested from Pisgah National Forest on Roan Mountain.

A very special thank-you goes to Pat Momich, retired USFS Interpretive Specialist for North Carolina, for putting down her gardening tools and ignoring the weeds long enough to come out of retirement and help me with the Appalachian Ranger District chapter and others. Her enthusiastic support, fostered by her years of service to the agency, gave me the psychological boost I needed to finish the project.

Meeting Lloyd and Imajean Allen was delightful. Their stories about saving Little Snowball Fire Tower and her father's devoted career with the Forest Service inspired the book's introduction. Our lively visit at Little Smokey Diner in Burnsville and the tour of Little Snowball Tower not only provided an educational experience but also allowed me to feel a part of the community. Also welcoming me to Big Ivy, David Crowder, the minister at Carson Chapel Baptist Church, gave me a tour of the former Civilian Conservation Corps (CCC) camp when he should've been enjoying the Fourth of July with his family.

Appalachian Trail salutes go out to Morgan Summerville, Appalachian Trail Conservancy (ATC) regional director; Peter Steurer, with the Carolina Mountain Club (CMC); and Dwayne Stutzman and Sara Davis, with CMC (Sara also served as vice-chairman of the Southern Regional ATC), for providing knowledgeable, constructive edits of the sections on the Appalachian Trail and the Forest Service acquisition of Max Patch Mountain. Thank you, Karen Cragnolin, executive director of Riverlink of Asheville, for looking over the chapter section on the French Broad River.

Thank you, Cathy Miller, for writing a blog about finding the golden-winged warbler near Max Patch and posting your gorgeous photos online so I could find you. Your personal story richly embellishes Pisgah's history. A last-minute word of thanks for his valuable, just-under-the-deadline critique of the Mount Mitchell/Toecane region goes to Jake Blood, president of the North Carolina High Peaks Trail Association.

ACKNOWLEDGEMENTS

I appreciate Jennifer Bauer for reviewing the section on Roan Mountain and for writing a great resource book about the area. Christine Kelly, wildlife diversity biologist with North Carolina Wildlife Resources Commission, found time in her crunched schedule to update the status of peregrine falcons and golden eagles studied in Pisgah National Forest. Thank you, Chris, not only for your valuable conservation work with these distinguished avian species but also for coming to my rescue, once again.

David Whitmire at Headwaters Outfitters near Rosman shared his volunteer and recreational experiences in Pisgah, as well as his family history with the Balsam Grove CCC camp. The knowledge of available resources and the loyalty to public education of staff at libraries, museums, Register of Deeds departments, historical sites, visitor centers and chamber of commerce offices have not gone unrecognized or forgotten.

Logging and railroad expert Jerry Ledford reviewed the sections on the Pisgah District's logging history, providing invaluable suggestions to improve the accuracy of the text. Readers can learn more from Jerry by visiting the Cradle of Forestry's family-fun, educational Train Day. Each summer for the past several seasons, Jerry has offered historic photo presentations and guided walks along the Forest Festival Trail to the 1914 Climax engine.

My sincerest appreciation goes to my husband, John Spencer, for his patience with the incessant conversations about Pisgah and the long hours that I spent "up in heaven" in my loft library; for accepting hastily prepared dinners; and for joining me on frequent research road trips, especially the wild drive on Pisgah's Brown Mountain ATV course in his baby 4WD Toyota truck. Sorry. Grateful wishes go to my son, Tim Worsham, for accompanying, once again, my words with his beautiful pen-and-ink illustrations. To my daughter, Christi Worsham, and my granddaughter, Brooke Lyda, to whom this book is dedicated, I thank you for becoming as connected to Pisgah National Forest as I have, preserving our memories not only in the pages of this book but also in a more permanent, special place.

I owe a bookcase-load of gratitude to my commissioning editor at The History Press, J. Banks Smither, for his continued support and knowledgeable guidance. Many others at The History Press also helped produce the final product. I sincerely appreciate the professional critique by my copyeditor, Ryan Finn, for his stylistic improvements, edits and constructive suggestions to improve the overall flow and accuracy of the text.

Writing the history of Pisgah National Forest must be something like tree growth in a forest. With adequate resources, time and energy, the writer and forest will grow. As new knowledge develops and growing conditions change,

the course of direction alters, adjusting to new heights and dimensions. Mind and marrow, leaf and limb branch out with greater energy, sustaining healthy growth. In seeking the light, heart and soul, core and cambium become stronger, overcoming adversity and enduring the elements. Strong roots provide stability. A diverse group of community members with various identities, functions, backgrounds and contributions form an interconnecting web that shapes the overall character of book and forest.

I thank all the "trees" in my forest. So does Pisgah.

INTRODUCTION

T he cost was $300 but the value was priceless. "How much will you give for that old fire tower up there on Little Snowball?" an official asked.

"I'll give you a lot more money to leave it where it is," was the reply. "It should stay where it's been for the past fifty years." Still, the historic fire tower built in 1934 and manned regularly by only two men was coming down one way or another. Natural elements and vandalism were taking it apart bit by bit. As a safety hazard, the Forest Service needed it removed.

"Make an offer," his visitor seemed to beg. Perhaps he just needed help getting the dilapidated structure off the 4,740-foot peak on the Great Craggies, or maybe he, too, was saddened to see it go.

The gentleman, almost as a joke, tossed a piece a paper out of his truck window with "$300.00" scribbled on it. His signature, Lloyd Allen, had been scrawled across the bottom. Allen had known Little Snowball Tower since he was a young boy. It was not just a symbolic guardian standing high on the ridge above his home, protecting the Big Ivy community from wildfires; rather, it was a source of inspiration and patriotic pride. The Civilian Conservation Corps (CCC) built that tower. During a time in American history when the country was struggling to survive the Great Depression, unemployed young men were paid salaries by the federal government to send money back home to starving families. Enrolled men worked in the nation's forests, building roads, bridges, telephone lines and recreational sites. At a time when wildfires were a major concern, the corpsmen built and manned fire towers to help spot early blazes so they could be extinguished before

hundreds of acres were consumed. Little Snowball Fire Tower was a symbol of a country's collective will to survive—its unified sense of perseverance to overcome hard times through hard work by protecting the nation's forests while the country healed from its economic wounds.

For Lloyd Allen, it wasn't just Little Snowball that stirred sentimental thoughts. The last fire warden at Green Knob Lookout was the father of his wife of fifty-four years, Imajean Allen. Lloyd had hiked to Green Knob many times offering dinner and a little company to his father-in-law, Blaine Ray, occasionally staying overnight. Until the 1940s, Ray had worked on Mount Mitchell as a weatherman, living with Imajean and her mother in a little ranger's cabin and collecting data on the slopes of the highest mountain in the East. Across from a large rock cliff on the Balsam Nature Trail at Mount Mitchell State Park, the foundation of the cabin and weather station is now claimed by spruce and fir of the forest. Leaving Mount Mitchell to work for the U.S. Forest Service, Ray manned Green Knob Tower until it closed in the late 1970s.

When the Forest Service accepted Allen's bid of $300 for Little Snowball, he and friend Bill Hensley removed the tower, retaining each historic piece. "I kept every bolt," said Allen. Even the heavy concrete step, engraved by CCC hands, was not left behind:

Aug. 1, 1934
CCC F-8
Co. 409

After tumbling it end over end to a large tree, the men raised it by hoist and chain high enough to lower it into the bed of their truck.

Little Snowball Tower was first manned by Mote Allen, who helped build it as a member of the CCC. When his CCC term ended and he was too old to enlist in World War II, the Forest Service hired him to be the lookout's fire warden. After Mote's retirement, Cling "Fabe" Webb was its dispatcher for twenty years, until the Forest Service retired the tower. After Lloyd Allen removed Little Snowball around 1985, the tower that cost less than a man's suit was stored in pieces at Allen's house for twenty years, waiting for a new home. In 2007, at Big Ivy Historical Park in Barnardsville, after one year of volunteer labor, the reassembled Little Snowball Fire Tower was dedicated. U.S. Forest Service supervisor Marisue Hilliard delivered the speech: "I'm proud to be here today representing the Forest Service in saying thank you… [for] finding a permanent home for this wonderful legacy." Later, Mote

Allen's great-granddaughter in Florida returned his tower journal back home in Little Snowball Fire Tower.

Pisgah National Forest holds a vast history. Its story includes Theodore Roosevelt, Gifford Pinchot, Carl A. Schenck, politicians, conservationists, activists and others who campaigned for the federal government to protect its forested natural resources. Pisgah's history is also a story of foresters, wildlife officers and timber management staff tending those woodlands, as well as those people who owned the land before it became a national forest. Pisgah's story involves scientists and botanists who discovered a new species and researchers who collect years of data to guide future management plans. Pisgah's tale includes hikers, hunters, birders, campers, fishermen, rock climbers and all others who enjoy its recreational opportunities.

And yet, it's equally important to recognize that the story of Pisgah relates a history of communities of people who have given Pisgah their physical and emotional energy, their intellect and passion and, in some cases, their lives. Pisgah's story entails the memories preserved in museums, historical societies, reconstructed schoolhouses, scrapbooks, boxes in an old attic and a "Honeymoon Cottage."

It's a story of citizens actively participating in the forest's future by saving a grassy bald or two, relocating a famous trail across another, crusading for a special area to be protected as a wilderness or wild and scenic river or campaigning for a special lodge site to be designated as a historic location. Pisgah owes a debt of gratitude to organizations that secured available lands for Pisgah until slower meanderings through federal channels appropriated the funds to buy it.

Pisgah's history includes dedicated people who cherish their ancestral roots connecting family to forest, like descendants of Civilian Conservation Corp enrollees. One corpsman's son works as a campground host at Pisgah's Carolina Hemlocks. The daughter of a recruit at the Big Ivy CCC camp volunteers at the concession stand at Big Ivy's Fourth of July celebration, and the daughter of an enrollee at Mortimer's camp donates her mother's exhibit of the town of Mortimer at the Wilson Creek Visitor Center. A Curtis Creek Camp daughter returned home to Old Fort after retirement to manage the local library, creating a CCC display in its reading room. An owner of an outfitter company whose uncles worked for the encampment at Balsam Grove has adopted the headwaters of the French Broad River, and a kind gentleman whose father helped the Buck Creek CCC camp build the Blue Ridge Parkway gave directions to this frustrated researcher on a road outside Marion looking for the former site

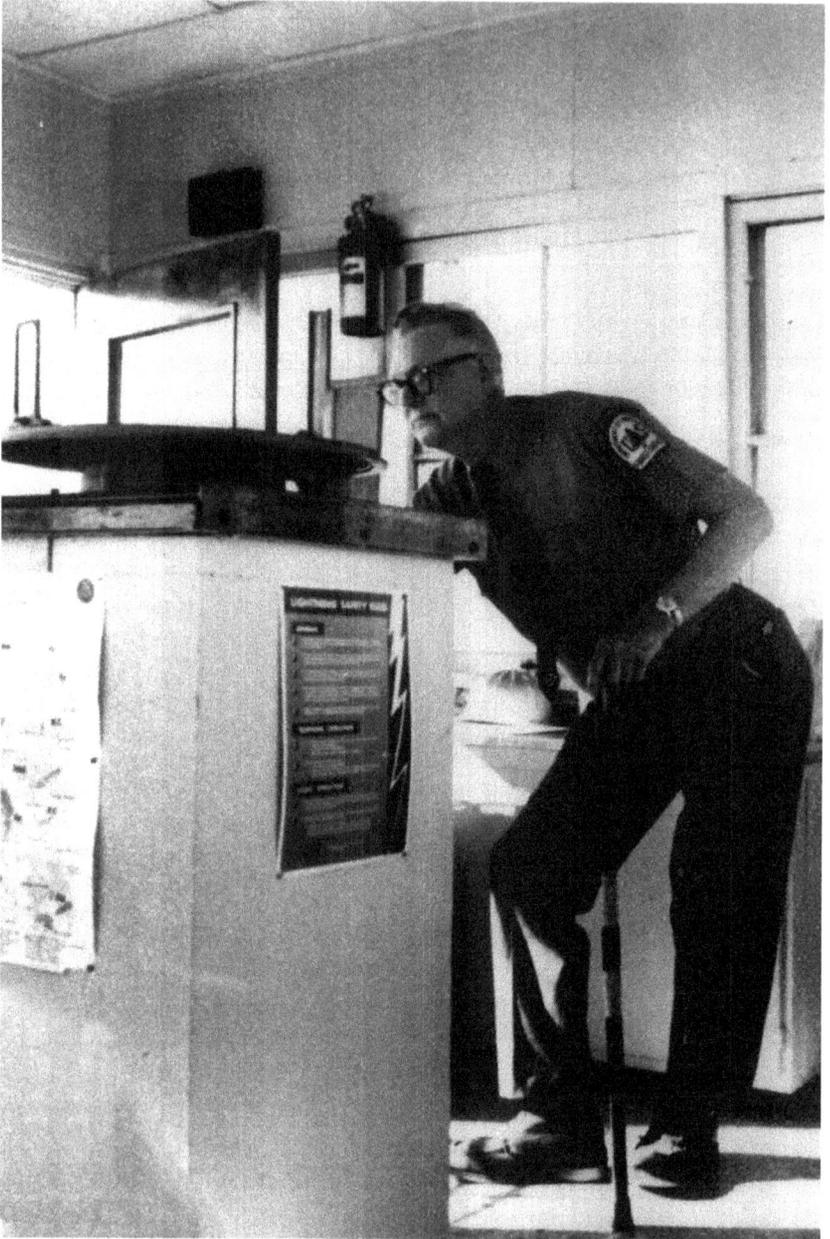

Cling "Fabe" Webb was the last Forest Service fire warden to man the Little Snowball Lookout Tower high on the Great Craggies. After obtaining a compass bearing on smoke that he had spotted in the distance, Webb would report his readings to one or two other towers, which would also take bearings. Triangulation, crossing lines drawn from several different remote points, helped officers pinpoint a fire's location more accurately. *Courtesy of Lloyd Allen.*

of that camp. When Jeffrey Thomas of Brevard researched Transylvania County's history of corpsmen working in Pisgah National Forest for his senior high school project, the experience changed his career goals. All these stories are a part of Pisgah's.

From the story of the man who designed the first fire towers for the Forest Service to a man who spent $300 to save one, the history of the Pisgah National Forest is captivating. However, there are only about fifty thousand words between these covers. Another fifty thousand words or more are missing. My hope is that my words detailing Pisgah's human and natural history will capture your interest and spirit and inspire you to go explore Pisgah's forests. There are enough stories and discoveries out there to fill several more books. Consider this book an introduction to Pisgah, and go find your own fifty thousand words.

Chapter 1

COMING TO
THE MOUNTAINS

W e are constantly thinking of all of you. But, with views like this, that surround us daily on our journeys, do you wonder why we are so reluctant to return home?" asked a visitor to the southern Appalachian Mountains. Postmarked in Waynesville, North Carolina, on July 5, 1922, the black-and-white postcard of Mount Pisgah, towering above a quiet mountain valley, preserved the repetitive theme in well-crafted, fluid penmanship.

"Come to the mountains," begged another. "The views are magnificent! We had a little rain yesterday, but the sunset was gorgeous! Wish you were here." From Asheville, North Carolina, to Youngstown, Ohio, a two-cent stamp delivered the plea on February 17, 1918. Pictured in soft, muted colors on the face of the postcard, Mount Pisgah and the Rat offered their own invitations.

A narrow highway leads motorists into peaceful Hominy Valley, arriving at Pisgah View Ranch at the foot of Mount Pisgah. Its massive cone-shaped pyramid spans the horizon with its commanding presence. Waves of forested ridges gently soften its outline; its smooth contours gradually blend into the valley floor. Since the mid-1800s, trails have led the adventurous to the crest of Pisgah Ridge.

"Bob-white! Bob-white!" called a low voice uttered between cupped hands. From a thick clump of rhododendron, sweaty palms eagerly waited for a response. "Bob-white! Bob-white!" his insistent cries repeated, imitating the call of an unmated, male bobwhite quail. Their secret code, announcing

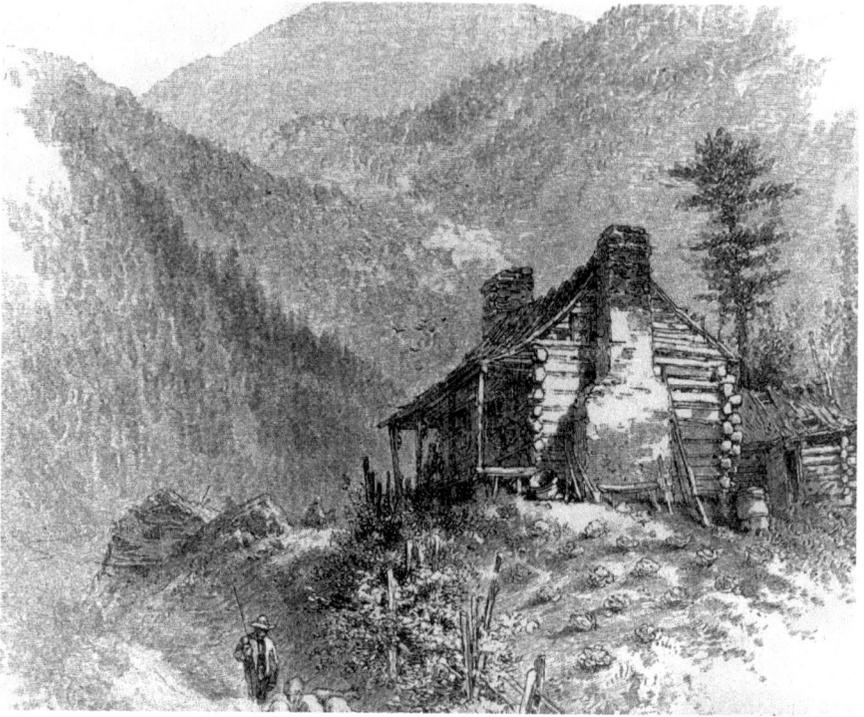

An 1880s woodcut print from *Harper's Magazine* depicting a cabin in the Blue Ridge Mountains. *National Forests of North Carolina Historic Photographs, D.H. Ramsey Library, Special Collections, University of North Carolina.*

the young man's availability and interest, was more urgent this time. This time, he was in trouble.

Slipping out, unnoticed, through the back door of her father's cabin, a beautiful young maiden joined her beloved sweetheart. No leaves rustled as they departed. No disturbed branches disclosed their secret escape. Footsteps, lighter than feathers and quieter than moccasined-feet, climbed the rugged mountain.

The girl's father had forbidden their love. Revenuers had banned the young man's whiskey-making still, which had, unfortunately, caused a man to lose his life. A posse and protective father took chase.

Maiden and man reached the cabin of Miss Peggy Higgins. A lost love had left the aging woman bitter and alone. On a mountaintop fourteen miles from Mount Pisgah, Miss Higgins invited the young couple to warm by her fireplace. Memories flooded her soul. Emotions, put to rest long ago, resurfaced.

After stoking the fading embers, Miss Higgins left to summon a priest from Hominy Valley. Upon their return, tired, arthritic fingers opened an old trunk. Delicately, she lifted out a long-flowing wedding dress, untouched for decades and never used—a treasured keepsake of a painful past.

Bride and groom sealed their vows with a kiss. A forest commotion ended the ceremonial bliss. They had been found. Paternal pride and posse were nearby. The newlyweds fled. As they climbed higher and higher into the reaches of Mount Pisgah, heavy snow covered their tracks. Where did they go? What happened to them? No one knows for sure. But on a cold winter day, when large snowflakes begin to pile up and ice pellets start gripping Pisgah's rocky cliffs, look up. On Pisgah's north flank, seen in Hominy Valley, look for the "Bride and Groom." In June 1925, an article in the *Southern Tourist* reported that the contented bride could be seen wearing Miss Higgins's wedding gown.

Versions of "The Legend of Mount Pisgah's Bride and Groom" differ in names and minor details, but the echo is always the same. Look up at Pisgah when the snow falls. Appliqued to the face of Pisgah, a poised bride stands confidently, her bridal gown and veil flowing in the mountain winds. By her side, her groom kneels in perpetual devotion. Look closely to the left, some say. A furious father is drawing near.

Downtown Asheville can also provide good winter views of the "Bride and Groom," but the "Rat" is seen all year. Asheville has long been proud of its iconic Mount Pisgah, rising 5,721 feet on the southwestern horizon of the city. A smaller mountain, known as the "Rat," with its head tucked under Pisgah's right shoulder and its domed backbone perched on Pisgah's steep slope, seems to be climbing the peak. An even smaller knoll forms his tail.

In his 1930 book *The History of Buncombe County, North Carolina*, Dr. F.A. Sondley described Mount Pisgah: "The most prominent of Western North Carolina mountains is Pisgah…It is rendered more prominent by the shape of Little Pisgah next to it on the south and presenting a striking resemblance to a 'Rat' or squirrel in its outline."

A simple child's tale relates the "Legend of Pisgah and the Rat." One spring, in defiance of his father's wishes, a rebellious young boy-rat foraged up Mount Pisgah ahead of his rat-family. To punish him for his disobedience, a mountain fairy turned him to stone—a solid message to all children today to obey their parents!

Mount Pisgah is one of nearly two hundred mountains in Western North Carolina that rise more than five thousand feet in elevation. Some of the most visited are Devils Courthouse, Cold Mountain, Shining Rock and

Grandfather Mountain. Mount Mitchell, Roan Mountain, Craggy Pinnacle Greybeard, Chimney Rock, Linville Peak and Shortoff welcome visitors to their inspirational havens, urging visitors to experience life at a slower pace, explore natural wonders that lift the spirit and return home refreshed and renewed. Climb a mountain. Fish a stream. Cross a log spanning a creek. Ride a horse. Push, tug and scramble through dense undergrowth to find a spectacular waterfall, believing that no one else has ever discovered it. Scale a bald summit or view one in awe from a distance. Remain quiet while eyes are cleansed of trials back home and drift across soft, blue, misty ridges rolling into one another as if permanently pushed together by a massive wave.

For generations, mild climates and fresh mountain air have enticed visitors to the southern Appalachians. Fleeing steamy, insect-infested summers in Charleston and Savannah, coastal plantation owners and other flatlanders sought refuge from malaria in the mountains of North Carolina. Wealthier tourists built summer cottages to stay during summer seasons.

By the late 1800s, doctors were prescribing clean mountain air, with mild temperatures, bright sunlight and high humidity, for sick patients complaining of a chronic cough. Southern Appalachian pamphlets, such as *Asheville, Nature's Sanitarium*, promoted the area's curative powers. Numerous southern sanitariums advertised wide, breeze-collecting verandas facing magnificent scenic views. Physicians moved their families to the Blue Ridge Mountains for their own health. Tuberculosis specialists opened pulmonary treatment and study centers. In Asheville in 1871, Dr. Gatchell opened the Villa, the first tuberculosis sanitarium in the United States. For health and pleasure, mountain mineral springs, naturally heated to more than one hundred degrees Fahrenheit, soothed ailing bodies and spirits. A main thoroughfare, the Buncombe Turnpike, guided weary wanderers along the French Broad River to the spa at Warm Springs.

Completed in 1827, the seventy-five-mile Buncombe Turnpike crossed the South Carolina line through Saluda Gap, Flat Rock and Hendersonville; passed through downtown Asheville; and followed the French Broad River to Warm Springs (now Hot Springs) and Paint Rock on the Tennessee state line.

"Move it out of the way!" yelled a hefty livestock drover on the old turnpike, cracking his red flannel whip. "My hogs are coming through!" From May to October, farmers pastured livestock on high mountain balds and in lush green valleys. Fattened hogs would bring a pretty penny for the price of pork in Charleston. Hog herders drove nearly 175,000 hogs along this route each year, joining thousands of sheep, horses, cows and turkeys.

"Come here and help me, man! My wagon wheel's stuck again." After last night's heavy rain, an ox cart was mired to the hub in mud on Asheville's Town Square. Heavy wagon-train traffic on the area's main highway, the Buncombe Turnpike, carved deeper grooves in yesterday's muddy ruts. Four-inch-thick, eight-inch-wide wooden planks, placed side by side across wooden supports, lined the roadbed of some southern roads. Double-thickness "plank roads" of the 1850s allowed all-weather travel. Widened areas improved traffic flow. But in the shadow of the old Buncombe County Courthouse and other hubs, where improved road conditions were lacking, muddy traffic snarled.

Landowners with property along the turnpike turned travel into profit. Station-keepers sold corn for livestock to North Carolina, Tennessee and Kentucky herders. Drover stands corralled animals for the evening and provided food and shelter for drovers. Hotels and lodges welcomed turnpike tourists. Loaded wagons headed to market, and eager tourists seeking scenic views mixed with cattle, swine and fowl on the old Buncombe Turnpike.

After building a toll bridge across the French Broad River, clever James Smith became quite wealthy. His wooden bridge near Asheville, the only way for turnpikers to cross the wide river, generated a steady income. A man on a horse paid about six cents, a footman or cow two cents, sheep and hogs a penny and turkeys half a cent. Loaded wagons cost more than empty ones. Four-horse carriages were more than two. Got a one-horse gig of pleasure? Twenty-five cents, please.

In 1837, in Warm Springs, James Patton built his 350-room hotel along the turnpike for first-class travelers. In grand architectural style, thirteen massive columns, symbolizing the thirteen original colonies, supported three stories, with open galleries and magnificent views. Hot, cold and tepid springs provided bathwater suited to personal preference. Water pumped from the mineral springs provided warm water at the hotel. Pipes stretching from high mountain slopes ran under the French Broad River to Patton's hotel in the flat valley on the opposite side, offering guests cool, fresh mountain spring water. An early Warm Springs brochure boasts:

> The Warm Springs...on the French Broad River, near the Tennessee line, are surrounded on all sides by the highest mountain ranges East of the Mississippi River, presenting some of the most magnificent scenery in the United States...mountain elevations from which the Tourist views the extended ranges of the Blue Ridge...looking into six different States, all presenting Nature's finest panorama.

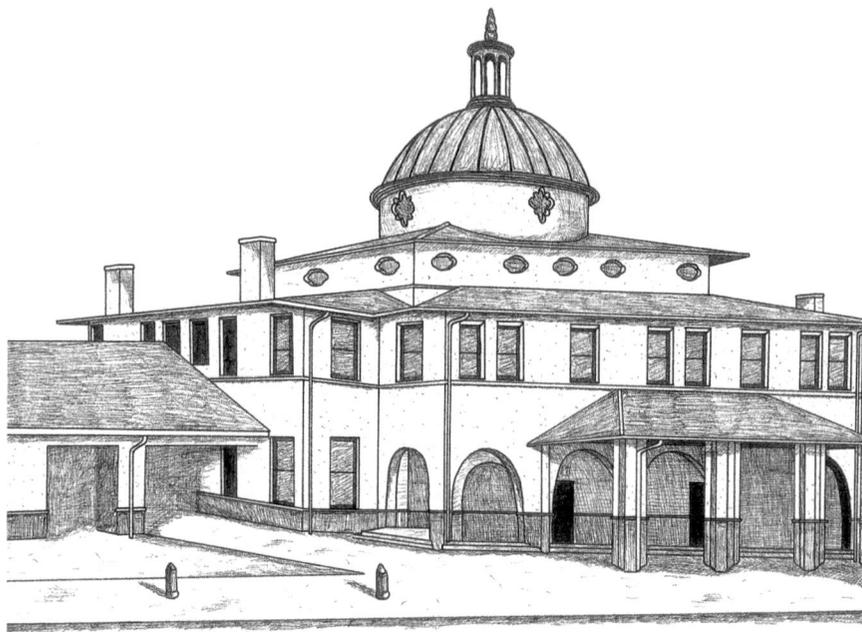

Southern Railroad Depot, Asheville, North Carolina. *Illustration by Tim Worsham. www. facebook/timworsham.*

The arrival of the railroad promoted mountain tourism more than grand hotels. Rail lines repaired after Civil War destruction were upgraded and extended. After decades of delays caused by embezzlement and topographical challenges, manual labor and skilled engineers brought rail service to Western North Carolina. Wrapping around steep mountains, trestling above deep rivers and ravines, tunneling through rocky cores and looping over high ridges, rail service arrived in Asheville in 1880. Now, not just wealthy tourists but also middle-class passengers visited the region. Double-duty logging trains added even more passenger service. Each year, Southern Railway issued a brochure suggesting scenic routes.

Travel became cheap and worry-free: no more stalled carriages, rutted quagmires, toll gates or muddy road jams. Destinations were no longer a frequented lodge at one location for an extended period of time. Excursions varied; exploring became pure fun and less health-oriented. Trains transformed remote areas into magnanimous, sightseeing adventures. Tourism flourished.

Accommodations built close to railroad depots entertained the most clientele. Depot-to-door horse-and-carriage services taxied visitors from train stations to nearby inns. Tourist numbers swelled; competitive hotels enhanced guest services to keep up with the growing demands. Innkeepers installed modern conveniences, served meals and offered guided excursions into the mountains during both winter and summer.

Resort hotels, such as Asheville's Battery Park Hotel and the elaborate Kennilworth Inn, welcomed the privileged upper class. Resort communities sprang up in Linville, Blowing Rock and Highlands. Little Switzerland, and Albemarle Park opened summer cottages. Mountaintop lodges, like the Cloudland Hotel on Roan Mountain and the Eagles Nest on Balsam Mountain near Waynesville, provided sweeping views in a remote setting. Boardinghouses became common. Asheville's famed author Thomas Wolfe grew up in his mother's boardinghouse, the "Old Kentucky Home." Julia Wolfe hosted tuberculosis patients, sharing company with repeat patrons and wandering transients.

By 1890, automobiles and improved road conditions had made independent travel even more popular. Travel magazines promoted scenic

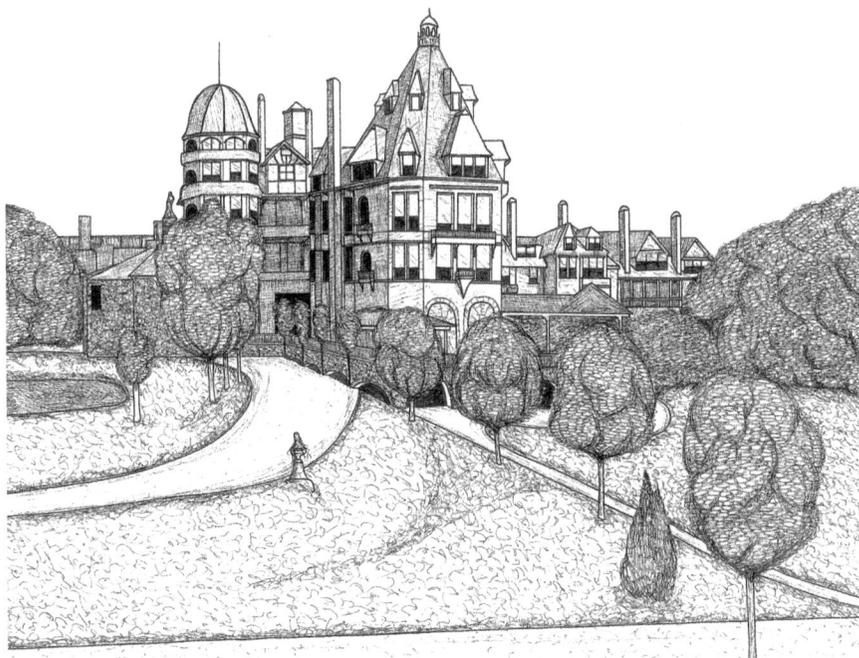

Battery Park Hotel, Asheville, North Carolina. *Illustration by Tim Worsham.*

An early 1900s advertisement promotes Western North Carolina. *Asheville Chamber of Commerce.*

drives. One promotional ad urged "motor-routing" in Western North Carolina, where "the mile-high mountains are a riot of color...Spring days are sapphire days, drenched with the soft exhilarating sunshine of the higher altitudes...days that give old pleasures a new tempo, a new flair, a new zest...You've never motored until your car glides swiftly along endless miles of matchless highways atop the world."

Reminiscent of Robert Louis Stevenson, Charles Dickens and Mark Twain, travel writers recorded their southern journeys in literary narratives. In 1876, Christian Reid, pen name for Frances Christine Fisher (Tierman), published her book *Land of the Sky*, a romantic

"TURNING," BY ALAN REYNOLDS

Is the Rat still stranded half way up Mount Pisgah?
Do persimmons still turn sweet when kissed by frost?
Do the autumn leaves alert the hunted whitetail
or is everything we cherished gone and lost?
I've built houses and I've helped men burn down cities.
I have danced with women who have shown me grace.
The foreign ports have always seemed the prettiest
and I've gone downhill until I've found my place.
Do the Appalachians shimmer when the leaves turn?
Do the grey squirrels bury acorns they forget?
And does Hominy Creek remember where we buried
the crow, and is he resurrected yet?
I still sing the songs and still forget the lyrics,
remember street names and forget the towns.
I pray for mountain rain to cleanse the barracks
where we made the lightning thunder down.
I will lift my eyes to Pisgah where the clouds hide.
I will track the bear and boar through rhododendron.
I will seek the spring that no one's ever drunk from
and when I find it I will know I'm home.

fictional account of youths in the southern highlands. Her flattering title continues to represent the beauty of the region. In 1883, *The Heart of the Alleghenies*, by Wilbur G. Ziegler and Ben S. Grosscup, promoted Mount Pisgah's accessibility and long-range views. "From its summit the views are boundless. The broad valleys, watered by the Hominy and French Broad, stretch toward the eastern limit."

Edward King, though, may have said it best in 1875. For more than twenty-five thousand miles, King recorded the South's human and natural spirit. His companion, the celebrated artist James Wells Champney, captured the region's personality in more than five hundred sketches. In his huge volume, *The Great South: A Record of Journeys*, King noted:

The day's journey was but a succession of grand panoramic views of gorge and height...we rode for several miles along a path cut out of the mountain's steep side and hundreds of feet below we saw the tops of tall pines and spruces...now we came into a valley through which a wide creek flowed rapidly, finding its outlet between two hills towering thousands of feet above us; to lie in the turf beside the cool stream and to drink in at every pore the delicious inspiration of the pure mountain air...on the south and south-west [of Waynesville] are Mount Pisgah...and Cold mountain, which rises 6,063 feet out of the "Big Pigeon" valley; and away to the south and south-east stretches the chain of the "Richland Balsam"...the dry and pure air gives new value to life, the healthy man feels a strange glow and inspiration while in the shadow of these giant peaks.

Flip over an old postcard. Magnify the tiny, faded cursive script that has preserved a traveler's enthusiasm for more than one hundred years. "Come to the mountains" was the oft-repeated refrain. And come they did. So did a refined gentleman once or twice. And then he stayed.

Chapter 2
A GENTLEMAN COMES

On an open, rounded hill, a lone pine seemed to stake its claim. Softened views of distant mountains dissolved into the blue horizon, as if blended by a talented artist. Was the lone pine illuminated by the yielding sun? Or was it basking in the spotlight of noonday glow? Nonetheless, the dark pine's silhouette on a hill rising above the seamless flow of the Swannanoa River into the French Broad caught his attention. On that symbolic spot, George Vanderbilt decided to build his Biltmore House.

A train's whistle signaled his approach. Departing New York's cold winter of 1888, George W. Vanderbilt III and his mother railed into Asheville's train depot. His father, William H. Vanderbilt, had passed away three years earlier. Maria Louisa Vanderbilt, his mother, needed relief from recurrent malarial symptoms. In 1885, Dr. S. Westray Battle, a retired U.S. Navy surgeon, began practicing pulmonary medicine in Asheville. Dr. Battle's expertise would provide Mrs. Vanderbilt's medical treatment, the luxurious Battery Park Hotel their accommodations and the milder climate and southern blue hills the therapy.

The rolling hills, open spaces and scenic mountains led George Vanderbilt on long carriage rides and walks through the forests, confirming what he had seen from the balcony of the Battery Park Hotel. As a perfect place to improve his mother's health, he could build a country retreat near Asheville, a relaxing refuge from smoggy, crowded New York streets. The retreat, however, would become his home.

George W. Vanderbilt III. *National Forests of North Carolina Historic Photographs, D.H. Ramsey Library, Special Collections, University of North Carolina.*

As grandson of Cornelius Vanderbilt, who was mega-successful in steamboat and railroad affairs, George Vanderbilt inherited millions. His brothers and sisters spent their fortunes building mansions in New York and Rhode Island. Although he owned other homes, the thirty-five acres leveled atop the little mountain of the lone pine provided the space he needed to build his 5-acre, 255-room mansion, the Biltmore House. By 1888, he had purchased 2,000 surrounding acres. Eventually, 10,000 acres of Biltmore Forest radiated from the house. By 1895, Vanderbilt's holdings included Pisgah Forest, totaling nearly 125,000 acres in Western North Carolina.

Biltmore's architect, Richard Morris Hunt, who had crafted several grand New York City buildings, suggested that the Biltmore House be molded into the landscape. Its size and design should complement the beautiful range of distant mountains, not overshadow them. Richard Sharp Smith supervised the architectural progress on site.

Landscape architect Fredrick Law Olmsted designed the gardens for Vanderbilt's country estate. He created a gentle roadway entrance, keeping steep banks and large rocks, saved native trees for roadside borders and allowed a variety of understory plants to grow wild like a true forest. Nature provided the basic design. He kept gentle streams and pools of water, "all consistent with the remote depths of a Natural Forest." Gardens viewed from the house would harmonize with outlying forests.

Vanderbilt hired painters, stonemasons, cabinetmakers and bricklayers, who placed the foundation's first block in the summer of 1891; 4:00 a.m.

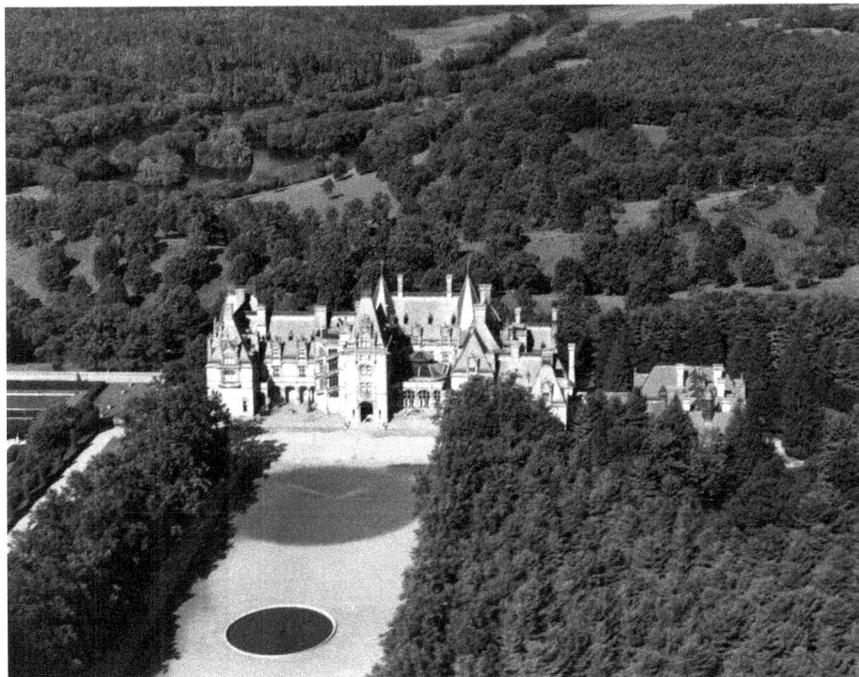

Aerial view of the Biltmore House. *National Forests of North Carolina Historic Photographs, D.H. Ramsey Library, Special Collections, University of North Carolina.*

mornings found European artisans on their way to Biltmore visiting Blomberg's Shop in Asheville for fresh supplies of tobacco. Local labor built roads and constructed a three-mile, private railroad spur from the Biltmore Train Station to transport building supplies to the house site, such as limestone, traveling six hundred miles from Indiana. For six years, crew members dug and ditched, pulled and piled, cut and carried and lifted and leveled—fashioning each piece of the mansion's puzzle into one magnificent structure.

Vanderbilt wanted a self-sufficient estate. Livestock provided not only valuable fertilizer for maintaining large nurseries, transplanted trees and vegetable gardens but also important food products for the estate. Gardens produced fruits, vegetables and grain products. One hundred beehives offered honey. Forests provided cords of firewood for both the estate and local residents. An early 1900s ad read, "Biltmore firewood. Phone: 700."

Farming was a natural part of Vanderbilt's heritage. In the mid-1600s, Jan Aertsen van der Bilt left Holland to settle in America's Dutch colony of New Netherlands. In 1715, he deeded one hundred acres on Staten

Island to his grandson, Jacob, a farmer and fisherman. Born on the island in 1862, George Vanderbilt later inherited his family's farm, Homestead. As a young adult, living with his mother in downtown New York, George harvested the farm's products to supplement their food and flowers. After he moved to Biltmore, Vanderbilt transported his prized Jersey dairy cows from Homestead to Asheville. The pedigreed herd produced record-breaking milk products. Vanderbilt's hogs were winners in a 1901 swine contest in Buffalo, New York.

In 1890, Olmsted hired Canadian horticulturist Chauncey Beadle to supervise the plantations and nurseries. The nurseries provided seedlings that were transplanted along carriage roads and throughout the estate grounds. From surrounding forests, Beadle collected native plant specimens. Exotic species were ordered from foreign countries. By 1893, Beadle had collected more than 4,000 varieties of trees and shrubs and more than 500,000 different plants. He had propagated from seeds and seedlings nearly 3 million more. For sixty years, longer than any other employee, Chauncey Beadle retained a supervisory role at Biltmore Estate.

Vanderbilt purchased lands beside the French Broad, Swannanoa, Davidson and Mills Rivers and tracts along the old Buncombe Turnpike, in the Pink Beds, Hominy Valley, Bent Creek and Averys Creek. Acreage on Busbee Mountain, higher than the Biltmore Estate, was purchased to provide a gravity-fed water supply. Vanderbilt bought large tracts of both agricultural and forested lands, some of it overused, overly grazed and excessively logged. The purchase of smaller tracts between larger ones stitched the landscape fabric together into one large country estate.

From several owners, including Senator Thomas L. Clingman, Vanderbilt purchased Mount Pisgah. Clingman considered those three hundred acres to be his most prized possession. In 1878, he wrote:

> *The twin-ridge, which, leaving the Balsam…gradually diverges to the east, terminates in the beautiful peak Mount Pisgah…Its top, five thousand seven hundred and fifty-seven feet above the sea, is a triangular shaped pyramid. Standing alone as it does, it affords a magnificent view for a hundred miles around. It forms the corner of the four counties of Buncombe, Henderson, Transylvania, and Haywood.*
>
> *The view…from the valley of [Hominy] creek…is always a striking object…Its beautiful blue on a summer evening is sometimes changed into a rich purple by the rays of a red cloud thrown over it at sunset. In winter… covered by a fresh snow in the morning, its various ridges present their*

outlines so sharply, that it seems as if they had been carved by a chisel into immeasurable depressions and elevations. After one or two day's sunshine, the snow disappears on the ridges, but remains in the valleys. The mountain then seems covered from summit to base with alternate bands of virgin white, and a blue more intense and beautiful than the immortal sky itself presents.

In 1835, Clingman received Mount Pisgah as a gift. At that time, North Carolina law required senatorial candidates to own at least 300 acres in their district, so his friend Zachariah Candler gave him the necessary acreage to run for office. Acquiring nearly 200,000 acres as a land speculator and revolutionary war veteran, Candler had soil to spare. Wielding the political power of property, Candler gave Clingman a 300-acre "huckleberry plantation" on the summit of Mount Pisgah. Fifty years later, Clingman sold his part of Pisgah to Vanderbilt for $800.

Even though Vanderbilt handled some of the transactions directly, Charles McNamee—Vanderbilt's friend, attorney, land agent and estate manager—negotiated some purchases on Vanderbilt's behalf, signing the deeds over to Vanderbilt later. Some landowners sold their farms readily. Others reluctantly relinquished inherited land. Only a few adamantly refused. Proud of his southern heritage, Martin Luther Lance of south Buncombe County had a soul connected to his soil like a cord to a mother's womb. Sever that cord, he thought, and lose a sense of place, purpose and identity. As a tangible, in-print reminder of his determination to retain ownership of his precious property, Lance kept a discolored, early 1900s Asheville newspaper clipping in his wallet:

Many strange looking boxes...have been coming here...marked Paris, Rome, Naples, Vienna, and...Athens, Greece, no doubt sent out hurriedly to avoid complications in the event of occupation by the Turks. The young millionaire, George Vanderbilt, is now in Europe picking up some treasures for his $6,000,000 palace up here in the "Land of the Sky"...the most wonderful private residence in the world. Mr. Vanderbilt himself selected the point for his home after traveling all the known world over, because it had the most perfect climate to be found anywhere. The Southern Railway officials say that this section is the most popular resort on their great system, and they attribute it to the air and the grandeur of the mountains.

Mr. Vanderbilt very graciously allows the public to visit his grounds and admire the palace....No king nor queen, nor prince, nor lord, on this earth has such a magnificent palace as the quiet, studious, book and art-loving

young bachelor has built for himself high up here among the mountains…
He has 180,000 acres, and can travel thirty-five miles in a straight line
from his door without reaching the boundaries of his estate…Seldom does
anyone come here without going out to see Biltmore.

Vanderbilt hired forester Gifford Pinchot to rehabilitate agricultural fields and tend his forests. Olmsted and Vanderbilt considered properly managed, sustainable forestry as one of the most important projects for the estate. Pinchot, educated at Yale and trained in scientific forestry in France, believed that Vanderbilt's forests held a great potential for productive forestry. Eagerly ready to practice his new skills, Pinchot and Vanderbilt surveyed the forests on horseback.

On a high bluff beside a grassy meadow at Buck Spring Gap on Pisgah Ridge, a quiet trickle emerged. Freed from the earth's deep, dark chambers, the pure, cold mountain water of a small spring glistened in the sunlight. There, in the gap of the Buck Spring, one mile southeast of Mount Pisgah, George Vanderbilt planned to build a mountain lodge.

In 1895, when the mansion was nearly finished, Gifford Pinchot and Dr. Carl Alwin Schenck, a recently hired German-trained forester, scouted Pisgah Ridge and surrounding woodlands to discuss plans for Vanderbilt's forests. Following a pioneer's steep route from Hominy Valley, carved yearly by livestock herded to high-ridge meadows, the two foresters climbed to Buck Spring Gap. Like royalty reigning over vast kingdoms, Mount Pisgah towered above them. The pair explored the forests of the Pink Beds and Big Creek Valley. Returning to Pisgah Ridge, Pinchot and Schenck camped at the foot of Mount Pisgah in a hut built for Pinchot's bear hunting trips, "Good Enough Cabin." There, the two men bonded with nature during the weeklong event. Forest management plans could wait.

Returning to Biltmore, Schenck learned that Pinchot planned to leave the estate to work as a consulting forester in New York, leaving Schenck to continue Pinchot's work at Biltmore and Pisgah Forests. In 1896, Vanderbilt, Schenck and Olmsted's son returned to Buck Spring Gap, marking the proposed lodge site. Although Richard Morris Hunt had died the previous year, the master designer of the Biltmore House had drafted preliminary architectural drawings for Buck Spring Lodge. Hunt's son,

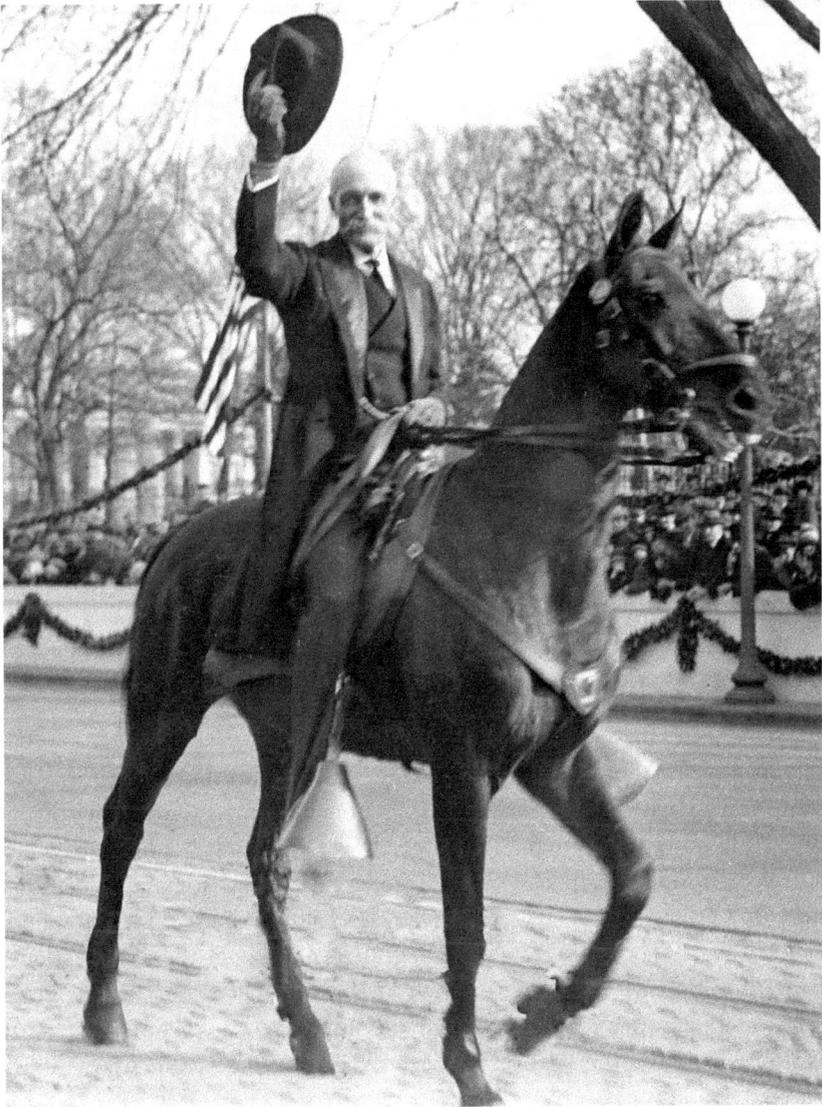

Gifford Pinchot. *National Forests of North Carolina Historic Photographs, D.H. Ramsey Library, Special Collections, University of North Carolina.*

Richard Howland, completed the project by 1902, modifying the plans per the owner's pleasure.

Vanderbilt requested one thousand chestnut logs for Buck Spring Lodge, but neither high-elevation Buck Spring Gap nor low-lying valleys offered

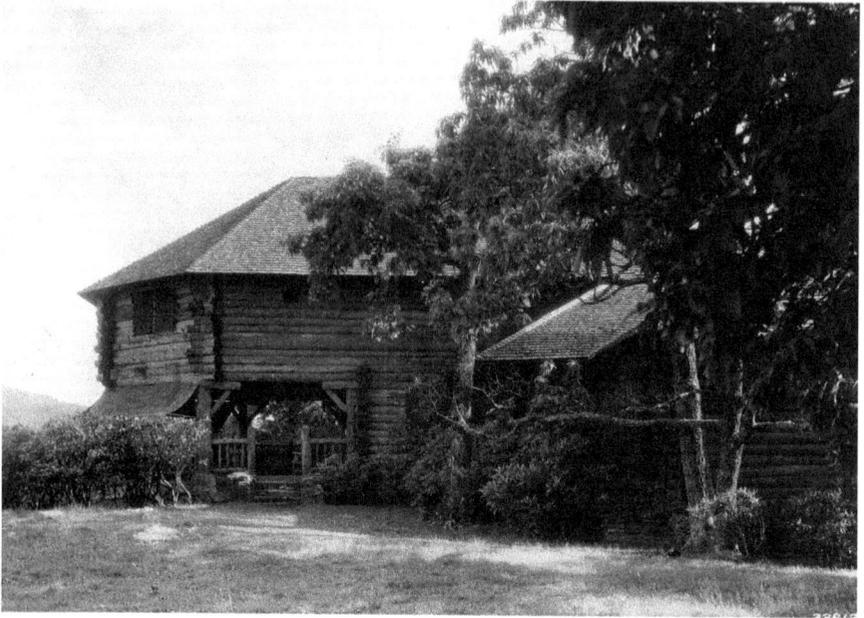

Buck Spring Lodge. *National Forests of North Carolina Historic Photographs, D.H. Ramsey Library, Special Collections, University of North Carolina.*

huge numbers of large chestnut. Northwest of Pisgah, in the Pigeon River Valley, however, project supervisor Dr. Schenck learned that family-owned logging companies and sawmills had been harvesting high-quality hardwoods for years. From Cruso in Haywood County to Pisgah Ridge, an old, rough path along Pisgah Creek crossed Hardy Cogburn's property. After obtaining a right-of-way, Schenck's crew and Cogburn relatives graded and widened the old roadbed within a few weeks. With a Hessian Bose clinometer (or forester's slope gauge), Schenck repeatedly measured the ground's angle of elevation, sculpting the roadbed up the two-thousand-foot incline within a 6 percent grade.

Construction workers crafted the lodge buildings from native materials. Local stone formed chimneys, steps, retaining walls and foundations. Tree-sized logs braced walls and ceilings; peeled logs secured porches and banisters. Rhododendron stalks, vines and tree branches—some stripped smooth and others left roughened with natural bark—created ornamental railings. More logs ordered in June 1896 completed the dining room with kitchen. Logs for stables arrived in July. "Elegantly rustic" described the lodge and other buildings.

For Vanderbilt, Buck Spring Lodge was more than a grand retreat on a ridge beside a loved mountain. Vanderbilt's lodge was a sylvan sanctuary, with a rich variety of trees, wildflowers and wildlife. As a base camp to fish, hunt and explore, Vanderbilt denned up alone at the Buck one summer, departing only once for a barber in Candler.

In 1898, George Vanderbilt married Edith Stuyvesant. Did Carl Schenck light a bonfire atop Mount Pisgah visible from the Biltmore House to welcome the lady to the mountains, as some claim? Schenck historians seriously doubt it; the German forester feared wildfires in woodlands under his care. Later, Vanderbilt added a small cabin at Buck Springs, tucked in its own private little haven, as a playhouse or schoolroom for his new daughter, Cornelia. A Mid-Way Cottage, connected to the main building by a covered breezeway, added four more bedrooms and two baths.

By the early 1900s, men and mules had opened a twenty-mile bridle trail between the Biltmore House and Pisgah Ridge, crossing the French Broad River by ford or ferry. Widened just enough for horses with wide bundles, men designed the trail for a lady's comfort too. Trimmed vegetation permitted ladies in long dresses, mounted sidesaddle, to pass more freely.

Vanderbilt Motor Road. *National Forests of North Carolina Historic Photographs, D.H. Ramsey Library, Special Collections, University of North Carolina.*

Stone retaining walls secured eroded areas. Leading the caravan, rangers cleared the trail of unexpected debris. Although the "Shut-in Trail" provided a route for lodge pilgrims to pass, provisions and staff still traveled Schenck's rugged wagon road from Cruso.

In about 1911, estate manager Chauncey Beadle proposed a new road through Hominy Valley up by Stoney Fork to Buck Spring Lodge. Using deep switchbacks to ease the grade, the one-lane road required limits for safe motorized use. Drivers ascending the motor road had to reach Pisgah Ridge by 1:00 p.m.; descending traffic could only travel after 2:00 p.m. Attendants stationed up on the ridge and down in Hominy Valley supervised traffic flow by communicating with a hand-crank phone system. Vanderbilt's Motor Road is now NC-151, paved and widened into two lanes. Until the Blue Ridge Parkway crossed Pisgah Ridge in 1962, many visitors traveled this route to visit Mount Pisgah. Pisgah View Ranch now rents the attendant's little gatehouse as a cozy accommodation for two.

Decades later, in a classroom at Pisgah Elementary School, students received an unusual homework assignment from their math teacher.

"But what does that have to do with math, Mr. Hill?" a seventh grader asked.

"Think about it. What *is* math?" Mr. Hill replied.

"Just numbers," a student summarized.

"Sure, it's about numbers," Mr. Hill explained. "But think deeper. Math is a relationship of numbers. A quantity is multiplied, divided, added or subtracted. Math tells a story of patterns, expressed in its own language. Math is dynamic, changing."

"But I still don't understand. What does that have to do with walking the creek?" insisted a little girl who didn't walk the creek very often.

"Math principles require proof," Mr. Hill responded. "So does our heritage. That special community out there where you live, Hominy Valley, follows a creek. Your family's history is out there; over the years, families have come and gone from this valley, multiplied and divided. Life patterns have changed. Find me some proof."

"What proof?"

"Walk the creek," assigned the math teacher. "Walk up Hominy Creek toward its headwaters and find out something about your family's past that you didn't already know. Knock on a door. Talk to a grandmother, aunt or

someone you've never met. Bring in some local proof on Friday—old letters, postcards or documents that tell a story about the community's past."

The homework assignment expanded beyond the traditional scope of mathematical instruction for thirteen-year-olds, but not for Mr. Chester Hill. Chet Hill was connected. His maternal Morgan family roots dated back to the earliest settlers in Hominy Valley. In the late 1880s, Morgans owned thousands of acres there. Family ties were precious. As young people matured, grew and left the valley, numbers changed; families multiplied and divided, changing patterns and forming new groups. "Walk the creek," he said. "Discover your past."

By that Friday, receipts from sawmills and country stores were coming in, some dating back to the 1830s. Unnamed black-and-white photos of wagons pulled by oxen mired in mud arrived. One child brought faded photos of a groomed man and wife headed to Sunday church. Old Hominy Station train tickets, brochures and Pisgah postcards left proof of visiting friends and family. Clipped newspaper articles told local stories stirring emotions, thoughts or new decisions. Pages of an old Bible preserved some sentimental papers. Others, tossed aside and long forgotten in a box in the attic, were now uncovered.

"Mr. Hill, I have something," said little Anita Davis, handing the teacher a slip of paper. Smoothing out tiny creases, Mr. Hill noticed the date: "July 18, 1911." He read aloud from an original receipt: "Received from Captain J.C. Lipe for G.W. Vanderbilt fifty dollars as pament [*sic*] for the old log church or Davis Chapel or Stoney Fork Church building…A.T. Davis."

Built in the mid-1800s, this one-room log meetinghouse was a shared school and church in Hominy Valley. Eighty students attended class at Stoney Fork until 1907, when the Buncombe County Board of Education chose to consolidate the school with the one-room Pisgah Meetinghouse. The new two-room Stoney Fork School replaced both of them. Located at the site of the current Davis Chapel Methodist Church, the original Stoney Fork School was taken apart and carted to Buck Spring Gap on the new Vanderbilt Motor Road. According to Walt Weber, Buck Spring Lodge historian, Stoney Fork Schoolhouse was the "oldest structure at Buck Spring but the newest one to arrive." The school became known as "Honeymoon Cottage," adding two more bedrooms and bath to the lodge complex.

In 1912, a new Buck Spring Lodge ranger, William H. Cogburn Sr., replaced Ranger Clete Davis, who had been shot by mistake by a poacher. Born in 1880, William was the son of Hardy Cogburn, Vanderbilt's closest

"SAVING BUCK SPRING LODGE SITE ON THE BLUE RIDGE PARKWAY"

By Walt Weber, retired in Brevard, North Carolina, from Baltimore, Maryland, after a thirty-three-year career with the Chessie System railroads, now CSX. After moving to North Carolina, he became active with Carolina Mountain Club and helped plan, build and maintain the Pisgah Ridge section of the Mountains-to-Sea Trail. Mr. Weber has actively campaigned for the Buck Spring Lodge site to be protected by the National Park Service as a historic site. He authored Trails Profiles and Maps, from the Great Smokies to Mount Mitchell and Beyond.

A 140-mile section of North Carolina's Mountains-to-Sea Trail, built and maintained by the Carolina Mountain Club (CMC), passes though the Buck Spring Lodge site. The forest had been reclaiming this area through the years after removal of the buildings and, except for the narrow passage of the trail, kept dear by CMC volunteers, was rapidly becoming obliterated.

In June 2004, CMC members and a Biltmore Estate representative met with Blue Ridge Parkway (BRP) officials and proposed that the site be cleared of the heavy growth of trees and brush, that the building foundations be uncovered and that interpretive photographic exhibits be installed where each of the buildings once stood.

Early on a cold November 5, 2004, about sixty brave souls—from CMC, from Pisgah Hikers of Brevard, other individuals—showed up at Buck Spring Gap to clear the brush where the Lodge buildings once stood. BRP stationed an employee with a chipper positioned at the edge of the parking lot to discharge the debris down the hillside. The forest came alive with the sounds from an army of chainsaws and weed whackers that were busily buzzing around the property. Many of the volunteers took on the role of army ants, marching back and forth, hauling the cut branches to the BRP chipper, which happily contributed to the unaccustomed sounds in the forest that day. This was an event! And it was covered by a local newspaper and WLOS-TV.

For whatever reasons, the environmental compliance survey—which was to be carried out by BRP at about the same time that CMC was shearing the brush—never happened. But the site continues in kept clear by CMC volunteer forces, several times each year, awaiting implementation of the phases of BRP's plan.

Buck Spring neighbor, his watchman during lodge construction and the owner of the Cruso wagon road. As a water boy for the lodge construction crew, William Cogburn had become familiar with the site. As a ranger, he served at Buck Springs until 1925. Cogburn led hunting excursions, tended guests and patrolled the grounds. He taught Cornelia how to shoot. Lining up acorns on a branch, a perfect aim and a .22-caliber rifle knocked them off one by one.

In October, in the valley below the lodge, Vanderbilt sold timber rights to the Carr Lumber Company on sixty-eight thousand Pisgah Forest acres. By May 1913, estate officials had met with the National Forest Reservation Commission at Buck Spring Lodge, offering to sell eighty-six thousand acres of Pisgah Forest to the federal government. By March 1914, George W. Vanderbilt was gone, dying from complications following an appendectomy. After her husband's death, Vanderbilt's widow continued to negotiate the sale of the Pisgah property. Final agreements were reached in 1916, forming the heart of Pisgah National Forest. This was the year of a devastating flood. Railroad and highway bridges were destroyed. Piles of logs torpedoed Biltmore's riverbank homes. Train depots and lodges became swimming pools, and Captain J.C. Lipe, the man who'd purchased Stoney Fork School for Mr. Vanderbilt, lost his life by saving his daughter's, tying her to the top of a tree engulfed by Swannanoa River.

Edith Vanderbilt retained the Biltmore House and estate, as well as 471 acres surrounding Buck Spring Lodge. She spent many summers at Buck Spring; gardening was a favorite hobby. Seedlings transplanted from estate greenhouses, however, didn't tolerate harsher, high-elevation climates. Plants ordered from Maine grew well in similar conditions in southern highlands. A resident of Hominy Valley remembered seeing Mrs. Vanderbilt on her way back to the Biltmore House, returning along the old Vanderbilt Motor Road. Visiting fruit and fresh flower stands in the valley, "she used to buy flowers from my grandmother," she recalled. "Mrs. Vanderbilt loved flowers."

Edith last visited Buck Spring in 1955 and passed away in 1957. When her heirs sold the Buck Spring property to the federal government for the new Blue Ridge Parkway, crews demolished the lodge buildings. Only Honeymoon Cottage and the little springhouse were saved. Today, after two more relocations, the little Stoney Fork Schoolhouse turned cottage is preserved in the Ramble, a gated community in south Asheville.

Sheltered among rhododendrons, guarding the spring's continuous ripples, the one-hundred-year-old springhouse often goes unnoticed. Drivers and

hikers turn off the Blue Ridge Parkway onto a roadway leading to Mount Pisgah's trailhead, focused on plans to climb the mountain. The historic springhouse hidden on the right is easily missed. Take a moment or two. Buck Spring is here.

U.S. FORESTRY EDUCATION

The Beginning

These are the inducements. There cannot be offered...an opportunity better than that...at Biltmore, for the study of Practical Forestry...You shall see the forests in all stages of their development from the embryo-forests planted in 1908 up to the primeval woods containing trees antedating by their birth, the discovery of America; you will be shown the difficulties, the expense accounts and the revenue sheets of the first forestry practiced on American soil.
—excerpt from Dr. Carl Alvin Schenck's invitations mailed to participants in the first Forest Festival, September 1908

Beginning on Thanksgiving Day 1908, three days of festivities celebrated the tenth anniversary of Dr. Schenck's original forestry management plan at Biltmore Estate and the tenth anniversary of the Biltmore Forest School. Take a tour, Dr. Carl Alwin Schenck invited. Join a carriage ride through Biltmore plantations of replanted pine, ash, maple, oak, chestnut, poplar and walnut. Tour a successful second-growth yellow pine forest created by successive cuttings. Socialize with fellow foresters, lumbermen and politicians at Battery Park Hotel's gourmet dinner.

Hear Biltmore students discuss forest regeneration projects. Estimate the potential yield of forest crops. Which tree species produced the most lumber? What species supplied products currently in demand? What logging technique worked best in rugged, high-mountain terrain? What transportation system was most efficient? Which tree species grew where and why? What effects did soil, climate, land gradient, elevation and insect pests

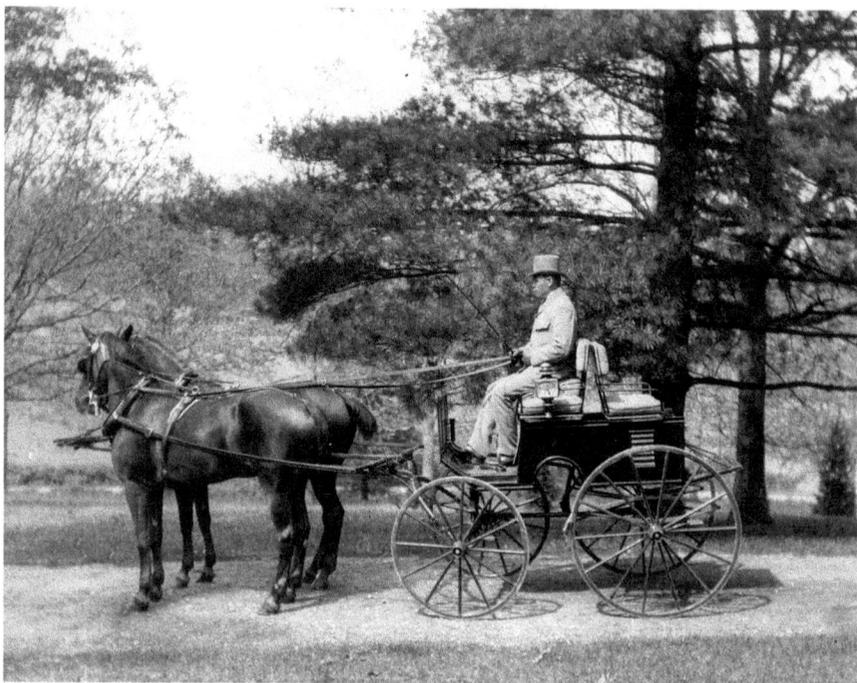

A horse and carriage escort visitors at the 1908 Biltmore Forest Festival, hosted by Dr. Carl A. Schenck. *National Forests of North Carolina Historic Photographs, D.H. Ramsey Library, Special Collections, University of North Carolina.*

have on forest growth? Which is the best method to regenerate a cutover site: plant seeds or transplant seedlings?

Visit Biltmore farms, nurseries and the dairy. Eat barbecue before the 'possum hunt. Depart Biltmore Village by train or carriage to study Pisgah's mountain forests. Enjoy lunch at a logging camp. Climb Mount Pisgah. Delight in its sunset, Schenck's newsletter invited, before "spending the night at the [Buck Spring] Hunting Lodge amongst the stars."

For two decades, George Vanderbilt had directed his chief foresters to manage Pisgah Forest, preserving its woodland heritage while producing discernible profits. Like well-tended gardens, managed forests produced healthy crops to meet marketable demands. Better methods brought greater profits. Sound, organized practices ensured a forest's future. At the Forest Festival, Dr. Schenck wanted to demonstrate the scientific forestry methods that he had practiced and their potential results.

To develop wise forestry plans for Pisgah, Vanderbilt employed two minds educated in the forests of Europe. Sound European logging practices and

forestry principles replenished forest growth. Decades-old, shortsighted American logging styles left denuded hillsides and depleted topsoil and created tinder-beds that often sparked wildfires. Forestry management in America needed Pisgah to be an experimental forest and classroom, and Pisgah needed a structured, scientific approach to manage and preserve its forested future.

Hired by Vanderbilt in 1891, Gifford Pinchot developed America's first forestry management plan. In Biltmore Forest, Pinchot recorded detailed descriptions of forest types within 5.7-acre squares marked on the estate's topographical map. Next, he grouped ninety-two compartments of 42.0 acres each into three blocks. "Improvement cuttings" to remove deformed, unhealthy trees alternated between compartments. Later, as forest health improved, a more uniform forest required an updated, permanent management plan.

Initially, Pinchot chose to limit mass cuttings. Trainees needed to learn new forestry methods and improve road access. They needed to remove grazing cattle from forestlands and practice better fire-control methods. Remain patient, Pinchot cautioned. Proceed gradually. Thinning an unfamiliar forest too quickly caused years of delayed progress.

While evaluating a stand of trees for health, site location and trunk diameter, Pinchot (or his ranger, Charles Whitney, a lumberman from the Adirondacks) marked trees selected for removal. A "Circle V" cut in a trunk at ground level and at chest height sealed its fate. Left alone and unmarked, mother-trees reseeded another generation. Protecting young, vigorous plants from a toppled tree, Pinchot's workers carefully chose each tree's direction of fall to minimize understory damage. Sawed, split and measured logs were loaded into wagons pulled by mules, and oxen moved heavy loads for shipment.

German and French textbooks offered Pinchot guidance. But European principles, Pinchot learned, didn't always apply to American forests. His convictions, however, remained firm—manage the woodlands using "practical forestry: conservative lumbering that left a growing forest behind it."

In efforts to reclaim overused agricultural fields, Pinchot transformed them into forest plantations. In addition, Pinchot planned a three-hundred-acre park, "Forest Acres." Planted with seeds gathered from around the world, his plan proposed individual acres, each nurturing its own tree species. At the 1893 Columbian Exposition in Chicago, Pinchot prepared the Biltmore Forest Exhibit, illustrating his working plans with photos, models and maps. A pamphlet detailed Biltmore's progress during its first year of practical forestry.

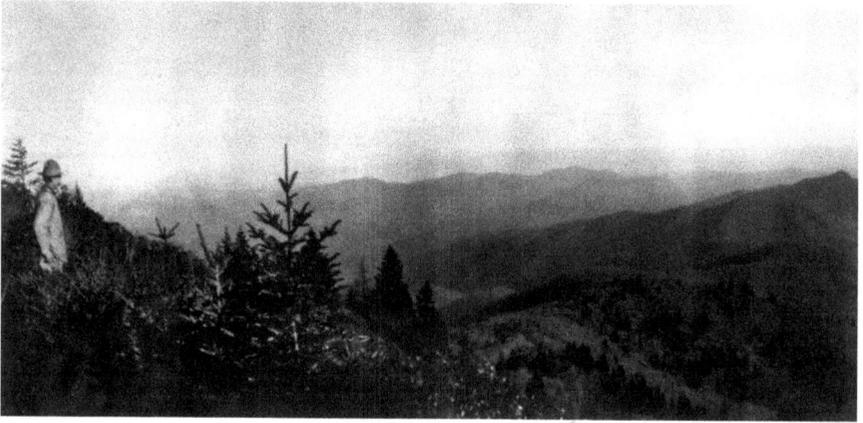

Gifford Pinchot views Pisgah Forest and the Pink Beds. *National Forests of North Carolina Historic Photographs, D.H. Ramsey Library, Special Collections, University of North Carolina.*

After evaluating eighty thousand acres southwest of Biltmore Estate, Pinchot recommended the purchase of this "superb region of sharp ridges, steep slopes and narrow valleys." Vanderbilt named it Pisgah Forest.

By 1895, when Dr. Carl Alwin Schenk arrived to replace Pinchot as the estate's chief forester, Pinchot's Big Creek Project was underway. In January, Pinchot had discussed his plan with Vanderbilt. In the secluded cove below Mount Pisgah, mature poplar trees needed to be cut. Massive trunks offered fine profits if sold at markets. Also, Pinchot explained, removing dense canopies allowed more sunlight to reach young saplings, encouraging quicker growth. Nature's regeneration of poplar trees secured the future of the next generation's harvest.

No roads penetrated the remote region. Let the river drive the logs, Pinchot proposed. Unlike heavy oak or chestnut, poplar trees floated. Build a dam across Big Creek, creating a pond, and load it with logs. At the appropriate time, open the dam floodgates, flushing logs downstream. Float them down Big Creek to Mills River and onto the French Broad. Forty miles later, process the timber at Biltmore's French Broad River Sawmill. By June, Vanderbilt had approved the plan. In October, when dam construction began, "The word to start on Big Creek came so late that it nearly rushed us off our feet," Pinchot wrote in his autobiography. "We had to reach our decisions, make our plans, perfect our methods, build our dam, and train our men as we went along."

Executing the Big Creek Project became Dr. Schenck's first major assignment. Lush, gorgeous Big Creek Valley, with "the most beautiful

trees," Schenck wrote ("towering tulip trees, with gigantic chestnuts, red oaks, basswoods and ash trees at their feet"), awaited saw and axe. Cutting huge poplar and skidding logs to riverbanks posed little problems. However, Pinchot's splash dam plan to propel logs downriver raised Dr. Schenck's doubts from the outset.

Schenck prepared for Big Creek by hiring John Cogburn of Cruso to build him a ten-dollar cabin nearby, with a "chair hewn from a cucumber log." Although he was familiar with splash dams in Germany's Black Forest, he studied local operations on Catawba River near Hickory, North Carolina, and other southern Appalachian sites. This river logging technique was one of the oldest and least expensive ways to transport logs out of a forest. Loggers built a temporary dam, loaded its reservoir with timber and opened the gates to let the river move the load. Schenck suggested that crews augment Big Creek's flow with a second dam on Big Creek's North Fork to double the water's force and power. A coordinated dam release, timing wave actions in each stream to meet at their confluent point, would intensify water velocity.

The plans failed. Most logs did not make it out of Big Creek cove. Trunks snarled. Logs jammed. Workers waited for rains to improve the stream's flow. But heavy rains caused seventeen-foot-long trunks to become stranded in private fields along Mills River. Local farms flooded. Huge logs destroyed bridges and riverside structures. Although some logs reached Biltmore, expenses mounted and lawsuits followed. The splash dams built of long, straight hemlock trunks were too high, and they leaked, reducing the water's thrust and impact. River bottoms, cleared of large rocks and debris, remained too shallow. Bankside barriers built to narrow the river's passage and increase stream-flow velocity were ineffective.

"We need roads! The first priorities in forestry should be maps and roads!" urged Schenck. Road access was imperative to inspect forests, transport staff, move logging equipment, transport timber and deliver supplies. Schenck promoted cost-effective forestry projects. Staff removed dead cordwood and reduced fire hazards. Workers continued replanting deserted pasturelands to restore vegetation and prevent erosion. By 1898, Schenck had enacted Pisgah's new forestry management plan.

He also cultivated young, ambitious minds. Although rangers regularly staffed Schenck's Forestry Department, men looking for a different career applied as apprentices under the professional German's tutelage. No structured forestry education opportunities existed in the United States. So, by September 1898, Biltmore Forest School's inaugural class was enrolled in America's first forestry program, with Dr. Schenck as its headmaster.

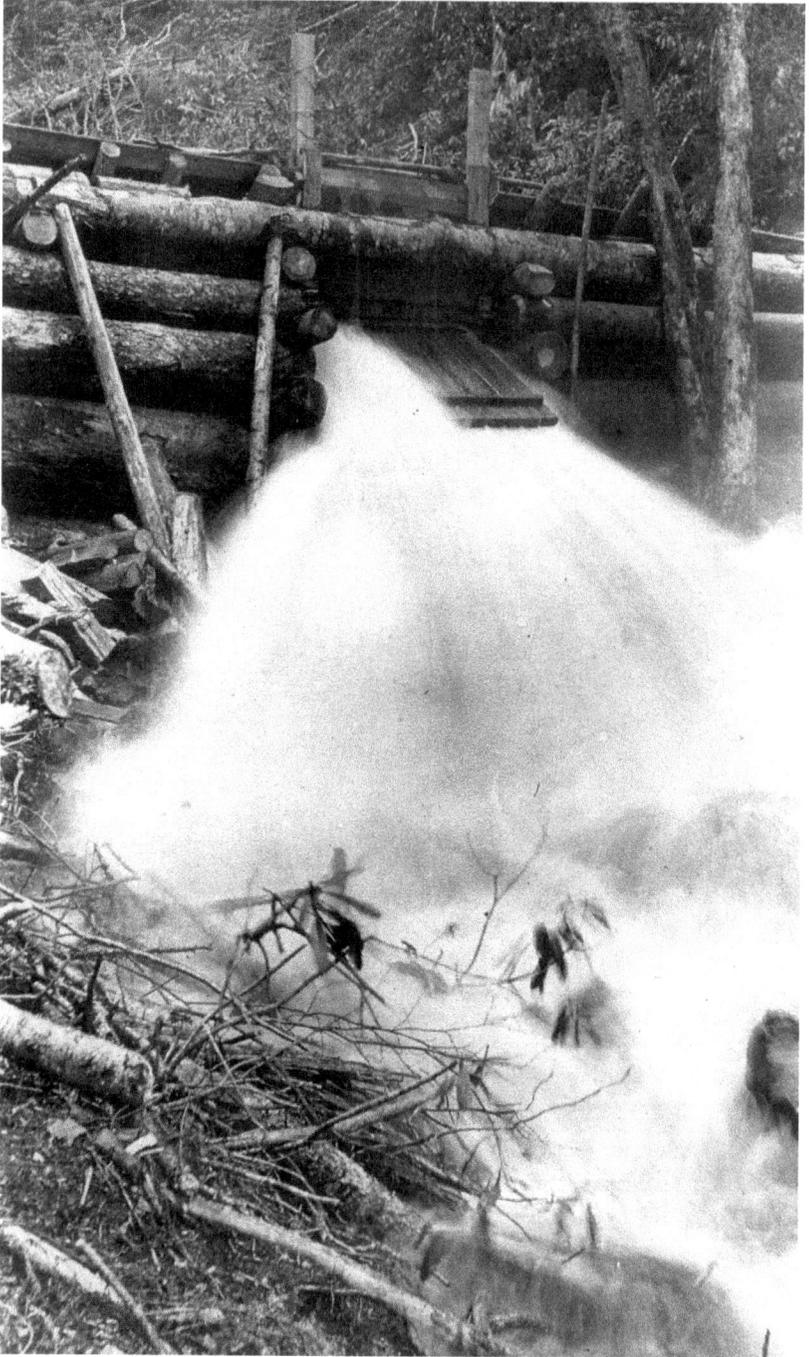

Splash dam on Big Creek. *National Forests of North Carolina Historic Photographs, D.H. Ramsey Library, Special Collections, University of North Carolina.*

Dr. Carl Alwin Schenck knew that forestry education was essential for the future of American forests. For decades, strict management of German forests had proven successful in profits and forest regeneration. In 1811, Henry von Cotta opened the world's first forestry school near Dresden, Germany. Nearly a century later, scientific forestry education and principles had not arrived in the United States.

Each course of study in Biltmore Forest School lasted eighteen months. Six months of internship-employment followed twelve months of classroom studies and fieldwork. Classroom lectures applied in fieldwork engrained not only a sense of accomplishment but also a deeper understanding of forestry principles. A writer in the school newsletter, *Biltmore Doings*, noted, "We realize what sort of man is required in the American woods—a man with intellect, experience, determination, and decisiveness; a resourceful man who has solutions of his own for the problems that are constantly arising." In a later issue, a Biltmorean student wrote, "The days…were replete with lessons derived from the lifework of Dr. Schenck—lessons in silviculture, ecology, utilization, protection and finance and that greater lesson of the value of energy, faith, and firmness of conviction."

Learn from the forest, Schenck encouraged. Rethink mistakes and failed plans. Measure, walk, climb, dig and walk again. Feel grooves in tree, and witness signs of weakness, invasion and injury. Scan the woodlands. Identify struggling trees, strong ones and those challenging others. Follow the land: know its contours, slopes and ridges. Get grounded: learn plants, algae and fungi. Respect forest creatures. Experiment and record. Question outcomes and re-test results. Assess data, create new plans and have new ideas. Plant, transplant and replant. Be open to the wisdom of the woods. Experience the living classroom. Allow the *forest* to be the master teacher.

"Whoa, girl!" a forestry student said, reining in a feisty mare. A firm squeeze of the bridle's bit demanded patience. Last night, he'd attended Biltmore Forest School's annual ball at Battery Park Hotel. Now it was April and time to go. It was time to go home to Pisgah.

Winter studies at Biltmore Forest had been productive, of course. Dr. Schenck's rigorous regimen permitted nothing less. Headquartered in Biltmore Village, winter classroom and lodging were comfortable. Schenck's "scholarly treatment" of lessons in forest policy, forest utilization and

management were enthusiastically received. Forest finance lectures, however, often required remedial work.

Dr. Clifton Howe taught botany and dendrology. Later Dr. Homer D. House assumed those duties. Botanical identification was required. Each student collected leaves, buds, flowers and fruits of one hundred different plants. Charles Waddell, electrical engineer for the estate, discussed electrical elements in woodworking equipment. A stereopticon ("magic lantern"), a nineteenth-century slide projector, illustrated mechanical details. Dr. Collier Cobb of the University of North Carolina–Chapel Hill taught geology and planned related field trips to Mount Pisgah. Other professionals lectured on tree diseases, entomology and other topics.

Morning lessons became afternoon fieldwork at Biltmore nurseries and plantations. Surveying lectures continued at plane tables in abandoned fields. Leveled on tripod legs, plane tables were ideal for mapping small areas. Compass readings at each site confirmed table orientation. Mapped areas helped designate planting plots for hundreds of white pine seedlings. Transplanted birch and hemlock restored other sites.

Schenck's students recorded diary entries for a daily grade. Howard Krinbill always penned the best, receiving the coveted "100+" above Dr. Schenck's smiley-face signature. Each completed essays on forest policy, cordwood calculations and other assignments. At winter's end, Pisgah Forest beckoned.

The Biltmore "boys" learn surveying and mapping techniques. *National Forests of North Carolina Historic Photographs, D.H. Ramsey Library, Special Collections, University of North Carolina.*

Seven horseback hours away lay Pisgah Forest, the revered spring and summer sylvan classroom for Schenck's "Biltmore Foresteers." Thirty foresters-in-training tied packs to saddles and mounted up. School regulations required each to provide his own horse, two woolen blankets, sturdy shoes, rugged raingear and "old and worn clothing, unfit for wear in town."

Punch was ready, too. Schenck had inherited the midnight-black, spirited gelding from Pinchot. Punch, Pinchot wrote in his autobiography, had "taught me most of what I knew about riding bucking horses... Punch won more bouts...[until] I could pick my handkerchief off the ground while he was putting on his act. " Now self-confident, stately and full of character, Punch and Schenck were perfectly matched. The pair rode as one.

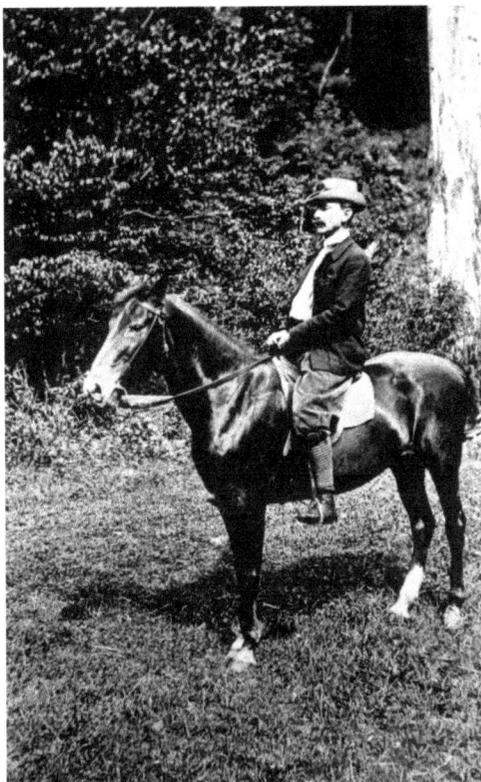

Dr. Carl Schenck is mounted on his horse, Punch, at Sunburst, North Carolina, 1910. *National Forests of North Carolina Historic Photographs, D.H. Ramsey Library, Special Collections, University of North Carolina.*

"Ve vill set up zee first camp near zee headwaters of Davidson River," Schenck announced. "Zee classes vill continue at zee Pink Beds."

"Want me to carry some forestry tools, Dr. Schenck?" volunteered a rookie.

"Nien, Nien," he responded. "Zee vagon vill bring zem."

"Doctor Schenck Considered a Brave Man in Brevard" claimed an article title in *Transylvania County News*. An angry farmer, nearly swiping Schenck's head with an axe, blamed him for laming his horse. Undaunted, Schenck never flinched. Rumors spread: "He was too proud to run and too stubborn to dodge."

Although Schenck was known for his quick temper and stubborn nature, students idolized him. Tall, thin and in his thirties, Schenck bore a thick, prominent moustache. Sharply dressed in knee-high, spurred boots; a

tailored forester's coat; a green tweed cap; and a grayish-blue, red-lined cape, Dr. Schenck had a commanding presence. He lectured eloquently. Dedicated to his "boys," the school and especially the forest, Schenck earned their respect and commitment. His passion for trees became theirs, too.

Coert Dubois, a 1901 Biltmore graduate, once reported:

> *I never knew anyone to whom trees had so much personality. One day while marking we came across a chestnut and black oak growing seemingly out of the same stump. The Doctor stopped and raised his arms in benediction and said:*
>
> *"Chestnut, wilt thou have this Black Oak to be thy wedded wife to live together in the Holy state of matrimony?"*
>
> *Schenck continued: "Those whom God has joined together let no man put asunder! Leave zem!"*

Forty miles south of Asheville, the Pink Beds—a three-thousand-acre mountain valley surrounded by high, forested ridges—was perfect for the school's campus. Before Vanderbilt purchased Pink Beds and Pisgah Forest, settlers had built cabins, grazed cattle, hunted game and made whiskey throughout the isolated region. After the sale, some settlers remained as employees. Others stubbornly stayed at will. To patrol the area for trespassers, Schenck hired rangers. Lodges provided housing. With axe, adze and mallet, heavy chestnut timbers were handcrafted into posts, beams and bracing. The "post and beam" or timber-framed structures were called Black Forest Lodges, named after Schenck's beloved German fir forest.

In the Pink Beds, the Forest School adopted an 1891 public schoolhouse as a classroom. Departed families no longer needed it. Biltmore lectures were held each morning six days a week. Dr. Schenck and other teachers taught forest management and protection, lumbering practices and methods, surveying and mapping and other forestry principles. Schenck also arranged instruction in plant structure and tree classification, soil composition and weather as well as animal and insect studies. Professors who'd taught at the Biltmore Village winter headquarters also instructed at the Pink Bed campus.

With no textbooks available in English, Dr. Schenck created them from his lecture notes. Old buildings were repurposed. When Hiram King sold his cabin, mill and barn to Vanderbilt, the estate saved his farm. Workers transformed King's barn into Schenck's office, and his farmhouse served as a ranger's headquarters. Upstairs, Ranger Gillespie and his wife boarded eight

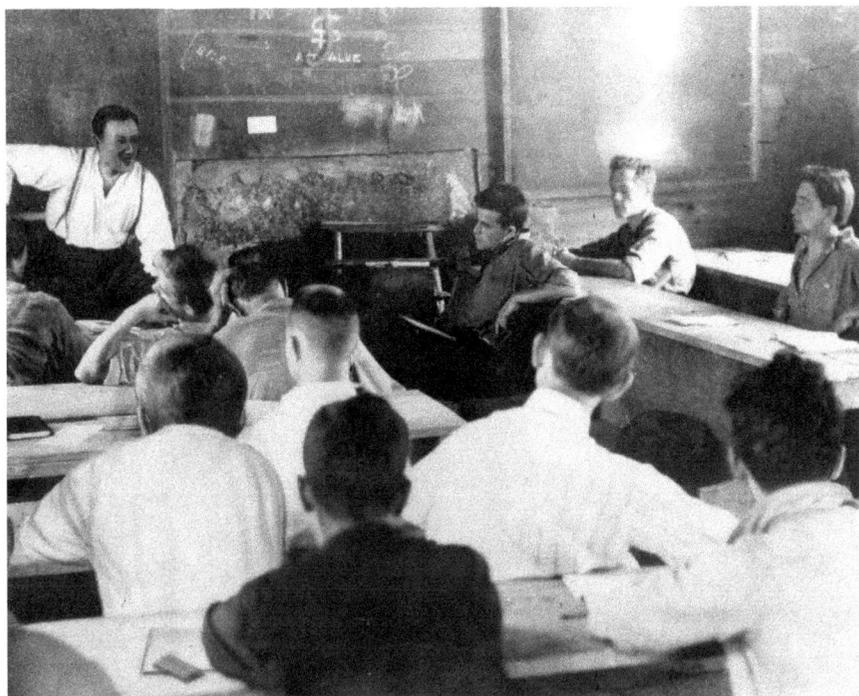

In the Pink Beds, students attended Biltmore Forest School classroom lectures in the morning and learned through fieldwork in the afternoon. *National Forests of North Carolina Historic Photographs, D.H. Ramsey Library, Special Collections, University of North Carolina.*

forestry students, preparing two meals a day for them. Biltmore students also found residence in other abandoned cabins at Pink Beds.

By 1902, in the center of campus, a mercantile store with postal service had opened for business. Blacksmiths from Brevard maintained wagon wheels, logging equipment and horseshoes. Dr. Schenck knew that hardworking young men needed diversionary fun and entertainment. By week's end, songs and beer-filled steins at "Sangerfests" fostered student camaraderie. Creative lyrics sung to catchy tunes satirized their forestry adventures.

Afternoon fieldwork took place on horseback or foot. Mark timber for firewood. Inspect second-growth timber. Build roads. Cut trails. Design forestry management plans. Determine a site's best logging method. Plough a plot, dig furrows and plant thousands of seeds. Plant twenty thousand seedlings at Davidson River. Build a bridge. Compute tan-bark estimates. Follow botanists on field excursions. Need more instruction? Get a lecture on a log. Identify tree diseases and insect enemies. Go timber cruising. Calculate

Biltmore Forest School students study botany with Dr. Howe. *National Forests of North Carolina Historic Photographs, D.H. Ramsey Library, Special Collections, University of North Carolina.*

stumpage. Determine the value of standing timber with Schenck's "Biltmore stick"—originally an axe handle with notches, the Biltmore cruising stick allowed foresters to measure the diameter and height of a tree to estimate its potential in lumber.

In 1905, Schenck's updated Pisgah Forest Management Plan detailed many accomplishments. Schenck recorded Pisgah's resources and noted forestry profits. At six inspection sites, "timber tallies" recorded the number of four species of trees, measured in ten different diameter sizes. Calculations estimated the total board feet available.

Woodlands had been "improved": unsound wood culled, old farmlands and fields replanted and tree downfall removed. Wildfires were better controlled. Boundary lines were posted and fenced. Observing land gradients, Schenck's crew had constructed low-maintenance roadways and 198 miles of trails, making resources more accessible. He projected "a continued annual surplus of revenue." Recommendations for future projects included improving the quality of current dwellings, resurfacing roads with stone for auto and tourist travel and, potentially, building a tannic acid plant or paper mill.

Since 1904, Biltmore and the U.S. Geological Survey had been gauging stream flow on the Davidson River. Schenck proposed a seventy-five-foot dam across Davidson River to increase power for a mill. He suggested a lake at the Pink Beds for an electric power plant or a picturesque lake between Looking Glass Rock and John Rock similar to the one at Lake Toxaway. A lake was conceivable near Turkey Creek on South Mills River, too.

Fate, however, held a different purpose for Pisgah. Less than a year after celebrating the ten-year anniversary of Biltmore Forest School, a startling announcement was made. "Biltmore is in trouble," Edwin W. Meeker, class president, wrote in an urgent 1909 letter to his classmates. "After fifteen years...on the Biltmore Estate, Dr. Schenck has suddenly been released... Unfortunately, Dr. Schenck's ideas did not coincide at all times with Mr. Vanderbilt's...Do all you can for Biltmore—the school must stay."

Biltmore Forest School relocated and survived five more years. Champion Fiber Company of Canton, North Carolina, welcomed a camp at its logging operations in Sunburst. The world offered broader experiences. Little River Logging Company in Townsend, Tennessee; piedmont pineries in North Carolina; logging camps in the Pacific Northwest; wood product industries in Michigan; and forests in the Adirondacks of New York provided educational opportunities. Each winter, Biltmore Forest School headquartered in Germany. The forests of Dr. Schenck's homeland provided a wide range of unparalleled field experiences.

By 1913, numerous American colleges and universities, unlike Schenck's Biltmore Forest School, were offering degrees in the field of forestry. Competition made it difficult for the Biltmore School to continue. Fewer than twenty students enrolled in Biltmore that year, and the school had no financial support. By November, the school was closed.

More than three hundred foresters graduated from Biltmore Forest School. Four became district or regional U.S. Forest Service rangers. Verne Rhoades, class of 1906, became Pisgah National Forest's first supervisor, campaigned for the preservation of Great Smoky Mountains National Park and helped start the Carolina Mountain Club. In 1895, Overton Price began as an apprentice for Dr. Schenck, graduated with Biltmore class of 1902 and became Pinchot's assistant forester in the Forest Service. Nearly a dozen graduates became state foresters and two dozen became forestry supervisors. Others careered in lumbering operations. Some alumni were forestry consultants in India, Canada, Mexico, Venezuela, Puerto Rico and the Philippines.

In his autobiography, *The Biltmore Story*, Dr. Schenck entitled the last chapter "A Farewell Message to My Biltmore Boys." He wrote, "I trust that…my graduates and also my friends…will no more forget the Biltmore Forest School and its teachings than I can forget them…When you come to visit with the Old Country you will find me welcoming you at Darmstadt… trying to graft some American ideas on German forest work. And, when I come to America to visit, as I shall do certainly from time to time, I hope to have you extend to me the same glad hand that I have shaken in the past."

After 1914, Germany became Schenck's permanent home. In World War I, he served as a lieutenant for the German army on the Russian front and was severely wounded in battle. For the next two decades, he lectured at American and German forestry schools, led European forestry field trips for American students and wrote extensively on forestry subjects. During World War II, Schenck remained rooted in his home in Lindenfels, a small village in Hessen. His house was built from Pisgah Forest chestnut or yellow poplar transported to Germany years earlier. Between Weinheim and Lindenfels, hundreds of sentimental poplars, also from Pisgah, stood proudly erect. Following the war, United States officials appointed Schenck chief forester of the American-occupied state of Hessen and requested his help with German relief efforts.

In the Pink Beds valley of Pisgah National Forest in May 1950, Biltmore Forest School graduates reunited. Verne Rhoades delivered the opening tribute:

What a unique school we had! What a grand profession to call our own! What a consummate teacher and scholar we had to inspire us!...Doc Schenck...not only studied and taught on foot and on horseback, but also along the flumes, on top of skidders, mounted on log trains, and even in the ships at sea...I dare say that if he were teaching today he would have his boys in planes and helicopters scanning the woods below...dropping down by parachutes into some secluded vale for lunch.

Dr. Schenck was unable to attend. Instead, his nephew, Dr. Hans Schenck, delivered hand-carved emblems of Fraser firs for committee members, a Biltmore pennant and Schenck's letter to the "boys." During a nostalgic "Sangerfest," his friend and cousin George W. Merck, president of the American Forestry Association, read the letter aloud. In song and spirit, Biltmore "boys" toasted fond fraternal friendship:

We can walk for twenty miles, but usually we ride
We traverse all the country with the Doctor as our guide;
We scale the highest ridges and slide down the other side,
In Schenckses Foresteers.

At the site of the old schoolhouse, the Plymouth Rock of Forestry, a large rock holding a commemorative bronze plaque was unveiled. Alumni planted three pine trees around it.

During an American tour in 1951, Dr. Schenck received many awards and reunited with Biltmoreans at Pink Beds. In its 1952 commencement exercises, North Carolina State College awarded him an honorary Doctor of Forest Science degree. In a letter mailed from Lindenfels on March 25, 1954, Dr. Schenck wrote, "A school may die but the spirit of the school can be immortal." Proud of his students' success, he helped compile a book of biographical histories of graduates called *Biltmore Immortals.*

"The very joy of a long life has been the labor performed in it," Schenck wrote. On May 17, 1955, at age eighty-seven, his labors ended in Lindenfels, Germany. Half of his ashes were spread in a village cemetery near his home in Germany. Half were returned to America and scattered in North Carolina State University's experimental forest outside Raleigh. Mounted on a granite boulder in the Carl Alwin Schenck Memorial Forest, a bronze plaque reads, "In memory of CARL ALWIN SCHENCK...this memorial forest is dedicated to honor a great teacher and the founder of the Biltmore Forest

Dr. Carl Alwin Schenck was celebrated in a 1951 American tour. *National Forests of North Carolina Historic Photographs, D.H. Ramsey Library, Special Collections, University of North Carolina.*

School, the first school of forestry in the New World. His ashes have been scattered here among the trees he loved."

The Biltmore Room at the university preserves items from Dr. Schenck's personal collection, literature received from the Forest History Society and contributions obtained from Biltmore alumni. Large collections of Schenck's work are also preserved by the Forest History Society in Durham, University of North Carolina–Asheville and the Biltmore Estate Archives.

While Dr. Schenck was still teaching at Biltmore School, Gifford Pinchot was forming the new U.S. Forest Service. One day, two of his foresters were trying to create a new Forest Service badge. One sketched a fir tree on a Union Pacific shield; the other took the paper and drew "US" on each side of the tree. A new era was coming.

Schenck's autobiography notes:

> *Mrs. Vanderbilt negotiated the sale of Pisgah Forest to the United States government. It was characteristic of her to want the forestry dreams of her husband and the beautiful mountain country…saved, not merely as an object lesson, but also for the use and enjoyment of the American public…*

specifying…that the area should be embraced in a national forest to be known as the Pisgah National Forest…Thus was my beloved Pisgah saved from dissection and destruction.

What was his response when he first saw Pisgah National Forest? "Wunderbar!" an Asheville newspaper reported. "Wunderbar!"

Chapter 4
ESTABLISHING PISGAH NATIONAL FOREST

After the Civil War, as Americans entered the Industrial Revolution, wood became one of the most important natural resources. All across America, private lumber companies bought or leased timber rights on thousands of forested acres. Unconcerned about a cutover forest's future, companies left stumps, slash and leftover debris scattered in their wake. Would deforested land, no longer stitched together by networks of underground root systems, erode into pure mountain streams? Mountain streams were important for irrigation, navigation and public water supplies. Left exposed and barren, would the headwaters of valuable rivers shrink and evaporate? How much silt runoff would restrict water flow? What happens when logging companies take the biggest and best trees and leave unwanted, dry brush behind? Will a spark ignite? Will a fire consume? Who tramples it out?

Foresters, scientists and concerned citizens, including the new president, Theodore Roosevelt, were watching too. If uncontrolled, reckless logging practices of private companies continued, conservationists believed, the country would be robbed of some of its most valuable natural resources.

Asheville eagerly waited for the president's arrival. In front of Asheville's Vance Monument, his speaker's platform was ready. Shop owners closed stores, children played hooky and the excitement was palpable. At 9:30 a.m. on Tuesday, September 9, 1902, Roosevelt rolled in on "Riva," his private rail car. Crowds roared as engine no. 304 puffed its loud salute. Senator Jeter C. Pritchard and Biltmore Estate manager Charles McNamee offered a warm welcome.

The North Carolina State Guard escorted Roosevelt to waiting carriages to take him to the Battery Park Hotel. Warm receptions followed. The same southern scenery that had lured tourists to the southern Appalachians for decades captured the president's attention. "Oh, this is magnificent," Roosevelt said, gazing out toward the mountains near Pisgah. "This is indeed...the grandest east of the Rockies!"

The Asheville visit would end with a reception at Biltmore Estate. But for now, restless crowds were waiting. Company F and Company K ushered the presidential parade back to the town square. Roosevelt spoke on national pride and civic involvement in government. He spoke of the importance of drafting good laws to be administered by an honest government. He urged the public and government officials to strive for good character: "We need honesty, we need courage, and we need, in addition, the saving grace of common sense."

That's what Roosevelt thought about conservation: it was common sense. Protecting the nation's natural resources in government-managed forest reserves was purely common sense. Decades before Roosevelt's presidential term, proof had provided strength to that sound practical judgment.

Roosevelt's visit to Asheville came just as the decades-long debate over how to protect the area's forests were reaching a fevered pitch. In 1876, a government study of American forest conditions, supervised by Dr. Franklin Hough, revealed a wanton waste of its woodlands. Let the government control the forests, he advocated. Practice consistent forestry principles. Improve management plans through education and research. Restore the forest's health. Plant trees, Hough reported. Increase public awareness.

After fifteen years of studies and debate, the 1891 Forest Reserve Act gave the president the right to create forest reserves from the government's remaining unclaimed lands, known as the public domain. Immediately after the law's passage, President Benjamin Harrison established Yellowstone Timberland Forest Reserve (now called Shoshone National Forest).

As Harrison and his successors created more forest reserves, Congress debated who could use them—cattlemen, loggers, scientists, miners, hunters, hikers or campers? How would the reserves be managed? Which policies would achieve what goals? Six more years of squabbling and 40 million protected acres later, President William McKinley signed the Forest Management (or "Organic") Act in 1897. The purpose of the Organic Act

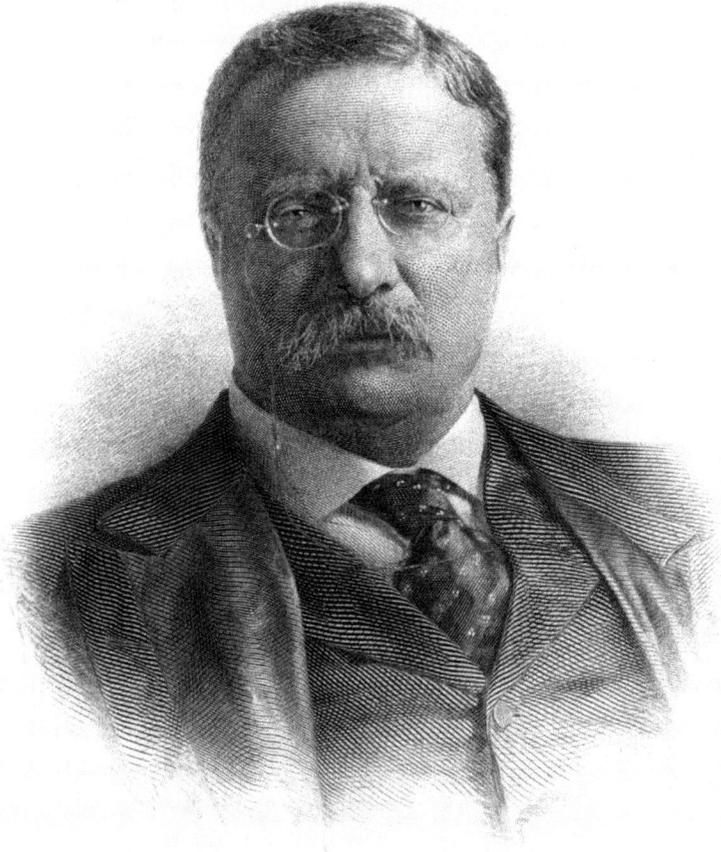

President Theodore Roosevelt. *National Forests of North Carolina Historic Photographs, D.H. Ramsey Library, Special Collections, University of North Carolina.*

was to protect the watersheds of valuable streams, to maintain the country's forests to provide timbered products and to regulate forests for security and fire protection.

As far back as the Revolutionary War, the federal government had given away lands in the public domain to encourage settlement. Some early owners became land speculators, accumulating thousands of acres. Their descendants inherited huge estates. For instance, property in Pisgah Forest had been part of the "Candler Speculation Lands." Between 1893 and 1894, Mary Lusk, granddaughter of Zechariah Candler, a Revolutionary War veteran turned speculator, sold more than fifty thousand acres of inherited land near Mount Pisgah to George Vanderbilt for $35,000.

The pace of the land giveaway accelerated after passage of the Homestead Act of 1862, as well as its southern version in 1866, offering 160 acres to individuals over twenty-one. The Timber Culture Act of 1873 gave 160 acres to residents who would, for ten years, successfully maintain 40 of those acres in trees. Vaguely worded, the laws were easy to exploit. A person could write "21" on the bottom of their shoes and legally claim that they were "over 21."

After having depleted woodlands from Maine to Michigan, loggers headed west for untouched forests. Logging companies paid people to apply for land grants and then took control of them. They purchased huge tracts of forested lands from the transcontinental railroads. By the 1880s, they had also turned south for that region's untapped timber resources. A new tract was purchased, logged and then sold for agricultural purposes, cleverly avoiding due dates for property taxes.

Sometimes, logging companies leased timber rights from landowners instead of buying the land. Often, they merely purchased a selected tree size or species. In 1912, near Looking Glass Falls in Pisgah Forest, Carr Lumber Company wanted yellow poplar. It logged forty thousand board feet of yellow poplar per acre. In other southern forests, companies paid forty to seventy-five cents for each oak, poplar or cherry tree.

By the late 1880s, 1 billion American acres had been given to companies, states or private citizens. Roosevelt claimed that national lands regarded as public domain needed to be protected for all citizens, each "holding a citizen's share…even if he never saw it; it was theirs, it was there." He continued, "Big, rumpled, roadless quilt of original America belonged to everyone. It belonged to the ages."

Expressing a profound support of forest reserves, Roosevelt's words resonated with an intimate knowledge of the natural world. While in college, he had taken natural history courses and published articles on birds. He had explored high mountain ridges, forested woodlands and broad river valleys in the Adirondacks and the Alps. In the 1880s, he owned and worked a cattle ranch in the Dakota Territory. He had seen up close how mismanaging the land left it in poor condition. During his two-term presidency, he would set aside more than 100 million acres, more than all other presidents combined.

In 1898, Gifford Pinchot was named chief of the U.S. Division of Forestry. Three years later, his close friend Theodore Roosevelt became president; Pinchot now had a passionate, daunting partner in his crusade for forest conservation. Roosevelt also supported Pinchot's quest to add eastern lands to the nation's forest reserves.

Pinchot knew the beauty of the southern Appalachians. As chief forester for George Vanderbilt, he had inventoried thousands of acres of southern woodlands. At his recommendation, Vanderbilt purchased land that he named Pisgah Forest. Those woodlands, however, which had prospered under America's first forest management plan, were not permanently protected. "There were no forest reserves in the East because there were no public lands," Pinchot, the author of that first plan, wrote in his autobiography. "The only way to get them would be to buy them." The first step? Evaluate the problem.

In 1900, Congress granted $5,000 to the Division of Forestry and the U.S. Geological Survey to study nearly 10 million acres of southern forests. Concerned politicians and local organizations, such as the Appalachian National Park Association (later changed to the Appalachian Forest Reserves Association), became increasingly vocal. For years, Dr. Chase P. Ambler, a tuberculosis specialist in Asheville and leader of the association, promoted the region's health benefits. Scarred landscapes left by loggers prompted Ambler and others to lobby for action.

For ten days in July 1901, several government officials personally evaluated the area. Secretary of Agriculture James Wilson, North Carolina's state geologist Professor Joseph Holmes and Secretary of the American Forestry Association and future director of the U.S. Reclamation Service Frederick Newell toured the mountains of North Carolina together. "And, of course," Pinchot wrote, "I went along."

Forest destruction was rampant. Essential watersheds were at risk. Protective action was critical. President Roosevelt agreed. On December 19, 1901, Roosevelt presented the conclusion of the investigative study to Congress:

> *I transmit herewith a report of the Secretary of Agriculture...upon the forests, rivers, and mountains of the Southern Appalachian region...Its conclusions point unmistakably...to the creation of a national forest reserve in certain parts of Southern States...and, they point to the necessity of protecting through wise use a mountain region whose influence flows far beyond the borders with the waters of the rivers to which its gives rise...*
>
> *Under the varying conditions of soil, elevation, and climate many of the Appalachian tree species have developed...In this region occur that marvelous variety and richness of plant growth which have led our ablest businessmen and scientists to ask for its preservation by the Government for the advancement of science and for the instruction and pleasure of the people of our own and future generations.*

The Appalachian Mountain Club, the American Association of the Advancement of Science, the American Forestry Association and the National Board of Trade were all in support. Similar efforts had been underway in New Hampshire to protect the White Mountains for some time, and supporters there wanted a separate bill for their region. But the powerful House Speaker, Joseph Cannon, declared that he would never give one cent for scenery.

Congressional discussions stalemated at first over states' rights. North Carolina's legislature ended that debate. Five states soon followed North Carolina's lead, authorizing the federal government to acquire land in their states for forest reserves, thereby surrendering each state's right to tax.

Ambler's association was persistent. In May 1902, at a meeting with the House Committee on Agriculture, members demonstrated the erosive impact of floods on mountainous terrain. On the floor in front of House members, two six-foot, thirty-degree sloped mountains were built. One was left bare; the other was covered with sponges below layers of moss and twigs. Water from a sprinkling can "rained" over both "mountains." "Floodwaters" created gullies on exposed slopes but penetrated mossy

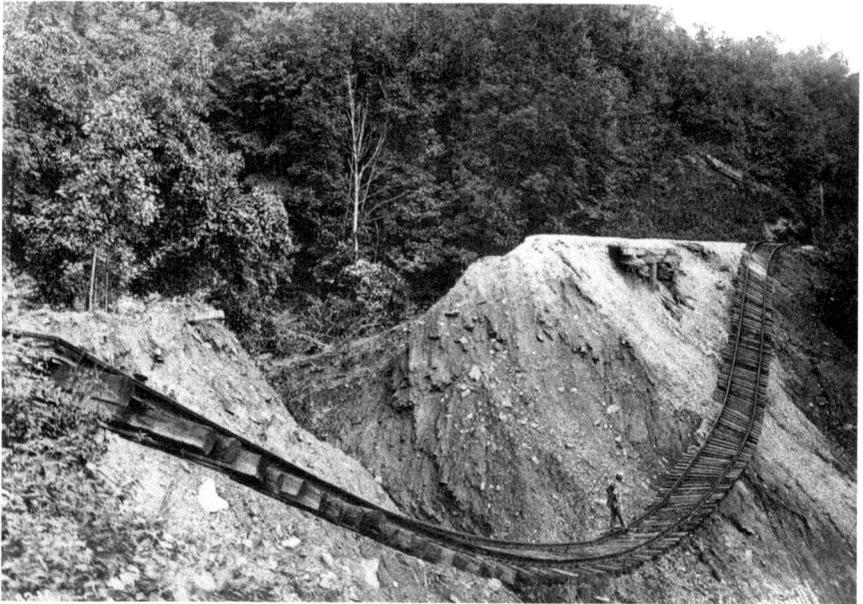

A man balances on sagging Southern Railway tracks between Asheville and Old Fort that were left dangling after the devastating Flood of 1916. *William A. Barnhill Collection at Pack Memorial Public Library, Asheville, North Carolina.*

"soils" on "forested" ones. Congress remained skeptical, and negotiations continued for ten more years.

Once majestic forests had become the "lands nobody wanted." Old logging sites, later plowed into cow pastures, were now neglected. Stripped forests had been deserted. Overly grazed fields had washed into nutrient-poor soils. Vegetation was sparse; recovery was slow. Barren lands held little moisture. Recurrent, seasonal floods inundated towns and homes. The largest ones were deadly.

Forest fires were lethal as well. In 1910, "the year of the fires," one single fire took the lives of eighty firefighters and scorched 3 million acres of Idaho and Montana. Public and political concerns escalated. The southern Appalachians helplessly anticipated their own disasters.

In February 1911, a solution was reached. Congressman John W. Weeks of Massachusetts, who had a summer home in New Hampshire's White Mountains, crafted a bill acceptable to all. It allowed the federal government to buy "forested, cut-over, or denuded lands within the watersheds of navigable streams deemed necessary for regulation" of their flow and called for the federal government to cooperate with state agencies and private associations in fighting forest fires. These lands would be restored, protected and managed by the Forest Service; in the case of firefighting, they would be protected by the Forest Service and its many state-level counterparts. The Weeks Act meant that public forests in the East could now join with western ones in the National Forest System.

———

"No hard and fast policy in regard to purchase can be laid down in advance," explained the National Forest Reservation Commission (NFRC), which was assigned to supervise purchases. "Each case must be considered on its individual merits. Perhaps when a nuclei of the necessary forests have been developed, the policy of rounding out and completing may appear more clearly."

The purchase of leftover land from timber cuts provided large tracts. "Lumber companies," the commission continued, "bought the stumpage, and having secured it, they have no further interest in the land. Such tracts the government should be able to obtain at a nominal figure."

Newsletters and ads circulated. The commission's responsibilities and sites of interest were explained; proposal forms with official envelopes were

provided. Both corporate and private landowners showed interest. Some needed money. Others needed freedom from tax burdens. Disheartened ones just wanted out, hoping to start afresh somewhere else. Reasonable offers from willing landowners were welcomed, especially when their land bordered larger wooded areas of interest. The federal government would not seize land from someone uninterested in selling it. Like an unfinished jigsaw puzzle, the map of national forests illustrates the ownership of unconnected, fragmented tracts of land.

The secretaries of agriculture, interior and war, two congressmen and two senators sat on the National Forest Reservation Commission. A Forest Service officer functioned as secretary. The commission's primary function was to approve selected purchase units to be formed into national forests. Thirty-five field agents, chosen by Chief Forester Henry Graves, evaluated each land offer. Would protection of this area ensure a consistent flow of navigable streams? If the Forest Service managed these lands, would it help prevent erosion, silt buildup and damaging floods? Can this site be rehabilitated? Is it accessible? Can it be? Is there standing timber? How much? What's its potential for future timber production?

Field agents arranged acceptable offers into purchase units. After the U.S. Geological Survey affirmed the site's relevance to the Weeks Act criteria, purchase units were submitted for NFRC approval. Officials verified boundaries, assessed fair market prices and cleared land titles. The time from offer to purchase could take years. Joining enough units together to form a national forest often took many more years. Creating Pisgah, the first national forest in the East, showed how frustratingly slow the process could be. Five years after enactment of the Weeks Law, Pisgah's forests, surrounding the site of the nation's first forestry school, were finally protected. On October 17, 1916, President Woodrow Wilson formally established Pisgah National Forest.

Negotiations had started years earlier. In 1912, two years after forming a ten-year timber agreement, including an option to buy, with Toxaway Tanning Company (Gloucester Lumber Company of Rosman), George Vanderbilt leased timber rights to Carr Lumber Company on sixty-eight thousand acres. That same year, Vanderbilt discussed selling Pisgah. For more than twenty years, he had supervised its reforestation and care; now, through the Weeks Act, the Forest Service could manage Pisgah's woodlands and make its natural beauty available to everyone.

Agents with NFRC evaluated Pisgah in 1913, but its purchase was not approved. The land was in too good a condition, the government said.

Vanderbilt's price of six dollars per acre may have also hindered the sale. On May 22, 1914, the *Asheville Citizen* reported:

> *Just about a year ago the commission paid a visit to Asheville and went all over the ground carefully. At that time it was said the price asked was a little too high and the matter was laid aside. It was stated by a member of the commission today, however, that the commission had decided there was no need for haste in purchasing the Vanderbilt estate as it was felt that as long as George W. Vanderbilt maintained its ownership the forests would be preserved in as good, if not better, condition than they would be by the government.*

Vanderbilt's death in March 1914 hastened NFRC's decision. "It was feared that the forestlands might be disposed of by speculators," the newspaper reported, "...and the change of ownership might be embarrassing to the government." To pursue Pisgah's negotiations, Vanderbilt's widow addressed a letter to the secretary of agriculture in early May expressing her "earnest hope that in this way I may help to perpetuate my husband's pioneer work in forest

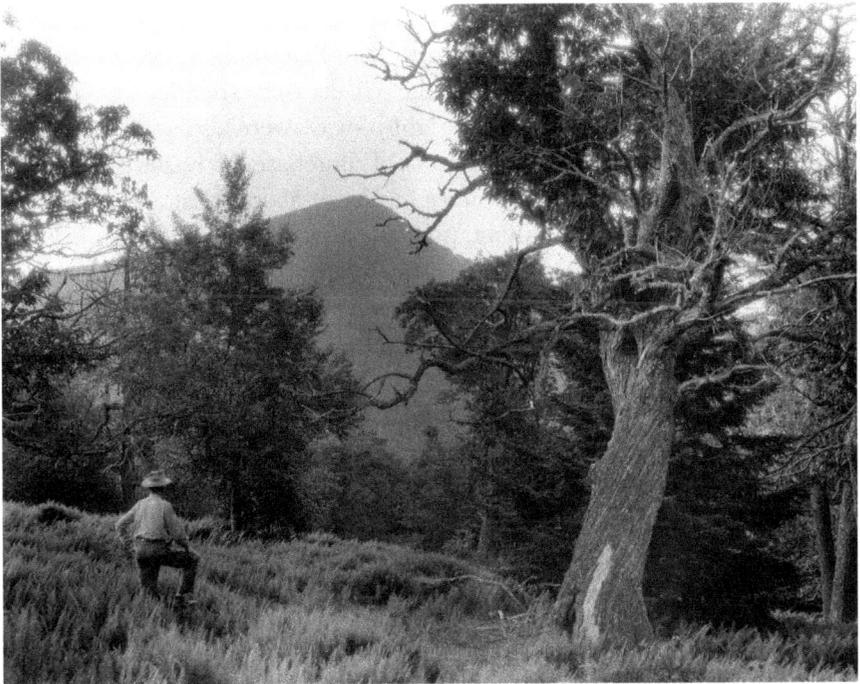

View of Mount Pisgah. *National Forests of North Carolina Historic Photographs, D.H. Ramsey Library, Special Collections, University of North Carolina.*

conservation, and to insure [*sic*] the protection and the use and enjoyment of Pisgah Forest as a National Forest by the American people for all time."

Overton Price, Pinchot's former aid and one of Schenck's first apprentices, joined Chauncey Beadle, manager of Biltmore Estate, to assist Edith Vanderbilt with NFRC negotiations. On May 21, 1914, Edith accepted $200,000 less than the original price, and the purchase of Pisgah was approved for about $5 per acre. By the time autumn leaves were changing color in the fall of 1916, nearby land purchases had also been accrued, and the Pisgah became a national forest.

Curtis Creek in McDowell County, located five miles east of Old Fort and twenty miles northeast of Asheville, was the first tract of land purchased under the Weeks Act. On August 29, 1912, NFRC paid Burke-McDowell Lumber Company for 8,100 acres. In 1916, Curtis Creek became part of the new Pisgah National Forest. Purchase areas near Boone became part of Pisgah National Forest in 1921. By 1936, areas in the Unaka Mountains had been transferred to Pisgah.

Section 2 of the Weeks Law required cooperation between federal and state forestry services. Federal dollars for fire crews would be granted to each state that would match those funds, following state legislature consent. Some states readily sanctioned the plan. North Carolina, though, delayed action for ten years. Later amendments to the Weeks Act expanded purchasing power. Disputes over easements and right-of-ways were also addressed.

In 1920, the commission's "Progress of Purchase of Eastern National Forests" reported that 1,841,934 acres had been acquired at an average of $5.26 per acre. In North Carolina, purchase units included Unaka, Boone, Mount Mitchell, Nantahala and Pisgah. Nearly 95,000 acres of Pisgah's 300,000-acre purchase unit had been approved, occupying "a nearly solid body on the eastern slope of Pisgah Ridge, the salient topographical feature of which is Mount Pisgah, rising to the height of 5713 feet."

Congress passed the Clarke-McNary Act in 1924, which expanded the Weeks Law to permit purchase of timberland regardless of its proximity to streams and headwaters. The law led to the establishment of the Uwharrie and Croatan National Forests in North Carolina. NFRC's 1961 report, published on the fiftieth anniversary of the Weeks Law, noted much more progress. Sixty-four purchase units, mostly in forty-eight eastern forests, had been designated in thirty-two states and Puerto Rico. By October 1976, the commission's achievements were evident and its goals met. Forests and watersheds from coast to coast were being protected. Enough acreage had been accumulated to create national forests in twenty-five eastern states.

Therefore, the commission was abolished. "This report," declared the commission, "will be the last of an unbroken chain."

"In the period covered by these reports," the final report continued, "the United States has acquired 21 million acres of land for inclusion in the National Forest System in the Eastern United States." One fourth of initial land purchases required reforestation; one half of the acreage had only seedlings. An estimated one fourth held mature forests.

In 2011, the magazine *Forest History Today* devoted an issue to the centennial of the Weeks Law. Writing of the impact of the law, historians Lincoln Bramwell and James G. Lewis summed it up:

> *Along with the 1891 Forest Reserve Act and the 1897 Organic Act, the 1911 Weeks Act forms the statuary foundation upon which the National Forest System rests. The Weeks Act enabled the federal government to purchase eastern private forestlands for inclusion in the system thus making it fully national...After decades of reforestation efforts, these national forests now support abundant flora and fauna and hide most of the scars from their past abuse...the centennial of the Weeks Act is an excellent reminder of the Forest Service's long history of leadership in forest conservation.*

Chapter 5

MOVING FORWARD

A re you going to do it?" asked his friend R.C. Hall.

"Oh, I don't know," the forester said, "I thought I'd see if the Washington chiefs come to me."

"Better think it over," he warned. "They have more than 1,500 applicants."

The new Pisgah National Forest needed a supervisor. Washington officials reviewed hundreds of qualified applicants. Pisgah required a leader who knew its forests, background and people, someone who had cruised its timber, estimated its values, identified its large trees and replanted smaller ones.

Someone who had studied in Pisgah would make an ideal candidate. Why not choose an alumnus of America's first forestry school, cradled in Pisgah's Pink Beds? Why not consider a reconnaissance leader who, under the 1911 Weeks Act, led southern Appalachian survey teams identifying purchase units for the National Forest Reservation Commission? That man knew the locals; they would trust him. A new national forest needed not only a leader to supervise its management but also one with a solid relationship with the surrounding community.

Verne Rhoades felt that his friend had exaggerated the number of candidates for the position, according to his autobiographical sketch published in the *Biltmore Immortals*, but when he "wrote a letter…outlining very briefly that I was quite familiar with the forest," leaders chose him to become Pisgah National Forest's first supervisor. After graduating from college in Missouri in 1903, Rhoades contracted typhoid fever as a lumberman in Oklahoma. Reading forestry material eased the boredom of

a long, five-week recuperation. A Biltmore Forest School catalogue changed his life: "I read it cover to cover, not once, but many times."

"I had not heard of forestry before," Rhoades continued, "but this outline of the life of a forester and the possibilities of a career in a pioneer profession fired my imagination [like] nothing else had ever done…I decided that when I regained my strength I would study at Biltmore. I sent for… Gifford Pinchot's *Primer of Forestry*, published in two small volumes. These were written in simple, clear prose and easily understood. They further strengthened my purpose to study forestry."

Meeting Dr. Schenck reaffirmed his new plan. He knew that he had made the right decision. The German forester's magnetic personality became quickly obvious.

"Have a seat," Dr. Schenck instructed Rhoades on January 1, 1906, when he showed up for class in Biltmore Village. Rhoades waited while Schenck finished his dictation. Dr. Howe, the school's dendrologist, walked in. Animated and charismatic, Schenck rose to introduce the two men. "Dr. Howe, I want you to meet…," Schenck began, turning toward Rhoades and introducing him as a distinguished dendrologist from Yale University. The professor came all the way from Yale to lecture to his Biltmore boys, he proudly explained. Rhoades was stunned. So was Dr. Howe. After several attempts, Rhoades finally interrupted. "I'm not a dendrologist, sir," Rhoades explained. "I'm not from Yale. I've never even been there. I'm your new student."

Dr. Schenck was embarrassed for only a moment. "I will tell you and Dr. Howe something [about this dendrologist from Yale]…while we were coming down the driveway…he was asking me what species of pine were growing along it. I told him *Pinus strobes*. Now don't you think that was a funny question to come from a dendrologist of Yale since white pine grows naturally over all New England?"

After graduating Biltmore in 1906, Rhoades worked as a lumber purchasing agent in Alabama, a timber estimator for C.A. Schenck Company (Dr. Schenck's forestry consulting company) and a technical assistant in New Mexico's Alamo National Forest. In 1911, the Weeks Act brought him back to Western North Carolina. As he was a forest examiner, the Forest Service assigned him to lead crews inspecting southeastern national forest purchase units. Within the Mount Mitchell purchase unit at Curtis Creek, Rhoades and his assistant, W.W. Ashe, investigated Pisgah's future eight-thousand-acre Burke-McDowell tract. Filed one month after the Weeks Act had passed into law, their April 1911 report recommended its purchase. U.S. Forest Service agent Daniel W. Adams of Old Fort filed a second report in May.

Originally a state land grant to W.W. Fleming of Charlotte, the Curtis Creek tract was sold in 1878 to Western North Carolina Land Company of Philadelphia. Under special contractual arrangements, Murray Lumber Company of Old Fort bought the property in 1901. Soon, Murray became bankrupt, and Western North Carolina Land resumed ownership. In September 1908, the company sold the tract to Colonel R. Johnston of Washington, D.C. However, the deed secured a $10,000 bond that the colonel never repaid. His Curtis Creek tract was sold at a Marion public auction on January 24, 1910. Bidding $10,575, Hudgins, White and McDowell purchased the property; Manley McDowell, however, had bought out the other two parties by February 1911. In April, McDowell deeded the property to Burke-McDowell Company of Morganton, which was now negotiating its sale to the Forest Service—a blatant reminder of eastern national forests formed from "lands that nobody wanted."

Drained on the west by tributaries of the right and left forks of Curtis Creek and on the east by Mackey's Creek—all flowing southward ten miles to the Catawba River—Burke-McDowell's tract stretched from the Blue Ridge highlands at 5,000 feet to within two miles of the railroad at 1,400 feet in Old Fort. With an average slope of 30 percent and an annual rainfall of seventy inches, Daniel Adams advised that "the danger of erosion is very serious and will be very much increased" if proper forest management was not initiated.

Some said that Union Tanning Company, which manufactured leather for shoes and machinery belts, was the largest in the world. Located near Old Fort's railroad, the tannery offered Curtis Creek loggers a nearby market for huge amounts of lumber. In an interview years later, Mary Virginia "Binkie" Adams,

Colonel Daniel W. Adams. *Bill Nichols, Old Fort, North Carolina.*

daughter of Daniel Adams, described the milling process. With dried hair and old flesh still clinging to cattle hides, Union Tanneries, she explained, shipped hides to Old Fort from South America by train. The rotting beef hides and the process of making leather created an inescapable stench. Locals logged hemlock and chestnut, hauling bark and wood to the mill for fuel and acid extract to process the leather. Once, when the tannery's woodpile caught fire, a sky full of choking smoke hung over Old Fort. Winds carried embers all the way to Mount Mitchell.

Although Union Tanneries processed many hemlock and chestnut trees, Dan Adams reported that private sawmills heavily logged Curtis Creek's poplar as well. Eight years earlier, a large sawmill on Mackey's Creek built a railroad, also harvesting massive poplar trees. Twelve to twenty families owned a total of 1,400 acres along both creeks. Some landowners cut timber to augment incomes but saw little profit. A 1901 flood, Verne Rhoades noted, heavily eroded both creek sides, limiting agricultural use.

In both reports, Adams and Rhoades recommended using flumes to transport logs to Old Fort's tannery. The steep terrain restricted other

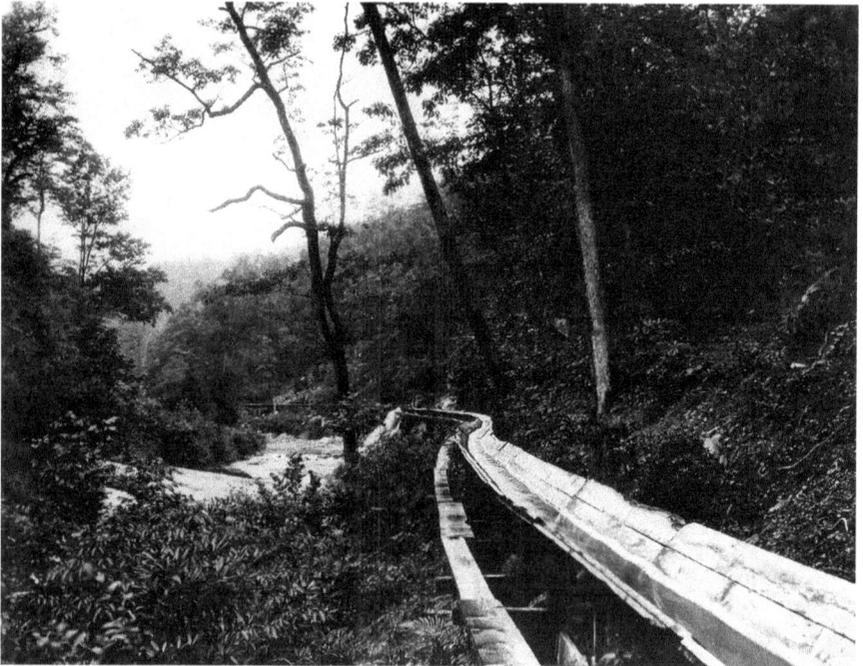

This early 1900s flume, with adjacent foot walk, funneled cut logs along Curtis Creek for eleven miles to Old Fort's Union Tanning Company. *Mountain Gateway Museum, Old Fort, North Carolina.*

transportation methods. At the time, the McDowell Company was constructing a log flume on the left fork of Curtis Creek. Water would stream down V-shaped, wooden flumes, pushing sawed timber down steep gradients. Consistently flowing mountain streams ensured a steady water supply.

For decades, at the mouth of Curtis, McDowell County resident John Smith has owned and operated a private sawmill and continues processing lumber today. In the early 1900s, he recalled, Forest Service agents evaluated his grandfather's Curtis Creek property to include it in the new Pisgah Forest. His grandfather sold some acres but kept some for his family. That flume, Smith remembered, snaking eleven miles down the mountainside toward Old Fort, made people curious. Living nearby, his mother was tempted "to play on that flume."

The Burke-McDowell purchase unit had extensive fire damage. Weakened trees were damaged further by wind, fungi and insects. Scorched soils limited growth and killed thousands of seedlings, roots and sprouts. About 70 percent of the standing timber was chestnut, wrote Adams, and 90 percent of that was "infected by a beetle, which reduces the lumber to a grade known as 'Sound-wormy.'" However, dense stands of white pines promised improved forest health by replanting pine seedlings.

"I am informed by Forest Examiner [Verne] Rhoades," Daniel Adams wrote, "that he was unable to find any record of taxation at the Registrar's office at the county seat." Rhoades confirmed that "there was no evidence that tract had ever been taxed." Boundary lines had not been surveyed. Both men's final analyses concurred, though. Without reservations, Adams and Rhoades recommended that the federal government purchase the Burke-McDowell tract to include in Pisgah National Forest.

Departing Elizabethton, Tennessee, one winter, Rhoades left to examine lands around Linville Gorge, Wilson Creek and Roan Mountain. With his horse "shod with ice-chalks," he first headed southwest to Hot Springs and turned east. Blizzards blinded his route past Mount Mitchell, Linville and Blowing Rock. Heavy snowdrifts slowed his journey over Yonahlassee Road along the crest of the Blue Ridge. Frequently, Rhoades chipped away heavy snowballs beneath his horse's feet to free his gait. After one ten-hour ride, Rhoades found a "welcome respite for a weary horseman" at the old Coffey Inn. Northward past Bakersville, he rode to Roan Mountain. There, a dense stand of spruce and

In 1911, Verne Rhoades examines lands for purchase by the U.S. Forest Service. *National Forests of North Carolina Historic Photographs, D.H. Ramsey Library, Special Collections, University of North Carolina.*

a raincoat shielded his horse, while Rhoades ducked behind wind-breaking boulders to sketch Roan's scenic landscape. Rhoades named the area "Boone Purchase Unit," after the explorer Daniel Boone, and submitted his recommendation for its protection by the Forest Service. He advised land purchases around Hot Springs as well. After three exploratory weeks, he rounded his circuit back into Tennessee.

For three years, Rhoades also conducted field inventories of purchase units in Georgia, South Carolina, Virginia, Tennessee and Kentucky. A telegram from Washington headquarters found him resting in a Chattanooga hotel after inspecting the Cherokee Purchase Unit. Verne Rhoades had been chosen to lead Pisgah.

Privately owned forests were now public lands. Lines were drawn. What *is* public land? What regulations restrict use? Whose interest is the most important—the logger's, hunter's, fisherman's, hiker's or the government's? Who decides? Protecting Pisgah's natural resources, balancing forest needs with public interest and improving forest health to ensure a successful future were a few of the new supervisor's initial goals. Following in the footsteps of Dr. Schenck was "sobering," Rhoades wrote. "It kept me trying to do my best and I was often confronted when I made a mistake, to recall how he, himself, had made many and had never tried to hide them."

Initially, Rhoades said, wildlife management was "hectic." To protect wildlife while regulating sportsmen's access, he suggested designing a game preserve. His boss, William H. Hall, chief of acquisitions in the U.S. Department of Agriculture, agreed. So, in 1916, when President Woodrow

A 1920s photograph of Pisgah National Forest's new supervisor, Verne Rhoades, with an assistant. *National Forests of North Carolina Historic Photographs, D.H. Ramsey Library, Special Collections, University of North Carolina.*

Wilson proclaimed Pisgah the first eastern national forest, he also created Pisgah Game Preserve, the first one in the East. Although North Carolina Wildlife Resources Commission assumed wildlife management years later, the Forest Service initially managed both the forest and its creatures in the new Pisgah National Forest and Game Preserve. Hall and Rhoades wrote fishing regulations. Hunting, in the beginning, was not permitted; loggers under contract still roamed the woodlands. The preserve also provided a breeding habitat for wildlife. Rhoades held community hearings to promote public education and support.

Rhoades proposed building fish hatcheries. Under Vanderbilt, Dr. Schenck had built six fish hatchery ponds, one flowing into the other to raise fish for restocking Pisgah's streams. A small building housed trout eggs obtained from the U.S. Fish Commission. Expectations for success were high until an 1899 flood wiped out the ponds. In the new Pisgah Game Preserve, the Forest Service, in collaboration with the U.S. Biological Survey, built fish hatcheries that supplied large, healthy trout for annual stream release.

Thousands of trout fingerlings perished in the cool streams, but releasing larger fish guaranteed greater success.

In May 1917, *Forest and Stream* invited anglers to "the newest national forest. A sportsmen's playground in the Appalachians will be jealously guarded to preserve its fish and other attractions…The streams run full and fast, and some run faster with a crash of white water over their boulder beds, flashing in the sun spaces, spreading a silvery tapestry over uptilted rock tables and filling the narrow valley with an uproar…The rivers are…not torrential, mostly rock bottomed, with some earth floor to darken pools for big fish."

Mrs. Carl Schenck feeds a buck named Monarch at a deer farm in Biltmore Forest. *National Forests of North Carolina Historic Photographs, D.H. Ramsey Library, Special Collections, University of North Carolina.*

On May 15, the 1917 fishing season opened under a permit system. For one dollar per day, each angler could fish four days per season. Women fished at half price. The first year's experiment determined adjustments in the number of permits granted in subsequent seasons.

Schenck had also restocked Pisgah Forest with turkey and white-tailed deer. The introduction of exotic species, such as Mongolian and European pheasants, failed miserably. Local hunters found them easy targets. Schenck's personal deer park near his home at Biltmore Estate provided many deer for release in Pisgah. Once, when Gifford Pinchot entered Schenck's deer park, a rutting, territorial buck named Monarch quickly lunged at Pinchot. Schenck's lasso looped the buck's forelegs, ending the mad drama.

Issued by the Department of Agriculture in 1921, a Pisgah Game Preserve booklet detailed hunting, fishing and camping guidelines. Buffalo and elk originally occupied this ninety-thousand-acre preserve, the brochure explained, but both were extirpated prior to the Revolutionary War.

However, on February 16, 1917, the *Brevard News* announced, "Elk and buffalo are coming. The fence is nearing completion...The elk are being caught in Yellowstone National Park." In the spring of 1917, a small herd of elk arrived to graze beneath Mount Pisgah on the ridge above Big Creek (now called Elk Pasture Gap on the Blue Ridge Parkway), but by August 1930, all elk had wandered farther afield in search of greener pastures.

The American Bison Society (ABS) chose Pisgah for its newest project. Since 1905, ABS had been working to preserve buffalo and other large animals whose numbers declined when settlers moved west. Led by its president, William T. Hornaday of the Smithsonian Institute, and honorary president Theodore Roosevelt, ABS established buffalo herds in Oklahoma, Montana and Nebraska. On January 16, 1919, six fine buffalo were chosen from the one-hundred-head herd at Blue Mountain Forest Park in Newport, New Hampshire, to repopulate Pisgah.

Anxious crowds waited outside Southern Railway's station at Hominy Valley. The train was a day late. It only took forty-eight hours by rail to go between Newport and Hominy. Why the delay? Crating three bulls and three cows from corrals to sleds and pushing them into rail cars only took a few hours. But frequent recouplings from passenger to freight trains, sidetracked and forgotten at several train stations, and the tedious removal of gas tanks from rail cars to permit a tunnel passage under New York caused long delays. When an electric engine started pushing ABS buffalo escort Martin Garretson and his beasts backward along a network of railroad track, his

frustrations exploded. Awakened by the jolting momentum, Garretson confronted the engineer.

"Oh! We thought this car was empty!" exclaimed the startled man.

"No, it's not. I have buffalo in here!"

"Why, this is that car of buffalo?" the engineer replied.

"Headed to Hominy," Garretson said.

"No, you're going to Harmony," corrected another rail agent.

"No, I'm not!" yelled Garretson. "To Hominy, not Harmony!"

"That's not what my schedule says. You're going to Harmony."

The confusion over Garretson's final destination delayed the buffalo migration several times. Finally arriving at Asheville's Depot, Pisgah's Supervisor Rudolph Dieffenbach boarded the train instead of Verne Rhoades. In 1918, Rhoades had left the Forest Service to attend Officer's Training Corps in Field Artillery at Camp Taylor, Kentucky. Commissioned as a captain, he served in World War I, returning after the war to his post at Pisgah.

After an overnight rest, drivers unloaded the beasts from rail cars into large wagons. Garretson, Dieffenbach and forest ranger Carlin rode horseback down Hominy Valley, leading the buffalo parade fifteen miles toward Mount Pisgah. Curious bystanders lined the route. Children ran from a schoolhouse to get a closer look. Warm, sunny skies made the day feel like springtime. When the

In about 1918, buffalo were reintroduced at Elk Pasture in the new Pisgah National Forest. *North Carolina Collection, Pack Memorial Library, Asheville, North Carolina.*

buffalo left the snow-covered fields in New Hampshire, railroad steam turned to puffs of snow as they departed the station. This day below Pisgah, however, was splendid. Vanderbilt's well-maintained motorway permitted a smooth passage.

Rounding the ridgeline's rocky ledge, the buffalo team arrived at Pisgah's elk pasture at about 3:00 p.m. Trenches that had been dug near the gate braced the hind wagon wheels and lowered the wagon's bed to ground level. Men shoved buffalo crates onto wooden planks. The most rebellious brute went first. Throughout the whole train ride, Davy Crockett stayed restless. Repeated headbutts shattered his crated walls, shredding the wood into mulch until quick hammers and scrap wood made hasty repairs. Now, freedom was sweet. "With a toss of his head, [he] turned his back upon the late source of all of his trouble and trotted away," wrote Martin Garretson in his report to the American Bison Society.

Within a decade of introducing the buffalo to Pisgah Game Preserve, the experiment had failed. "Due, it is believed, to the climatic conditions or some element in the pasturage too foreign to their accustomed diet," the *Asheville Citizen* reported on July 30, 1930, the buffalo at Pisgah did not survive.

According to Supervisor Rhoades, Carr Lumber Company and others continued operations after government acquisition. Carr complied with the agreed terms of the 1912 twenty-year timber lease contract with George Vanderbilt. Accessing the project site that was currently being logged, Carr's railroad tracks snaked along Big, Bradley and Wash Creeks and followed North and South Mills Rivers. Their railroad coursing up the headwaters of Davidson River and Looking Glass Creek to the Pink Beds aided logging operations in those areas until 1926 to 1927.

"With lumber prices improving," a 1916 newspaper noted, "the operations of the Carr Lumber Company on the Pisgah Forest boundary are going at full speed...The log track up Lookinglass Creek has been carried two miles north of the ridge separating the waters of Lookinglass and Mills River... The timber is...one-half poplar and the other half oak and chestnut... The Carr company has made no plans to emulate the Perley and Crockett company...[running] sight-seeing trains on its road although there is no lack of scenery on the route."

Since 1915, Perley and Crockett had offered sightseeing tours aboard their logging trains. In one of the most lucrative lumber deals in North

Carolina history, Dickey and Campbell Lumber Company, logging the Black Mountains and Mount Mitchell Purchase Area, sold out to Perley and Crockett in 1913. When Governor Locke Craig and Joseph Holmes of the NC Forest Service secured purchase of the 6,684-foot-high Mount Mitchell as North Carolina's first state park in 1915, Perley and Crockett seized a golden opportunity.

They planned to capitalize on tourists wanting to visit the East's highest mountain. When logging railroads weren't transporting logs to the Perley and Crockett sawmill or pulpwood to Champion's paper mill in Canton, they would transport tourists from Black Mountain up to Mount Mitchell. The Mount Mitchell Scenic Railroad line attracted crowds of people. Ten new passenger rail cars, a new wooden observation platform and lodging at Camp Alice, with dining room and tent-cabins, had been added by May 1916.

Into the 1920s, Perley and Crockett logged surrounding mountainsides. Smaller companies continued to log Pisgah National Forest along Curtis Creek. Champion Lumber Company logged forestlands south of Canton. Below Devil's Courthouse, at the headwaters of the French Broad River, Gloucester Lumber Company of Rosman also harvested timber.

Perry Davis rides a rail cycle to a fire in Pisgah National Forest. *National Forests of North Carolina Historic Photographs, D.H. Ramsey Library, Special Collections, University of North Carolina.*

Logging operations often sparked forest fires. Despite spark arrestors, policies requiring companies to burn discarded brush and other measures, fires were frequent. Unseen or underreported, smoldering hotspots flamed into uncontrollable blazes. Intentionally burning right-of-ways, Rhoades said, helped reduce dry tinder, but fires continued. Fire control became an urgent priority.

The Forest Service hired locals to help spot, prevent and control forest fires. Platforms on high mountains and in tall trees and constructed wooden towers elevated fire wardens. Radios and telephone lines between lookout stations improved communication. Rangers on horseback scouted forested landscapes, scoping for the first signs of smoke. Recognizing early signs prompted quicker response and improved outcomes. Working for the Forest Service in Arkansas, Daniel Adams recognized the importance of prompt action. On June 20, 1912, the Department of Agriculture published his manuscript, *Methods and Apparatus for the Prevention and Control of Forest Fires, as Exemplified on the Arkansas National Forest.*

Grandson of Dr. James Calloway, a physician who joined the Cherokee Indians on the "Trail of Tears," and son of Civil War Confederate brigadier general Daniel W. Adams, Dan Adams joined the Forest Service in 1905. At Arkansas (now Ouachita) National Forest, created in December 1907 by Pinchot and Roosevelt from the public domain as the first national forest in the South, Adams replaced its first forest supervisor, Samuel J. Record, in July 1910, moving the supervisor's office to Hot Springs. Adams designed the first fire tower for the Forest Service, devised the cross-triangulation method of pinpointing a fire's location and invented a fire-suppression foam with soda and sulfuric acid that reduced water use by one-third.

Men hiked or rode to presumed wildfire locations only to learn, after the blaze was out of control, that the fire was actually miles away. Build fire towers, Adams proposed. Erect ridge-top towers at designated reference points. Locate fires by triangulation. Lookout wardens spotting smoke radioed or phoned other tower rangers. Compass readings of smoke sightings drawn on maps at each tower crossed, or triangulated, at a wildfire's position. Adams also designed water- and chemical-carrying equipment for horse and man, firefighting train engines and other accessories.

After the Weeks Act passed, Adams transferred from Arkansas to North Carolina to evaluate purchase units. He chose to live in Old Fort, owning 3,500 acres surrounding Catawba Falls—now part of Pisgah National Forest. In World War I, rising to the rank of lieutenant colonel, he, like his grandfather, befriended American Indians and asked to lead Indian troops. After the war, Adams built a dam and power plant on Catawba River to

Forest Service officer Daniel Adams, who designed the first Forest Service fire tower, wrote in *Methods and Apparatus for the Prevention and Control of Forest Fires* in 1912: "It was found in the Arkansas Forests that merely the quick and accurate location of fires, in conjunction with the old methods of firefighting, with [green boughs] of pine tops, wet gunny sacks, and shovels did not suffice for fire control…[these methods were] entirely inadequate to cope with the rapidly burning surface fires, driven by high winds in broadleaf cover." This later Forest Service fire control toolbox displays more "advanced" firefighting equipment. *National Forests of North Carolina Historic Photographs, D.H. Ramsey Library, Special Collections, University of North Carolina.*

supply the town with electrical power. A spur railroad line from Old Fort to Catawba transported logged timbers. His fish hatcheries restocked nearby streams. A monument in tribute to his accomplishments now marks the entrance to Pisgah's Catawba Falls Trail.

On August 21, 1925, the *Asheville Times* reported the resignation of Pisgah's supervisor, Verne Rhoades. "He has done his work well," the article noted. "He has brought to his official labors the trained understanding of the expert forester and the rich personality of an extremely likeable man."

Federal government land acquisition continued. By 1930, Pisgah protected three times its original domain. Officials expected even more purchases. As Pisgah's acreage increased, administrators divided supervision into districts based on geographical regions. Over the years, four divisions became three districts. Today, the 500,000-acre Pisgah National Forest is divided into the Pisgah Ranger District, the Grandfather Ranger District and the Appalachian Ranger District.

In addition to the Pisgah Game Preserve, other protected wildlife areas were established in Western North Carolina. Bordering Buncombe and McDowell

Wildlife officials load fawns in a truck to be reintroduced into wildlife areas with low deer populations. *National Forests of North Carolina Historic Photographs, D.H. Ramsey Library, Special Collections, University of North Carolina.*

Counties, near the Curtis Creek tract, the Mount Mitchell Game Refuge and Wildlife Management Area was established in November 1927. By the early 1930s, game wardens had transferred eleven Pisgah elk (four bulls and seven cows) and six fawns from Pisgah's preserve to Mitchell. After adjusting to their new surroundings in holding pens at Neals Creek and Bald Knob Ridge, wardens released eighty deer at Mount Mitchell over a four-year period.

The Pisgah District had abundant deer—enough to help restock wildlife management areas that did not. In the 1930s, Civilian Conservation Corpsmen were assigned to "deer drives" to estimate the number of deer in Pisgah's forests. A four-hundred-acre plot, chosen by a forest ranger, was surrounded by 125 men. At a signal, the men walked toward one another "after a short breathing spell" and made "as much noise as possible," reported the author of a Balsam Grove CCC newsletter. They counted not only deer on the run but also "turkey, grouse, fox, rabbits, and pole cats," the reporter explained. "It was lots of fun!"

Officials relocated adult deer that had been captured in wood-and-wire cages baited with apples. Young deer caught by workers for four dollars per fawn were transported to Pisgah's U.S. Fawn Rearing Plant near the Pink Beds (the only one in the country). When cow's milk wasn't available, staff bottle-fed fawns evaporated milk diluted with 40 percent water. Trucked to other game management sites, six-month-old deer found forage on new home ranges. Deer keepers raised about 135 fawns per year. Between 1928 and 1944, Pisgah repopulated other sites with approximately 344 deer.

On the eastern slope of Grandfather Mountain, near Mortimer and Edgemont, the Daniel Boone Game Refuge was established in August 1929. Until the 1960s and 1970s, game wardens lived on site in government housing. (In 1928, the Nantahala National Forest formed Wayah Bald Game Preserve.) In a 1937 *Marion Progress* article, a ten-year update on North Carolina's preserves reported that "a total of approximately 42,000 acres [are] set aside in Western North Carolina as State Game Refuges...established...to create a breeding ground for useful wildlife...a place where game animals and birds may retreat and be at rest...multiply undisturbed...and increase overflow to the surrounding territories."

When private logging operations in the region began to wane in the late 1920s, companies left, families deserted mill towns and men lost steady incomes. Carr Lumber Company's contract ended in Pisgah Forest. Old Fort's Union Tanning Company, a market for Curtis Creek timber for sixty years, closed in 1930 after the plant was struck by lightning. Across the southern Appalachians, families suffered. Men rode from town to town

Bottle-feeding at the fawn farm. *National Forests of North Carolina Historic Photographs, D.H. Ramsey Library, Special Collections, University of North Carolina.*

atop Southern Railway boxcars looking for work. Disembarking at Old Fort, hungry men went door to door asking to cut firewood for a day's meal. The Great Depression had arrived.

One Roosevelt saved forests by creating the U.S. Forest Service. In the 1930s, another Roosevelt saved men *around* the forests. In that way, President

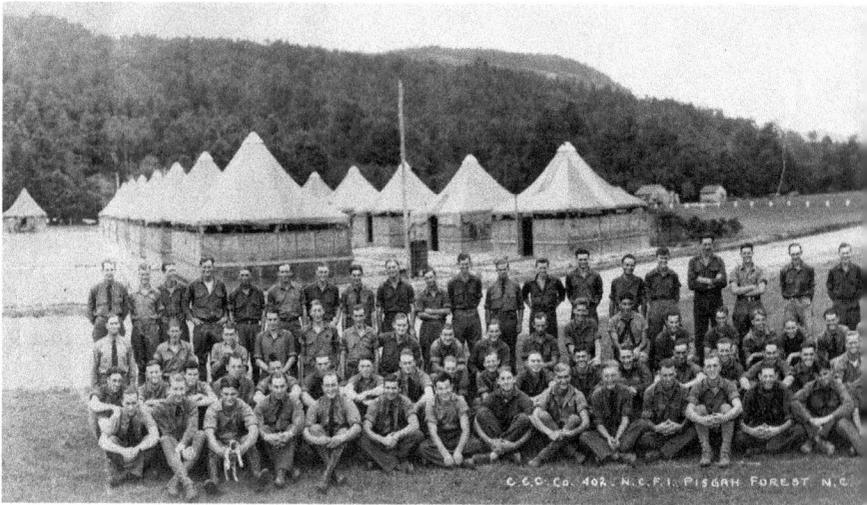

Civilian Conservation Corps Camp John Rock, F-1, Pisgah National Forest, was the first CCC camp at John Rock and the first CCC camp in North Carolina, August 1934. *Courtesy of Roswell Bosse North Carolina Room, Transylvania County Library.*

Franklin D. Roosevelt helped save the forests, too. The Great Depression brought poverty, unemployment and low self-esteem. Idle hours fostered desperate, often illegal acts. FDR's creation, the Civilian Conservation Corps (CCC), provided income, purpose and education to young men and their families. The CCC also provided labor and manpower needed to restore America's forests. By 1933, when government-allocated funds for the U.S. Forest Service were reduced by 50 percent compared to its previous fiscal year, the CCC brought relief. No agency in the CCC system—state, private, federal or national park—benefited from Roosevelt's "Tree Army" more than the U.S. Forest Service.

Within a month of FDR signing the Emergency Conservation Work Act, CCC camps began operations in and around Pisgah National Forest. North Carolina was allotted 7,650 recruits. Based on financial needs and other factors, county welfare officers selected potential workers. At local medical stations, such as Asheville, new recruits, ages eighteen to twenty-five, arrived for physical examinations. Transported to Fort Bragg or other military posts, enrollees received a two-week "hardening process" (physical conditioning) before a six-month's assignment in a conservation camp.

Some encampments in Pisgah National Forest were established at deserted logging campsites. Beneath the cliffs of John Rock, in the flat valley beside Davidson River, the Carr Lumber Company's old logging camp was perfect.

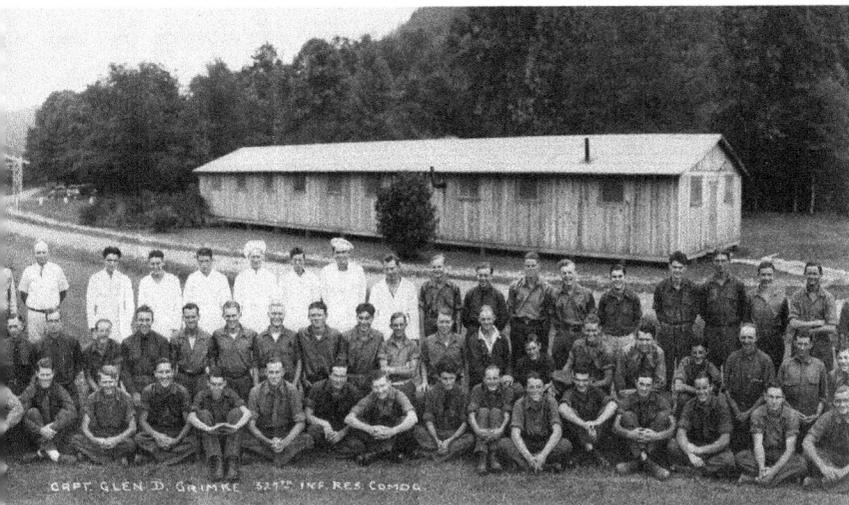

CAPT. GLEN D. GRIMKE 327TH INF. RES. COMDG.

The wide valley, in easy reach of forestry work projects, offered clean water and open space. Recruits from the Charlotte, North Carolina area arrived. With the men's spirits high and appetites stimulated, mess hall cooks realized after the first meal that more rations were needed. "The mountain air was taking effect," a Charlotte newspaper reported.

Four barracks, an officer's quarters, a medical tent, a commissary, a blacksmith's shop, an oil house, pit-latrines and bathhouses were among the camp's buildings. Temporary camps often relocated after completing assigned tasks in an area. Stationary camps, like John Rock, offered schoolhouse lectures and athletic field competitions. Later, a second CCC camp would occupy John Rock. In addition to fighting fires, major accomplishments included building Frying Pan Lookout Tower, firebreak lines, eighty miles of trails, two hundred miles of phone lines and several fish hatcheries. Some enrollees helped with Pisgah's deer farms.

Another Pisgah District encampment, inspected and approved by a major from Fort McPherson (the commanding headquarters for conservation corpsmen in Transylvania County), was the North Mills River camp. The War Department assigned World War I army veterans to oversee CCC camp housing, food, clothing and discipline. From Fort Bragg, soldiers arrived to help construct both John Rock and North Mills River camps. North Carolina State College forestry graduates came to supervise some of Pisgah's CCC projects. Construction of fourteen-mile Yellow Gap Road from Mills River to the Pink Beds, creating an alternate route to Mount Pisgah, was a major accomplishment.

Men from a Morganton CCC Camp transferred to Asheville near Pisgah's Bent Creek. After initial preparations, corps members from Mississippi, Georgia and Florida joined them to set up sample plots and field laboratories for the Appalachian Forest Experimental Station. Camp Gloucester at Balsam Grove worked near Rosman.

In Pisgah's Appalachian Ranger District, Camp Alex Jones, named in honor of a deceased Corps officer, operated near Hot Springs on the lawn of the old Mountain Park Hotel. Proximity to town reduced boredom and feelings of isolation. Amenities were more accessible. Locals regularly applauded CCC projects. In addition to building fire towers, constructing sections of the Appalachian Trail were major accomplishments. When the camp closed in February 1939, the company was transferred to Fort Oglethorpe, Georgia.

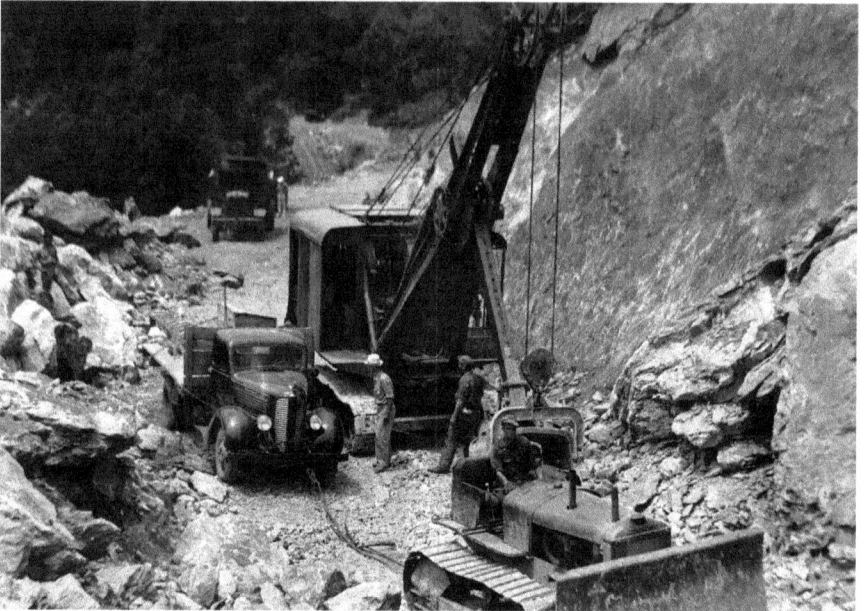

"James Grayson Sawyer (1909–1973) from Old Fort, North Carolina, seen here, ran the road-clearing, road-building bulldozer creating many roads throughout the western North Carolina mountains with the CCC in the 1930s. He later moved to Michigan with his wife, Vista Woody Sawyer and children in 1942. There, he owned his own grading business continuing the work he learned in the CCC, operating bulldozers and dump trucks," wrote Dee Daughtridge, his daughter and branch manager for the Marion Davis Memorial Branch Library, Old Fort. *Courtesy of Dee Daughtridge.*

In the Big Ivy region of Appalachian District, an encampment near Barnardsville improved visitor facilities at Craggy Gardens. Corpsmen carved a road from Barnardsville to the rhododendron gardens, built a new parking lot and designed trails to Craggy Dome. Wooden benches and a picnic shelter handcrafted by the CCC still beckon Craggy visitors today.

Camp McCloskey, named for Brigadier General Manus McCloskey of Fort Bragg, boasted a fine swimming pool and an athletic field. At a weekend open house for locals to inspect the camp, men were found "healthy and happy...A number of people dropped in, some of whom stayed until 'teatime,'" a newspaper reported. "When the cook beat a lively tattoo on a heavy tin pan, the young men rushed the works and ate with apparent relish a meal of creamed bologna, lye hominy, tomatoes, potato salad, bread, coffee and bread pudding with marshmallow topping."

Located ten miles northwest of Marion on Buck Creek, Camp McCloskey aided the efforts of other Grandfather Ranger District CCC camps: two camps in Caldwell County (Camp Globe and Camp Grandfather Mountain at Mortimer) and Camp Jim Staton at Curtis Creek near Old Fort. Reforestation, erosion control and highway beautification were primary objectives. Camp Globe built a long-overdue road between Globe and Lenoir. Several camps coordinated major firefighting efforts. When McCloskey closed in June 1941, remaining corpsmen were transferred to Hot Springs, Mortimer and Mount Mitchell. Conscientious objectors occupied Camp McCloskey during World War II.

After the Civilian Conservation Corps disbanded and Camp Staton on Curtis Creek closed, John Smith, an Old Fort sawmill owner, bulldozed the encampment site at the request of the Forest Service. It was planning a new public campground. Trucks arrived to transport foundation rocks from their barracks and other buildings to the head of Linville Gorge. There, on NC Highway 183, memories of Curtis Creek corpsmen are firmly embedded in the chimney beside the Linville Gorge Information Cabin. The trees from Pisgah that were used to build the cabin, Smith said, were processed at his sawmill.

In an interview with the Forest Service, Bill Vines, a former Mortimer CCC man, described his experience. After six months, he progressed in the ranks, learning new skills. Still needing a job, he reenlisted. Developing leadership skills, Vines trained others in road construction and the use of heavy equipment. He manned fire towers and recorded weather data to

The CCC camp at Curtis Creek, Camp Jim Staton, is now the site of Pisgah's Curtis Creek Campground near Old Fort, North Carolina. *Courtesy of Bill Nichols, Old Fort, North Carolina.*

determine if changes in humidity and temperature affected fire dangers. When CCC enrollment diminished as World War II demanded more men, Bill stayed with the Corps as a junior foreman. In Grandfather Ranger District, "when the CCC went plumb out," he said, "the district ranger was there, the foreman was there, and me...We were the only three men left on the district...We went to hiring back to build up the crew."

By 1942, when the Civilian Conservation Corps ceased operations, nearly 5 million man-days of work had been completed in North Carolina; 60 percent of those were accomplished on national forestland. North Carolina recruits had built 2,600 miles of roads, 400 miles of trails, one thousand bridges and 1,800 miles of telephone lines. Forest fire management improved with eighty-five CCC-constructed lookout towers, 1,200 miles of firebreaks and forty-six thousand firefighting man-days. Numerous campgrounds and picnic shelters were created. Some five hundred buildings were constructed.

Erosion control improved. Nearly 200,000 square yards of road banks were sloped and seeded. North Carolina's "Tree Armies" collected thirty-

seven thousand bushels of pine cones and sixteen thousand pounds of hardwood seeds to replant 3,500 acres of wasted forestland. Timber improvement on 204,000 acres preserved future forests. Seventy-one fishponds raised 658,000 fish to restock rivers and streams. "When the Civilian Conservation Corps closed its books on June 30, 1942," a Marion newspaper noted, "it had completed nine and a quarter years of service in conserving the natural and human resources of America...CCC camps under the jurisdiction of the US Forest Service and the state forester advanced the cause of forest conservation in North Carolina by at least a generation." The work of the Civilian Conservation Corps embodied what would later become the U.S. Forest Service motto: "Caring for the land and serving the people."

GRANDFATHER
RANGER DISTRICT

This district may be the largest in all of North Carolina's national forests, but that's not its greatest feature. Grandfather is rich. Within its 180,000 acres, Grandfather Ranger District is brimming with natural and human history and scenic beauty. Even single-engine aircraft cruise over its landscape to scan its magnificent wealth.

At Shiflet Field outside Marion, a fixed-wing, Cessna-172 Skyhawk taxis to the west end of the small grass airstrip. A windsock confirms that winds from the east are light and variable. Liftoff is gentle; ascent is steady. Barely five hundred feet off the ground, the Cessna sails over lazy Catawba River before Catawba flows under Southern Railway's train trestle into man-made Lake James. Soon Catawba's waters mingle in Lake James with those from Linville River recently departed from Grandfather's estate.

Created in 1923 and named for James B. Duke, founder of Duke Power Company, Lake James entertains residents, campers and water sportsmen. A state park occupies part of its 150 miles of shoreline. Along its easterly course, plane and pilot sweep over six thousand aquatic acres. Directly ahead, Linville Dam signals the pilot to bank north toward Pisgah National Forest.

At an altitude of 5,500 feet, the Skyhawk rotates to a heading of 010 degrees, following Linville River upstream to Linville Gorge. Under a clear, crisp blue sky, the gorge's grand features are seen immediately. The long Linville Mountain forming the steep western wall stands proudly erect like a grand canyon. On Jonas Ridge, its eastern rim, spectacular mountain-sized geological formations line up for an eagle's eye inspection.

Grandfather Mountain and Linn Cove Viaduct. *Photo by the author.*

Shortoff Mountain on the southern end of Jonas Ridge rises sharply above Lake James. The Chimneys, Tablerock Mountain, Hawksbill and Sitting Bear line up in succession. The highest, Gingercake Mountain (4,120 feet), sits at the head of the gorge. Eddies rippling off mountain peaks like invisible river currents gently toss the light aircraft.

Like a proud patriarch, Grandfather Mountain rises on the horizon, giving birth to Linville River and Wilson Creek to nurture its southern slopes. Privately owned for decades by Hugh Morton, Grandfather Mountain is now a state park. Linn Cove Viaduct of the Blue Ridge Parkway outlines its base.

With a gentle pull on the yoke and rotation to the east over Pilot Ridge, Cessna-172 rolls out 180 degrees later on a southern course parallel to Linville Gorge. Following the headwaters of Wilson Creek downstream, the Skyhawk sweeps over the district's Wild and Scenic River. Brown Mountain rises to the west. Johns River parallels to the east.

Northeast of Morganton, the pilot circles back toward Lake James, flies over Shiflet Field and heads due west above Interstate 40. Passing the town of Old Fort and Wildcat Mountain, pierced off center by a radio tower, the Skyhawk cruises toward Evans Knob on the Eastern Continental Divide, its soils protecting the headwaters of Catawba Falls. Hundreds of preoccupied

I-40 motorists crossing the Blue Ridge Escarpment on Old Fort Mountain are oblivious to nature's secrets in Catawba River Valley below.

Turning northeast, pilot and plane slip by Andrews Geyser, a fountain built to honor a railroad man for the seven tunnels through rugged mountainous barriers, connecting Old Fort to Asheville by rail. Flying over Pisgah's first purchase at Curtis Creek, the Skyhawk follows the railroad track back to Shiflet Field (1,211 feet) to prepare for landing. The pilot lowers the wing flaps, reduces airspeed and descends to landing-pattern altitude. He rolls out on final approach, pulls the nose up gently and glides it in. Touchdown.

Explore Grandfather Ranger District at ground level by auto, foot, canoe or kayak. Follow a river, road or trail. Straddle a horse, mountain bike or ATV. Climb a rock or toss a smaller one in a pool. Make a wish. Sunbathe on a flat rocky shelf or journal on another. Soak tired feet in a quiet pool or cast luck into a wild stream. Let a waterfall steal a soul, calm a mind or divert a thought. Climb a cliff. Let Grandfather share its stories.

LINVILLE GORGE

After tumbling from its birth on the highest of Grandfather Mountain's seven peaks and gracefully flowing through quiet flatlands, Linville River hurdles a rocky shelf forming its twelve-foot-high Upper Falls as if providing a warning of the dramatic drop ahead. Within moments, roaring Linville River plummets through massive boulders, taking a thunderous sixty-foot plunge into its sculpted crater. Carving and re-carving its foundation over geologic ages, the river's strength has etched Linville's riverbed two thousand feet deep over fourteen miles, its river course reshaped repeatedly by floods, fractures and natural elements.

For generations, Linville Gorge visitors have scanned in awe at the rock formations chiseled by nature's forces, naming some "Chimneys," "Bull Face," "Babel Tower" and "the Camel." Some gaze from an overlook in silent reverence as if paying homage to a sacred shrine. Others whisper, pointing out a jagged ledge, a peregrine falcon or rocky prominence. Called *Esseeoh* by the Cherokee, meaning "river of cliffs," Linville's features seen at dawn, high noon or dusk are always photogenic.

Linville Falls and Gorge could have been cursed with a luxury tourist resort, a hydroelectric power plant or a persistent logging company. An 1890 Linville Falls owner, Morganton Land and Improvement Company,

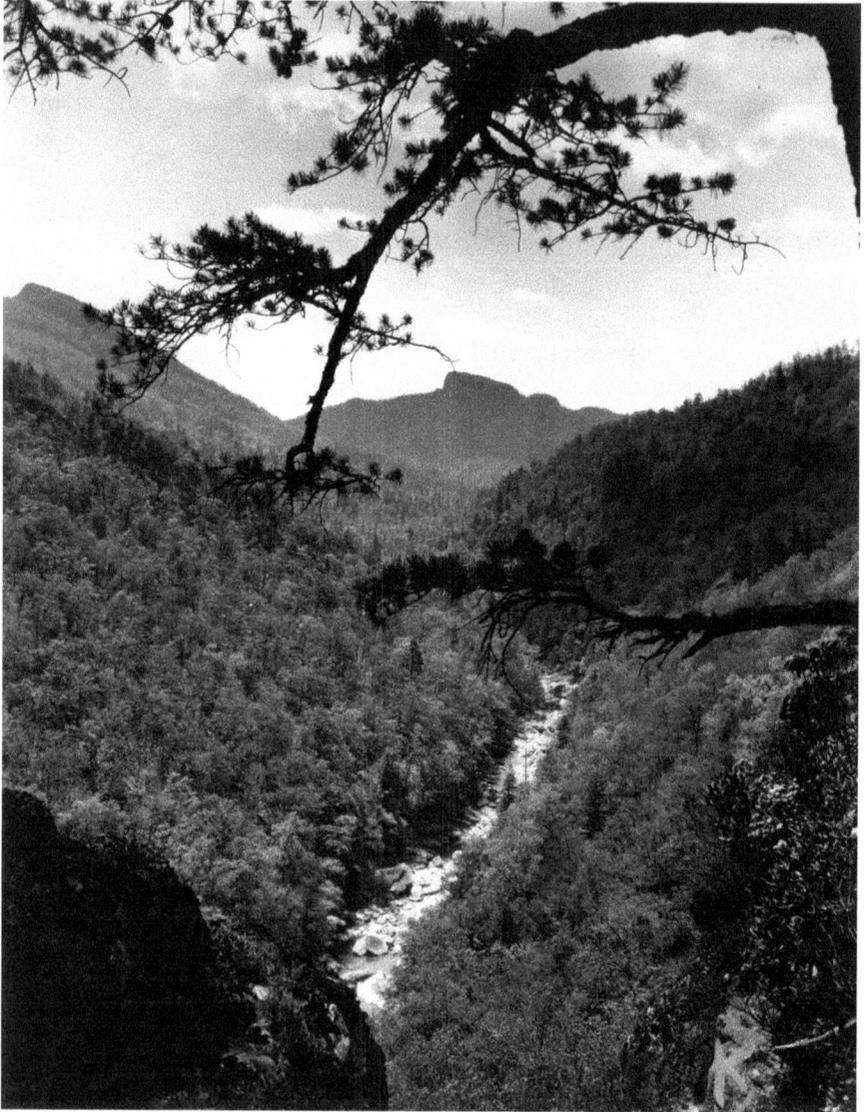

Photo by George Masa of Linville Gorge showing Hawksbill and Tablerock Mountains. *North Carolina Collection, Pack Memorial Public Library, Asheville, North Carolina.*

unsuccessfully proposed a mountain lodge for the site. Preliminary structures designed to harness Linville River for electrical power were washed downriver in the Flood of 1916.

In the late 1880s, when mountain scenery, fresh air and healing powers were luring visitors to the area, real estate developer and regional promoter

Hugh MacRae purchased sixteen thousand acres, including Grandfather Mountain. MacRae built luxurious Eseeola Inn, with a deluxe golf course. He and Samuel Kelsey, who created the resort town of Highlands, North Carolina, constructed Yonahlassee Trail, a toll road from Linville to Blowing Rock—the snowbound trail followed by USFS examiner Verne Rhoades in 1911. For eighteen miles, Yonahlassee (Cherokee for "trail of the bear") outlined the base of Grandfather Mountain.

Linville Falls became popular for vacationers. When Fred "Fritz" Hossfeld purchased the property in 1897, he capitalized on Linville's scenic beauty by offering guided waterfall hikes. He had planned to develop a resort community of white-framed cottages. Local logging and passenger trains provided transportation. W.M. Ritter Lumber Company logged the forests near Linville Gorge shipping timber to its sawmill in Pineola. By 1907, the town, now called Linville, was known as "Stumptown." When timber resources were depleted, Ritter relocated to Wilson Creek.

When Hossfeld died, his sister, the heir to Linville Falls, wanted to sell the property. Like George Vanderbilt's widow negotiating with the Forest Service to protect Pisgah's future, a retired attorney, Marion C. Wright, lobbied for the federal government to purchase Linville Falls and its river gorge. In the mid-1930s, engineers designing the Blue Ridge Parkway for the National Park Service planned for the route to pass by Linville Falls. Successful meetings in 1951 with parkway superintendent Samuel Weems and National Park Service officials prompted John D. Rockefeller Jr. to donate $92,000 for 1,200 acres around Linville Falls, ensuring its preservation.

That same year, the U.S. Forest Service purchased 7,500 acres of Linville Gorge, adding it to Pisgah National Forest. When the Wilderness Act passed in 1964, Linville Gorge became the East's first designated wilderness area, defined as a place "where the earth and its community of life are untrammeled by man, where man himself is a visitor and does not remain." To maintain a primitive natural environment, the Forest Service issues camping permits to limit human impact from overuse and allows only hiking along its wilderness trails. After North Carolina's Wilderness Act passed in 1984, more acres were added; Linville Gorge's protected area now totaled 10,975 acres. More recent additions increased the size to about 12,000 acres.

To view Linville Falls, hike National Park Service trails from the parkway or hike Forest Service trails off NC-183. To explore Grandfather District's Linville Gorge Wilderness, both east and west rims of the gorge have trails that lead backcountry hikers, primitive campers, rock climbers, hunters,

Brooke Lyda and her dog, Sparky, hike a Pisgah National Forest Trail in Linville Gorge. *Photo by the author.*

fishermen and vacationers to rocky overlooks or along steep trails descending into the canyon.

On the west rim, USFS maps are available at the Linville Gorge Information Cabin off NC-183. Excellent unofficial maps, generated

over many years by volunteers, are available at LinvilleGorge.net and FriendsofLinvilleGorge.org. Maps are essential in wilderness areas, where trails are often unmarked. A short drive on the Kistler Memorial Highway passes Bynum Bluff Trailhead, leading to the river's fishhook bend beneath sheer rock cliffs. Massive boulders altering the water's course force rapid currents into cascading white foam.

Farther down the road, a short trail leads to Wisemans View, overlooking Hawksbill and Tablerock Mountains. Deep in the gorge below, a helicopter, in July 2006, flew three footbridge sections from North Cove, a community located on the north fork of Catawba River, and lowered them across Linville River. The Spence Ridge Trail Bridge connected trails on both sides of the gorge until 2014, when floodwaters washed the bridge away.

Along graveled Kistler Highway, seven steep trails connect to the strenuous 11.5-mile Linville Gorge Trail, which parallels Linville River. Two cars placed at separate trailheads offer day-hikers a looped option. Consider your physical capabilities, though; a one-mile, nine-hundred-foot trail descent can create a huffing climb back up.

The eastern rim of Linville Gorge is reached by taking State Road #1265 off NC-181. Two east rim trails descend into the gorge, but Tablerock Mountain is a favorite destination for hikers and rock climbers. Since 1967, Outward Bound School, an educational program building confidence and leadership skills through outdoor adventures, has operated its Tablerock Base Camp nearby. A USFS fire tower once stood on the rocky summit. Metal rings that secured its heavy cables remain embedded in the surface. From Tablerock Picnic Area, a five-mile trail passes over the east rim, the Chimneys and Shortoff Mountain toward Lake James. Avid rock climbers ascend the North Carolina Wall, Devil's Cellar and other challenging cliffs.

Linville's varied topography and range of elevation support a wide range of plants and animals. Look for bear, fox, squirrel, raccoon, deer, turkey or grouse. From Pinnacle Platform, birders watch for migrating hawks and songbirds. The Friends of Linville Gorge lead mushroom forays and wildflower walks. In addition to maintaining four Forest Service trails, the Friends are collecting data to catalogue Linville's flora and fauna, especially the rare and endangered species. Turkey-beard, gay-wings, yellow lady's slipper, sand myrtle and several species of orchids are some specialties. Federally listed Heller's blazing star (*Liatrus helleri*) and mountain golden heather (*Hudsonia montana*) grow in Linville Gorge. Contorted, artistic table mountain pines on rocky outcrops require a fire's intense heat to open seed-bearing cones.

Tablerock Fire Tower. *U.S. Forest Service.*

The North Carolina Wildlife Resources Commission (NCWRC) has been monitoring peregrine falcons in Linville Gorge at the North Carolina Wall and Shortoff Mountain for nearly twenty years. Eyries (nesting sites) have been observed on the cliffs of Tablerock Mountain as well. For more than thirty years, the fastest bird on the planet, which can dive at prey at two hundred miles per hour, had been federally listed as an endangered species. Widespread use of pesticides had reduced peregrine populations to near-extinction numbers. Although banning DDT, protecting nesting sites and other conservation measures allowed the falcon to recover, prompting officials to remove it from the federal endangered species list, North Carolina continues to monitor the peregrine as an endangered species within the state. NCWRC biologist Chris Kelly reported that Shortoff, occupied by peregrines for thirteen years, has been one of the most productive nesting sites in the gorge. In the spring of 2013, observations of peregrine nestlings in an eyrie on Shortoff promised successful fledglings. Returning later in the nesting season, Chris found an empty nest. A great horned owl nestling occupied the cliff below. Adult owls taking care of their own may have invaded falcon territory. During nesting season, Forest Service and wildlife officials close inhabited cliffs to hikers and rock climbers.

"DIANA AND THE BURST TRANSMITTER"

By Christopher M. Blake, PhD, Friends of Linville Gorge director. Christopher Blake was one of the May 1969 army trainees in the Gorge in this field exercise for Green Beret A-Team radio operators. For further information, check out the website www.friendsoflinvillegorge.org.

Two human forms emerged from dripping shrubby as night settled over a stormy, chilly late Mayday in Linville Gorge, somewhere on Shortoff Mountain. 1969.

Clad all a-green—even to their green tams—the pair stepped into the camp's fire glow, one bearing a mysterious black box. Firelight flickered across the seamed faces of these elder warriors, across the sheen of the wet poncho lean-to, over the radios and electric generator on its stool, upon the curious faces of four radiomen apprentices.

One of the pair knelt and opened the box, disclosing the device they had come to "check out"—that is, explain, familiarize and deposit with the trainees until each had performed satisfactorily on the thing.

It was the CIA's Burst Transmission Device—the AN/GRA-71. The 9½-pound unit converted an encrypted Morse code message onto magnetic tape for scrambling. The compressed message "burst" out as a signal in a fraction of the time it'd take to manually key in the Morse messages. Enemy monitors would have a harder time catching the signal and tracking its source when the prescheduled "burst" went out like a "burp of static."

The message had first to be put in strings of five-letter code words, or "Diana." This referred not to the Roman version of the Greek goddess Artemis but to a randomized system of encoding English using letter-to-letter English alphabet correspondences.

The messages had to display military-type decorum even though wholly fictional and created in a Pisgah Forest as "Central Highlands of Vietnam-type" field scenario. They could concern imaginary med-evacs, jet air strikes, VC positions or tunnel complexes, ambushes and even movements of NVA regulars if the text followed radio protocol. At Fort Bragg, Green Beret radiomen received and decoded the messages for grading by other instructor sergeants.

In 2010, lawmakers passed the American Recovery and Reinvestment Act, granting more than $15 million for projects in North Carolina's four national forests. In Grandfather District, officials planned to upgrade thirty miles of trails and remove nonnative plants. Aggressive nonnative plants reproduce and spread quickly, outcompeting native vegetation for sun, water and minerals. More than ten unwanted species have been targeted in Linville Gorge, including the Princess tree, Chinese silver grass and mullein. Working with the USFS, WildSouth, a community conservation group, recruits volunteers to help remove these invasive plants.

Other projects, eliciting the help of Job Corps Civilian Conservation Center and the North Carolina Division of Forest Resources, included removing trees and brush. In 2012, under the Collaborative Forest Landscape Restoration (CFLR) program, the USFS initiated the ten-year Grandfather Restoration Project to "restore the fire adapted forest ecosystems…and benefit native plants and wildlife, control non-native species and protect hemlocks against hemlock woolly adelgids [HWA]." Projects are underway.

Eastern and Carolina Hemlock trees are valuable natural resources that protect regional watersheds. Wide-spreading, shallow-root systems prevent erosion. Towering more than 150 feet tall, dense hemlock canopies shade forest floors, keeping rivers shady and cool for trout, salamanders and other riparian neighbors. As America's most shade-tolerant trees, hemlocks can thrive in only 5 percent sunlight, providing suitable habitat for hundreds of creatures. However, hemlocks are under serious attack.

In 1951, in the eastern United States, biologists first discovered the presence of hemlock woolly adelgids, nonnative, destructive insects originally from southern Japan. No natural resistance or predators existed in America, so adelgids reproduced and fed on hemlock needles unchecked. Within a few years, infested hemlocks died. Deep green stands of hemlocks from Maine to Alabama are now brown. In Linville Gorge, USFS injects an insecticide into the soil around selected trunks and releases predator beetles in hopeful attempts to save the hemlocks.

For decades, wildfires in the Linville area have caused concern. In 1916, the *Asheville Citizen* reports that loggers, iron and coal workers, foresters, real estate developers and civic leaders met to form the Linville Protection Association, discussing fire control policies for their forests, including "the proposed Boone National Forest of 100,000 acres." (The National Forest Reservation Commission officially proclaimed Boone a national forest on January 16, 1920. Boone joined Pisgah in March 1921. Until they were consolidated in the 1960s, the west side of Grandfather District

in McDowell and Burke Counties was the Catawba Ranger District, and Grandfather District occupied the east side.)

Managing Linville's fires remains a Forest Service priority. Between 2000 and 2012, four fires scorched 20,000 Linville Gorge acres. Three were caused by human-related events, and one was set by lightning. In November 2013, a Linville Gorge fire quickly spread south from Tablerock Picnic Ground. Investigators sought Veterans Day campers for questioning. With the fire burning more than 2,500 acres, more than 190 fire personnel from four states, including Cherokee Hotspots from Tennessee and a crew from Oklahoma Bureau of Indian Affairs, battled the blaze for nearly thirteen days. Winds and dry brush made containment more difficult.

Forest Service officials lifted trail and road closures on November 25, 2013, the first day of deer rifle season.

A hiking journal entry dated September 12, 1992, reads:

> *Clear, sunny day; temp: low 70's; mild breeze; Pat and I hiked from the top of Old Linville Road to Kistler Memorial Highway at Linville Gorge Wilderness on the Overmountain Victory Trail, a route marched by 1000 Revolutionary Patriots late September 1780 to defeat Major Ferguson and his Tory army at Kings Mountain. Two cups of coffee and a long drive to the trailhead necessitated an early "trail break." "Nature was calling" for me to find a tree. After selecting the site, I heard a branch creak and looked up. There, above me, a bow-hunter crouched in the forks of a large limb, smiled.*
>
> *"It's deer season for archers," he said. "This is my tree."*
>
> *"I'll find another one."*
>
> *The trail was a steady, frequently steep ascent for the first two and a half miles. A steep half-mile descent followed before a steady rise again. A beautiful, cave-like arbor of rhododendron during the last mile darkened the day to a dusk-like ambience. While crossing two fields, I spotted a dark-phased tiger swallowtail. A monarch butterfly sipped on milkweed.*
>
> *A tiny caterpillar suspended in the middle of the trail at eye-level on a thread so fine that it was invisible to the human eye. A black-bodied, white-haired caterpillar with a black head and antennae, fore and aft—who was he? I moved my extended index finger horizontally above the little fella' to watch him gently swing in the air, and yet, I never felt the touch of the*

strand of silk or see it move. My human eyes could only see a mid-air caterpillar arcing through the air at my finger's command.

Rock-a-bye, 'Pillar, from a tree top
When the finger moves, thy body will rock.
When the thread breaks, thy body will fall.
Down will come 'Pillar, silk swing and all!

Flowers blooming today: Nuttal's milkwort, asters, yarrow, goldenrods, white snakeroot, blazing stars, Joe-Pye weed. The prize for the day: orange-fringed orchids!!!!! Heard: chickadees, downy woodpeckers, towhees.

Arrived Linville Gorge at 3:30 p.m. Walked across Kistler Memorial Highway to climb .2 miles up to the Pinnacle, overlooking Lake James, Linville Gorge, Tablerock and Shortoff Mountains. I could have stayed 'til sunset.

WILSON CREEK WILD AND SCENIC RIVER

Although spectacular Linville Gorge can hardly be matched, Wilson Creek's landscape has its own individual charm. The scope is smaller but no less grand. From the upper slopes of Grandfather Mountain's Calloway Peak (5,920 feet), Wilson Creek scrambles down 4,000 feet, creating dramatic waterfalls, sprays and flumes; carving long, deep furrows in widened cracks and polishing neatly rounded potholes; and sanding massive rock edges into smooth planets that seemed to have dropped from outer space to Wilson's 1,020-foot creek bed. In majesty, strength and power, Wilson should have been named a mighty river, not a creek.

After flowing twenty-three miles, Wilson meets Johns River at Colletsville. Taking John's name, both mingle with Catawba River near Morganton after Linville and Catawba meet in Lake James. Tributaries join, too. Through seven North Carolina and four South Carolina lakes, all flow east, where Catawba River takes the name of Wateree River and then Cooper to unite with the Atlantic in Charleston Harbor.

Named for Adam Wilson, who claimed the area in 1775, the region's hardwood forests had attracted logging companies by the early 1900s. Departing Pineola and Linville's depleted forestlands, Ritter Lumber Company moved its logging operations to Wilson Creek in 1904. Mortimer, its logging town, included a sawmill, a store, a church, a school, a blacksmith, a boardinghouse, a lodge and homes for about eight hundred people.

Incorporated by the North Carolina General Assembly on February 6, 1907, the town of Houck was renamed Mortimer, for brothers Bill and Jim Mortimer. Bill was Ritter's storekeeper and the town's first mayor, and Jim was the superintendent of logging operations.

Isolated in a valley between Yellow Buck and Staircase Mountains, where Wilson and Thorps Creeks meet, the growing community attracted loggers and locals, families and merchants. By 1905, Caldwell and Northern Railway (later owned by Carolina and Northwestern Railroad) had extended standard-gauge rail service from Colletsville to Mortimer. Ritter's narrow-gauge logging railroad tracks spurred off the main rail line into the forest. The *Colletsville News* reported on September 8, 1905, that "Ritter Lumber Co. is pushing their narrow-gauge railway on to Edgemont," a secluded community a few miles north of Mortimer. At the end of the railroad line, owners of Edgemont Inn hoped to turn it into a mountain resort, but a wildfire blazing from Grandfather Mountain to Wilson Creek was followed by the famous Flood of 1916, destroying the dreams of many.

Timber, train trestles, buildings and homes were ruined. The *Lenoir News* reported on Tuesday, July 18, 1916, "Lenoir is marooned…railroad bridges and country road bridges…have been swept away…the smaller streams swollen to great rivers by 36 hours of torrential rain at times reaching cloud-burst magnitude…Catawba [rose] 45 feet higher than ever before…This downpour seems to have reached greater proportions in the Johns Creek, Wilson Creek and Mulberry Creek sections."

As rivers crested, residents climbed high riverbanks, watching years of life and hard work wash downstream. "Bridges, houses and hundreds of thousands of pieces of lumber and logs floated by," the newspaper reported. "One man…counted more than 50 stacks of wheat…Several cows and pigs floated by…one hog still alive [was] fished out…Several horses and an automobile passed by bobbing up and down in the mad current."

With Ritter's logging operations swamped and forest resources diminished, the company left Wilson Creek in 1917, selling its property to United Milling Company. When the cotton mill opened in 1922, steady incomes from factory employment reinforced family security. But fires in 1925 spreading south from Upper Creek severely damaged the rebuilt community. Bankruptcy closed the mill in 1928. By the late 1900s, the Forest Service had secured property at Wilson Creek, and the CCC, under the guidance of the Forest Service, brought relief in 1933.

CCC officers occupied Mortimer's Laurel Inn; cooks prepared meals in its kitchen. Corpsmen bunked in cottages left deserted in the old logging village

Certificate of Discharge

from

Civilian Conservation Corps

TO ALL WHOM IT MAY CONCERN:

THIS IS TO CERTIFY THAT *Carl William Crump, CC4-230052 MBER OF THE

CIVILIAN CONSERVATION CORPS, WHO WAS ENROLLED ...Jan 18, 1937... (Date) ... AT

...Charlotte, North Carolina,.... IS HEREBY Honorably DISCHARGED THEREFROM, BY REASON
OF** Acc emp per Par. 28 a, WDR, CCC, 5-15-35, & S.O. # 49, Hdqrs. Co.
Said, CCC, NC SCS-18, Monroe, N. C. dated July 1, 1937.

SAID ...Carl William Crump... WAS BORN IN... Edgemont...,

IN THE STATE OF ...North Carolina,... WHEN ENROLLED HE WAS ...17... YEARS

OF AGE AND BY OCCUPATION A ..Farmer... HE HAD ...Blue... EYES,

...Brown... HAIR, ...Fair... COMPLEXION, AND WAS ...five... FEET

...ten... INCHES IN HEIGHT, HIS COLOR WAS ...White...

GIVEN UNDER MY HAND AT ...Monroe, N.C.,... THIS ...first... DAY

OF ...July..., ONE THOUSAND NINE HUNDRED AND ...thirty-seven...

Fulton D. Berry
(Name) (Title)

C.C.C. Form No. 2
April 5, 1863

FULTON D. BERRY, Captain 534th C. A.
Commanding Company 3416, CCC, NC SCS-18.

*Insert name, as "John J. Doe".
**State reason for discharge.*

CCC discharge certificate. *Courtesy of the graduate's wife, Ethel Crump, and daughter, Frances Walker Crump.*

or in newly constructed barracks. Men rebuilt roads, trails and buildings, including the cotton mill, which later reopened as a hosiery. However, by August 1940, three days of steady rainfall had flooded mountain rivers. Half of Mortimer was gone.

Ethel Crump could record Mortimer's history. She lived it. In March 2014, friends celebrated her 100th birthday. As a little girl, she worked at

Mortimer's Laurel Inn scrubbing floors. When she turned twelve, she and her father walked to work each morning at the cotton mill. At age 2, she survived the Flood of 1916 and, at age 26, the wild Flood of 1940. Her husband, Carl William Crump from Globe, North Carolina, worked in Mortimer's CCC camp.

Ironically, a woman who survived both floods lost her collection of old Mortimer photographs when her basement flooded decades later. No flood, though, could wash away deep-seated memories planted by a lifetime of hard work, perseverance and commitment. From memory at age eighty-five, Mrs. Crump created a circa-1926 map of Mortimer, identifying town buildings. She marked the home of her father, Roy Philyaw, two houses down from Dr. Ship's office beside Ritter's powerhouse. Between Wilson Creek and the railroad, similar cottages, with shared outhouses located behind every other home, lined up in neat little rows. Crossing Wilson Creek beside a swinging bridge, Ritter's logging railroad joined C&N's Railroad at the train depot. Mayor Bill Mortimer tended Ritter's Store across the tracks.

Her exhibit is displayed at Caldwell County's Wilson Creek Visitor Center. Since 2001, the center has preserved Wilson Creek history. Annually, Colletsville Historical Society hosts a "Heritage Day" there. Descendants of Mortimer's CCC camp hold a reunion each fall. Pull up a rocking chair on the front porch and listen. Mrs. Crump's daughter, Frances, may be rocking there with her husband, Roger Walker. Perhaps Glynis James, Mrs. Crump's "adopted" daughter, will be managing the center that day.

The father of Glynis James, retired Flight Officer Lieutenant Joe James, volunteers with the Forest Service to maintain Phillips Branch Trail. As a career NCWRC pilot, Lieutenant James enforced game laws in state and national forests, including Wilson Creek, in his Super Cub 4180Z. For twenty-eight years and fifteen thousand flight hours, requiring replacement engines eight times, he scouted forestlands watching for poachers hunting or fishing out of season or sportsmen spotlighting deer at night. At times, Officer C.W. Smith, who was the first USFS law enforcement officer in Grandfather District, joined him. Search-and-rescue, manhunts and drug enforcement missions also received the lieutenant's aid. Radio communication to a dispatcher reported the location of the incident to ground officers. At retirement on March 17, 1987, the *Newport Observer-Enterprise* quoted the local sheriff: "[Lieutenant James] is decisive in his maneuvers, traits of a true bush pilot…he can spot wading tracks in streams at 1000 feet."

Pisgah owns about 5,000 acres of the nearly 7,500 acres surrounding Wilson Creek, flowing nine miles of its twenty-three-mile length through its

forests. In 2000, when Wilson Creek was designated one of the nation's "Wild and Scenic Rivers," Forest Service officials developed a new comprehensive management plan. In a partnership with Caldwell County and its visitor center and the public's input, the USFS designed a plan to protect Wilson's resources and accommodate its diverse recreational use.

Learn the region's history at the visitor center and then sit under a blooming silverbell tree in May, framing a picnic table with its gentle, arching branches. Leafing out after a winter's rest, a tall poplar tree tosses its young fox-head leaflets into the breezes, searching for new energy from the springtime sun. Overhead, a Parula warbler, or "zipper-bird," zips his buzzy song up a musical scale to an abrupt stop. Male black-throated green warblers, hooded warblers and yellowthroats, recently returned from warm southern winters, serenade from forest edges, flirting for a female friend. Other creatures choose Wilson, too. Lizards thrive in Wilson's rugged, cracked rocks and dry forest floors. Fourteen species of reptiles live here; some are unfamiliar, like the southeastern crowned snake (*Tantilla coronate*).

Grab a map and bottle of water. A trail guidebook helps, too. Trails trace historic railway tracks, logging roads and well-trodden paths. On an old logging road near Wilson Creek, the Mountains-to-Sea Trail passes through on its way from Clingmans Dome in Great Smoky Mountains National Park to Nags Head on the coast. Hike to Lost Cliffs, Big Cliffs and smaller ones. From Little Lost Cove Cliffs, see Grandfather Mountain, the Blue Ridge Parkway, Hawksbill at Linville Gorge and a 360-degree, panoramic view of Pisgah National Forest.

Some trails circle into others. Loop the loops or visit for a while and backtrack. See something new on the return trip. Take a long creek-side trail or rise above to follow Wilson's rugged ridge. Most trailheads are marked, but trails are rarely blazed. Don't forget the map.

The waterfalls of Wilson Creek area are some of the most impressive in the state—falls that slide and drop, twist and tumble or take a dramatic plunge. Plunge basins may be a deep emerald-green pool or just a retainer to hold water until it prepares for its second artistic escape. South Harper Creek Falls create a gorgeous, two-hundred-foot cascade. View Harper Creek Falls and its North and South cousins. Loop them all. Huntfish Falls shouldn't be missed either. Find a flat slab. Feel the water's power. Does it sound like thunder, a gurgle, a heavy storm or a washing machine? Wildflowers adorn trails in spring and summer, leaf colors enhance the forest by fall and waterfalls may crystallize come winter. Harper Creek and Lost Cove areas are designated wilderness study areas.

Hopscotch flat rocks, dip into deep pools or wade for the sheer fun of it, staying aware of slippery surfaces. Find a boulder chiseled into a cradle; take a nap in the arms of Grandfather. Turn a stone, find a salamander and roll it back. Creatures invisible to the human eye may live there, too. Massive boulders squeeze waters into narrow passageways, providing thrilling rides for experienced kayakers. Rocky bleachers provide grandstand views. Or find your own space, get a permit and drop a line and sinker. Wilson Creek and the tributary Thorps Creek offer great trout fishing.

Pitch a tent at Mortimer or Boone Fork Campground. Like other USFS lakes, an annual Kid's Trout Fishing Day is held here. One lazy fishing day at Boone Fork, a dad said that a foot-long trout swam parallel to the shoreline beneath his feet. Dropping his pole, he scooped the whopper up with "my two bare hands!" He added, "The Forest Service does a good job. It's a well-stocked lake!"

Monroe Coffey was the first district ranger at the Wilson Creek Ranger Station (seen here) at Edgemont, North Carolina. *Courtesy of Wayne Beane.*

Mortimer offers a central camping location for a variety of outdoor activities. Hiking trails are nearby. An equestrian trail, Thorps Creek Trail, departs from the campground. The Watauga Turnpike (FS-45) invites mountain bikers. Read Mortimer's past history in its landscape and remaining foundations. Beside the flagpole at the campground, a large white building that once served the CCC is now a USFS work center. Primitive rock-work borders streams and terraces the picnic area. Beside Brown Mountain Beach Road, former textile mill walls rise near a popular swimming hole. Sunbathe on a large rock beside Caldwell and Northern Railroad's concrete pillar. USFS Flash Flood signs warn visitors of sudden rising waters. A flash flood at Mortimer in 2012 closed twelve campsites.

"Monroe Coffey, the well-known Forest Ranger for 28 years of the Grandfather District...has retired," began a 1945 *Lenoir News-Topic* article. Born near Grandfather Mountain, Ranger Coffey, stationed at Edgemont as Wilson Creek's first district ranger, accepted the position in 1917. Replanting trees destroyed near Rockhouse Creek in the Flood of 1916, building roads and trails, placing telephone lines and managing wildfires were Coffey's major accomplishments. Hand-raising fawns

Coffey's General Store, Edgemont, North Carolina. *Illustrated by Lucille S. Morgan.*

transported to the area, Coffey restocked Wilson's wildlife. Two elk raised in a pen on Rockhouse Creek above the old Rainbow Girls Camp did not survive in Grandfather's forests. In Coffey's store, Archie Coffey displayed their antlers above his stove.

Leave Mortimer and take a scenic drive toward Edgemont. See the renovated train depot and Coffey's store. Take FS-464 from Edgemont toward Harper Creek and Lost Cove Cliffs. Drive through the land of dramatic waterfalls. Travel one-lane bridge to one-lane bridge from Globe to Gragg. Continue northward toward Grandfather Mountain, passing roadside waterfalls and rapids. Envy the landowner with his personal majestic waterfall behind his home. Beside the road, look for the old quarry site that supplied rocks to build the Blue Ridge Parkway. Grandfather Mountain rises on the horizon. Linn Cove Viaduct girdles it like a loose belt. Fall foliage drives along this route are spectacular. The Forest Service road intersects with the former Yonahlassee Road, now US-221.

"Lights! Camera! Action!" director Michael Mann might have said, filming part of *The Last of the Mohicans* at Linville Gorge. But cameras cannot capture the unpredictable, erratic and fleeting action of the Brown Mountain Lights. Flickering lights mysteriously rise from its crest. Descriptions vary. Since 1913, U.S. Geological Society research studies have not conclusively determined their origin. Are they Indian maidens searching for Cherokee braves lost in a battle with Catawba Indians on Brown Mountain? Is it a slave looking for his lost master? Do the lights reflect railroad and automobile lights, phosphorescence emitted during organic decay or natural chemical discharges? Is moonlight setting airborne water droplets aglow? Are they ghostly lanterns from the old Brown Mountain Fire Tower? One clear night, you can decide for yourself. Brown Mountain Overlook on NC-181, Wisemans View at Linville Gorge, Blue Ridge Parkway Milepost #310 and Lost Cove Cliffs offer the best options for the "lights."

Capturing the action on camera is nearly impossible at Pisgah's only ATV (all-terrain vehicle) and mountain bike course. The rutty, nonstop, roller-coaster, bumpy thrills require mental and physical focus. Cameras would only get in the way. For a five-buck permit, riders navigate thirty-four miles of ATV trails ranging from easy to very challenging. Ignited by lightning, a five-hundred-acre wildfire closed the course for a week in April 2014.

Rock-hop three times, wade once and then switchback twice, a guidebook instructs. Circle trails in and out or stroll a gentle path. Ascend steep ridges; take a break. Listen. Hear a migrating warbler or a courting mate? See a soaring raptor, a colorful wildflower or quartz streaking through gray rock? Get wet, but be smart. Find a quiet pool, a shallow rocky edge or a soft sandy beach. Experience waterfalls. Relive history. But take warning! One can't know Wilson in a day. Plan to come back.

CATAWBA FALLS

Pisgah owned Catawba Falls and one thousand surrounding acres for a number of years before public access was obtained. Like the philosophical adage says, "When a tree falls in the forest, does it make a sound?"—was Catawba Falls still as gorgeous unseen? Over the steep, rugged Blue Ridge Escarpment, Catawba Falls dropped more than 150 feet from its upper fall's plummet to its tumbling, lower cascades. Without Foothills Conservancy's help, Catawba Falls could be performing its dramatic descent without a captive audience.

From 1914 until his death in 1957, Colonel Daniel Adams—conservationist, civil engineer and former Forest Service agent—owned Catawba Falls and 3,500 surrounding acres near Old Fort. In about 1916, Adams built a dam on Jarrett's Creek, supplied running water to Old Fort and founded his company, Pure Mountain Water. Fond of water fountains, he built four in the area; one remains intact in the town today. Harnessing its powerful energy, Adams dammed Catawba River in 1924, built a power plant and supplied the town with electricity. Native Carter Hudgins, interviewed in 1986 for the *McDowell News*, praised the colonel's diverse interests. As a teenager, Hudgins helped Adams build the Catawba River dam, "camping up near the falls…I hope they can get the Forest Service to buy that land up there," he said. "It would be a fitting monument to a man who cared so much for this area."

By 1989, Catawba Falls had become part of Pisgah National Forest. Descendants of Colonel Adams sold 1,031 acres to the Trust for Public Lands (TPL). Established in 1973 to aid conservation projects, TPL helped negotiate land acquisition between landowners and the federal government. Although discussions had started four years earlier, and monies from the Land and Water Conservation Fund (LWCF) had been designated to purchase Catawba, government leaders rechanneled those dollars for forest

fire management. Congressional outrage fueled by staunch supporters, such as North Carolina's Congressman James McClure Clark, pressured President George H.W. Bush. In March 1989, Bush reversed Congress's diverted decision. Catawba Falls was secured. By September, money from LWCF had enabled the Forest Service to acquire the Adams property from TPL. The colonel's daughter, Mary Virginia "Binkie" Adams, stated, "This scenic attraction has been in our family for the past seventy-five years. We… are glad to see that the property will be preserved in its natural state for the benefit of all posterity."

Proposed by President John F. Kennedy and passed by Congress in 1964, the LWCF was created to provide funds to expand national parks and forests and to protect those areas for recreational use. Their funds were generated through the sale of "golden eagle" windshield stickers, fees for recreational areas, taxes on motorboat fuel and sales of surplus federal property. When those measures did not provide the money needed to meet its goals, the agency was granted the revenue earned through offshore drilling leases. Since 1965, nearly $100 million has been appropriated annually for environmental projects in more than thirty-four states. Budget drought years in 1982 and 1996–99 granted no help. Through fiscal year 2006, $3.6 billion has been approved for more than forty thousand projects.

Although Catawba Falls belonged to Pisgah, public access remained uncertain. By 2005, Foothills Conservancy of North Carolina had secured loans and a $124,000 private gift to acquire sixty-five acres adjoining USFS lands. This represents one way that Foothills, a regional land trust, works to permanently conserve land. Foothills purchases property and then transfers it to a public agency, such as the U.S. Forest Service, when government funds are acquired. In 2007, a private lender helped Foothills purchase twenty-three more adjacent acres, providing trail and parking access to the falls. In order for Foothills to be able to transfer the land to Pisgah, government action became urgent. Persistent pleas from Congressmen Heath Shuler and David Price prompted Congress to sign House Report #1002, the "Pisgah National Forest Boundary Adjustment Act of 2009," authorizing the Forest Service to "alter the boundaries…to give better access to Catawba Falls." Congress appropriated $713,000 through the LWCF to purchase the land from Foothills Conservancy, representing the first funds granted through this program to North Carolina projects since 2002.

In 2010, officials unveiled a plaque honoring Colonel Adams, to be placed at the Catawba Falls trailhead. By 2012, the USFS had constructed a new parking lot, exhibits, restrooms and the trail system. "Ten More Acres to

Hike," proclaimed the *Asheville Citizen-Times* on November 14, 2013, in green, bold-faced letters. Foothills Conservancy, once again, saved ten more acres adjoining the Catawba Falls area until the USFS received $105,200 LWCF dollars to purchase it. "Is Catawba Falls still gorgeous, if it goes unseen?" Ponder no more! But stay tuned. As this book goes to print in 2014, the Land and Water Conservation Fund expires. Will Congress reinstate the program?

Hike to Catawba Falls. Follow Native American footsteps. Cherokee and Catawba Indians fought to own the headwaters of Catawba. An eventual truce gave Catawba Indians the lands east of Catawba River. Cherokees received the lands west of Broad River, rising south of Black Mountain, North Carolina, to flow southeast. Lands between Broad and Catawba Rivers provided mutual Indian hunting grounds.

On a rock pedestal, a tribute to Colonel Adams marks the Catawba Falls trailhead. Cross the river and pass a stone power plant, remains of the hydroelectric dam and foundations of a second powerhouse on the right. A quarter-mile wooden pipe framed by iron hoops funneled Catawba's waters from the dam to the lower building to generate electricity.

Wildflowers flourish in season. A rare little beauty, lost for one hundred years, was rediscovered on the banks of Catawba River. Shortia or Oconee Bells (*Shortia galactifolia*) was first discovered in North Carolina mountains

Colonel Daniel Adams sits on the dam he built near Catawba Falls in 1924. *Courtesy of Bill Nichols, Old Fort, North Carolina.*

"SWANNANOA CREEK"

By John Buckner, retired area personnel executive with Burlington Industries. Mr. Buckner grew up hiking in Black Mountain and has hiked extensively throughout Pisgah National Forest and completed the nine hundred miles of trails in Great Smoky Mountains National Park at age seventy-four. As chairman of the Swannanoa Valley Museum hiking committee, he organizes and leads museum-sponsored hikes.

The hiker walking through Swannanoa Gap at Ridgecrest eastward along Swannanoa Creek will travel through history.

Indians traversed the Gap when following the nearby Suwali-Nunnehiehi trading path, which ran east down the Catawba. In 1776, forces of General Griffith Rutherford, 2,400 men bent on annihilating the Cherokee, used this route. The first white settler, Samual Davidson, also went this way in his homesteading attempt on Christian Creek. After his death at the hands of Indians, his family sought safety at Davidsons Fort, escaping through Swannanoa Gap. Davidson's avengers returned this way.

Then came the stage coach line in 1820. Legendary stage driver John Pence was immortalized by writer Christian Reid in her novel, written in the 1870s. Her stage ascending Swannanoa Creek to the Gap, she described the scene as "The Land of the Sky." Hence her book title. The name stuck!

The Civil War battle of Swannanoa Gap was a thwarted Union attempt to traverse the Creek. Felling trees, Confederate forces blocked the narrow gorge, giving their snipers easy advantage. A grave in the Gorge marked only "US SOLDIER" leads to speculation as to its occupant. Was this a result of the battle or a later escape attempt by Confederate prisoners being returned to the Army of Virginia?

Then came the railroad. In its construction, over one hundred convict laborers sacrificed lives from landslides and accidents. On March 11, 1879, Governor Zebulon Vance was wired "daylight entered Buncombe County today" (through Swannanoa Tunnel). Replaced by railroad, the stage coach era passed.

Today, the hiker will follow remnants of the old coach road and see railroad debris washed down from the rail line above. Evidence of homesteads, notably of the Richard Allison family, remain. Travelers will find the passage rough, mostly deserted, intriguing, mysterious and beautiful.

in 1788 by French botanist André Michaux, who preserved his specimen in a Paris herbarium. Forgotten for fifty years, American botanist Asa Gray rediscovered it during botanical research. The unidentified plant was named in honor of Gray's botanist friend Dr. Charles Short. In 1841 and again in 1843, Asa Gray followed Michaux's journal accounts, retracing his North Carolina excursions, but failed to locate Shortia. Agonizing over the loss, botanists offered rewards to anyone finding it. Beneath dense rhododendron on shady banks of Catawba River, seventeen-year-old George Hyams, a son of an herbalist in Statesville, North Carolina, found Shortia in May 1877. The variety of Shortia that grows near Catawba grows nowhere else in the world.

Catawba Falls Trail ends at the base of Lower Falls. A difficult hand-over-foot climb leads to the Upper one. An 1888 explorer wrote, "The climb to the latter [Upper Falls] is like trying to walk up a wall. For two hundred yards or more, we had to hold onto trees and bushes every step lest we fall and know no more."

Hunting, fishing and hiking are popular activities, but cycling isn't permitted on Catawba Falls Trail. Nearby, the paved, four-mile Point Lookout Trail and five-mile Kitsuma/Youngs Ridge Trail do. Combine both of these trails for a tough climb from Old Fort's Picnic Area to Ridgecrest and return via Point Lookout Trail in a smooth coast back to the car. Hikers are invited, too. In the fall, the colorful views into Royal Gorge are spectacular. Formerly Old US-70, Point Lookout greenway traces an early east–west route through the Blue Ridge Mountains to Point Lookout, a popular tourist attraction. Southern Railway's seven tunnels, carved by convict labor, cut through a three-mile Blue Ridge rock wall nearby. Between 1877 and 1879, eastbound met westbound convicts under Swannanoa Mountain 1,800 feet later, sculpting its longest tunnel.

In November 2012, a reporter wrote, "What exactly happened in these woods we might never know. But musings over its pioneer mysteries and Civil War history along Swannanoa Creek in this part of Pisgah National Forest is great fodder for a late fall hike." From Ridgecrest to Old Fort's Picnic Ground, Swannanoa Valley Museum's guided walk leads hikers along the historic stagecoach route. John Buckner, the guide, describes railroad, settlement and Civil War history. "I wonder," Mr. Buckner said, "why this never became a major hiking trail."

CURTIS CREEK

In 1975, Grandfather District ranger Jack Kennedy promoted a new self-guided, twelve-mile auto tour from Old Fort to the Blue Ridge Parkway through the Curtis Creek area—the first USFS tract purchased in the East. Designed to demonstrate "what a well-managed forest looks like… and to show how the Forest Service coordinates both wildlife and timber management," twelve markers along the route coordinated with numbered explanations in a brochure.

An open field at marker no. 1, purchased with LWCF aid, was maintained as a wildlife opening for turkey, grouse, deer and other animals. Since 1932, Forest Service leaders had coordinated wildlife programs with the North Carolina Game Lands officials, who had restocked the area with turkey. Curtis Creek's mixed hardwood forests, scattered stands of pine trees and open clearings created perfect turkey and deer habitat. Within the next mile, motorists passed Mount Mitchell Bear Sanctuary. Established in 1971 by the Forest Service and wildlife commission, twenty-five thousand rugged acres were reserved for black bears. Clear streams were stocked with trout. Marker no. 4 noted a rough-fish barrier built across Curtis Creek, preventing migratory bass, sunfish and suckers from competing with trout for food and cover.

Dedicated to Dr. Chase Ambler, an Asheville physician who campaigned for protection of local forests, a large exhibit now replaces the marker at the site of Pisgah's first purchase. Two stone posts (constructed by the CCC) that originally framed the entrance to Pisgah National Forest marked stop no. 5. Other stops demonstrated thinning programs, even-aged timber stands and forests in different stages of regeneration A half-mile self-guided nature trail, created by North Carolina State University's Extension Forest Resources Department, demonstrated timber and wildlife management practices. Above Buck Creek and Sugar Cove, the day's tour ended at a scenic overlook. Woods Mountain guarded the horizon.

Although roadside markers and descriptive brochures are gone, Curtis Creek Road (FR-482) now invites not only motorists but also mountain bikers, hikers, horseback riders and hunters. Anglers fish for trout in clear, cool mountain streams. Hike Snooks Nose Trail to Green Knob Overlook and Fire Tower on the Blue Ridge Parkway. See twenty-foot Hickory Branch Falls near Curtis Creek Campground. After reviewing a trail map, consider a remote, strenuous hike crossing Mackey Mountain.

Consider putting down stakes at Curtis Creek Campground. Hosts answer questions about local history. Although moss and leaf litter cloak its surface,

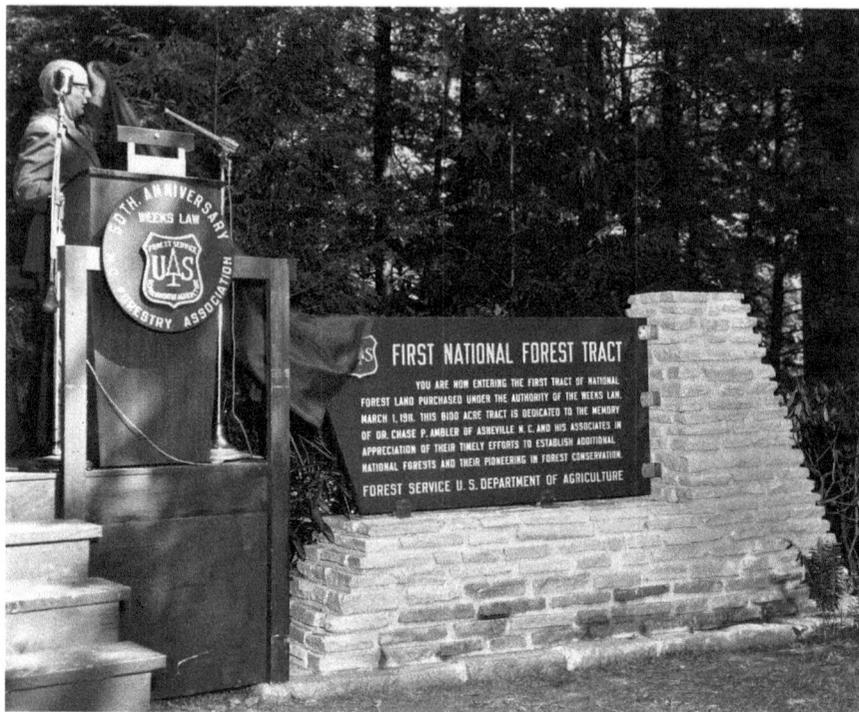

On the fiftieth anniversary of the Weeks Act, regional forester James K. Vessey unveiled the Pisgah National Forest Monument at Curtis Creek, commemorating the first tract of land purchased under that law. *Mountain Gateway Museum, Old Fort, North Carolina.*

wildflowers trim its edges and a lone yellow birch claims space in its cracked center, a concrete shower platform used by CCC Camp Jim Staton remains visible. Near the banks of Curtis Creek, where waters tempt children to wade, catch crawdads and throw rocks, the eight-foot wide, T-shaped shower platform retains concave indentions in its raised border that drained a day's worth of sweat, grime and grit cleaned away by a soothing shower. On the west side of Curtis Creek Road, near the bridge at the campground, a monument honors the work of the men of the CCC. In 2008, CCC enrollees gathered to celebrate their seventy-fifth anniversary.

In a tall, wooded bank behind the monument, a stacked-rock, six-foot-high CCC building may hold secrets. Rocks and dirt excavated from the hillside tucked the square building into its semi-subterranean cave. Someone thought it was an old toolshed. Could it have been a root cellar? Is it large enough? A square concrete roof holds embedded one-inch-diameter iron pipes opening over opposite sides. Was the surface covered with rocks or sod, and did the

pipes provide drainage? To prevent freezing in winter and spoiling in summer, what vegetables could have been stored here? Potatoes? Squash? Salted meat? Another rectangular cement pad nearby is guarded by poison ivy.

After driving Curtis Creek Road to the Blue Ridge Parkway, turn north to exit at Buck Creek Road (NC-80). From a large parking area, Woods Mountain Trail crosses a narrow spine to the former site of the USFS Woods Mountain Fire Tower. From the trail, long-distance views of Grandfather District's landscape are highlighted by Tablerock and Hawksbill Mountains in Linville Gorge, Grandfather Mountain and Mount Mitchell. For a thrilling adventure, access the sixteen-mile mountain bike and equestrian Woods Mountain Trail from US-221.

Drive scenic Buck Creek Road. On the right, take Sugar Cove Road to a USFS historic area. Now concealed by kudzu and thick undergrowth, Camp McCloskey first housed CCC enrollees here and, later, World War II conscientious objectors. Bushwhackers might be able to locate rock foundations, concrete pads and other camp relics that are defying nature's elements—symbolic proof of the resilient men who worked here. A Forest Service gate blocks unmaintained Sugar Cove Road, which led to Curtis Creek Road near the Mackay Mountain trailhead. Locals report that Buck Creek enrollees traveled up Sugar Cove to build the Blue Ridge Parkway. Drive back to Buck Creek Road, turn right and pass beautiful Lake Tahoma and its old rock casino before reaching US-70.

Although the original USFS conservation plans for national forests were to restore woodlands, manage timber and protect watersheds, the 1975 *Curtis Creek Pisgah National Forest* brochure emphasized, "Today, these National Forests are managed for such multiple benefits: timber, wildlife, natural beauty, pure water and environmental research—all based on nature's requirements as well as current needs of the American people." Nearly forty years later, Pisgah perpetuates that philosophy.

On Easter Sunday, April 20, 2014, a family drove eastbound on I-40 to Exit 90 at Nebo. The Grandfather Ranger Station was located nearby. Beside the wide parking lot, shoveled dirt, draped tarps and newly graveled walkways promised a future nature trail. Offices, however, were closed. Yet something moved. It was just a quick glimpse, but certainly not imagined. There it goes again! "Did you see that?" a little girl whispered.

"I think so. What was it?" a grandmother whispered back.

"Shhh! There it goes again! And another one!" she said, even quieter this time. No bigger than a ping-pong ball, a fuzzy tan blur, camouflaged in a bright morning glare against bare earth and pale grass, rolled across Grandfather's front yard. A vocal, protective parent swooped overhead before landing hard on soft turf close by.

"Its wings are broken!" the girl feared. "It's hurt!"

There, within yards of I-40 on the front lawn of Grandfather Ranger District's home, a killdeer performed one of nature's enchanting displays. Feigning a broken wing and screeching a painful plea, it diverted the attention of hungry predators or just the intrigued innocent. Tiny killdeer babies scurried out of harm's way.

Yes, Grandfather is rich. Even a ranger station facing busy traffic is rich. Come see. Grandfather is eager to share its wealth.

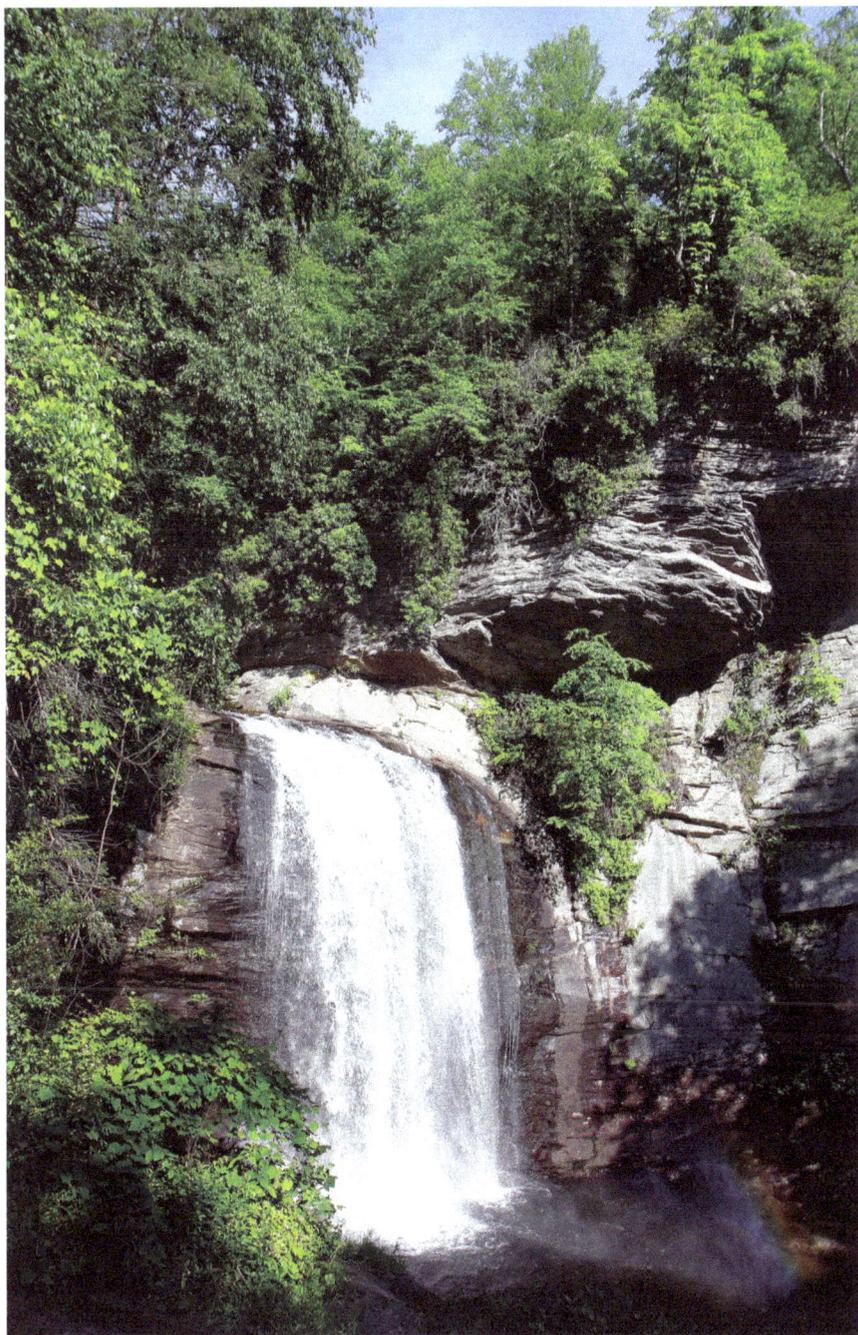

Easily accessed along the Forest Heritage Scenic Byway, Looking Glass Falls, plunging eighty-five vertical feet over its rocky edge, is one of the most photographed waterfalls in the Pisgah Ranger District. Before George Vanderbilt bought the property in the 1890s, Alanson and Sarah Tinsley settled here in about 1870. Their children bathed in the pool at the base of the falls. A rainbow at the base of the falls was captured in this image. *Photo by the author.*

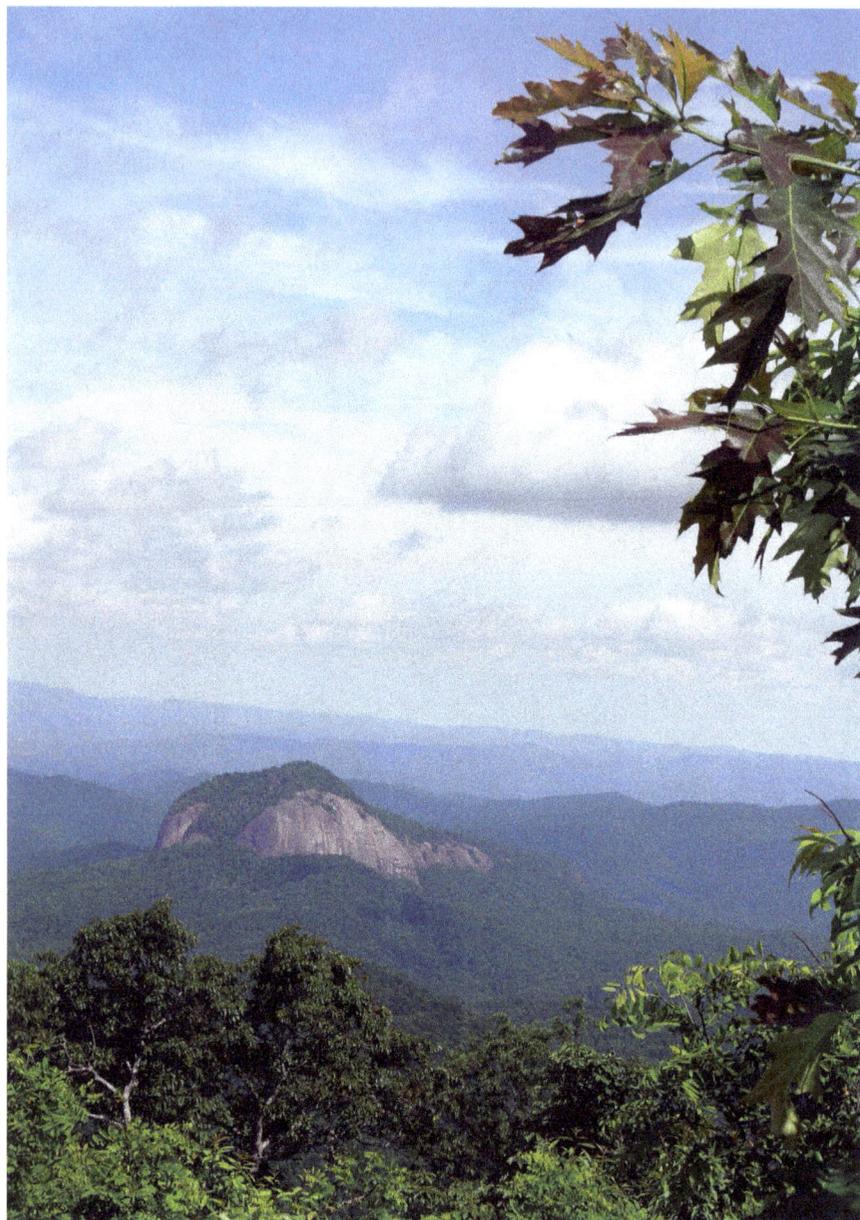

Excellent views of Looking Glass Rock (3,969 feet), rising above the forested coves and ridges of the Pisgah Ranger District, can be seen from the Blue Ridge Parkway at Milepost #417. Viewed through binoculars (but unseen in this photo) are two rock climbers ascending the sheer rock face of its Whiteside granite. *Photo by the author.*

Opposite, top: Mount Pisgah above Hominy Valley. *Painted by Mary Mabel Israel and provided by her son, Dr. Ken Israel.*

Opposite, center: Mickell Perfili and Chase Ferguson of Charlotte visited Pisgah Ranger District for Chase's birthday weekend to experience the local swimming holes. On May 24, 2014, the pair took the first plunge down Sliding Rock after it opened for the season. *Photo by the author.*

Oppoiste, bottom: A group hikes over Black Balsam Knob, the highest mountain in the Pisgah Ranger District, on their way to Shining Rock Wilderness. The Blue Ridge Parkway can be seen in the distance. *Photo by Bill Lea.*

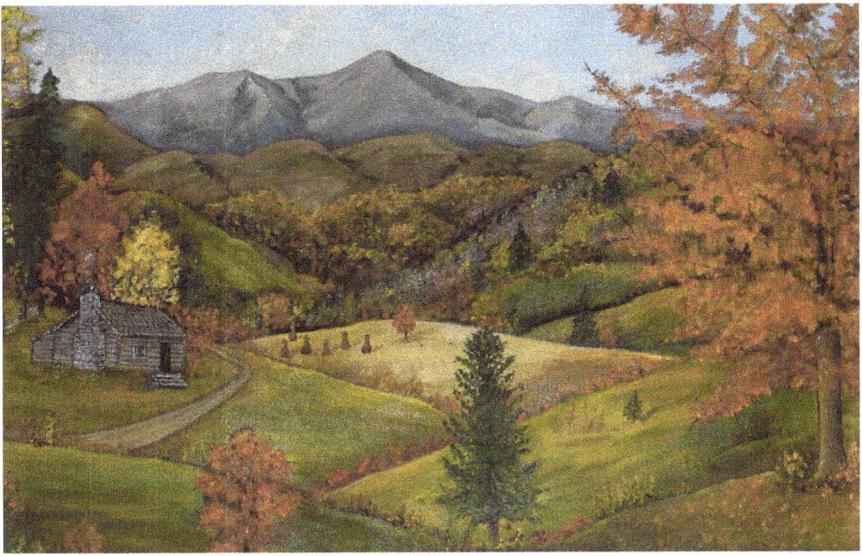
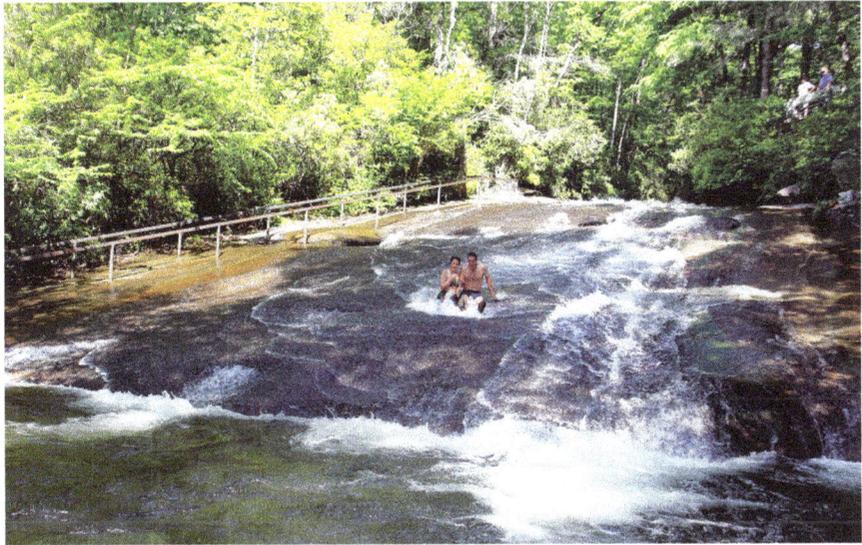
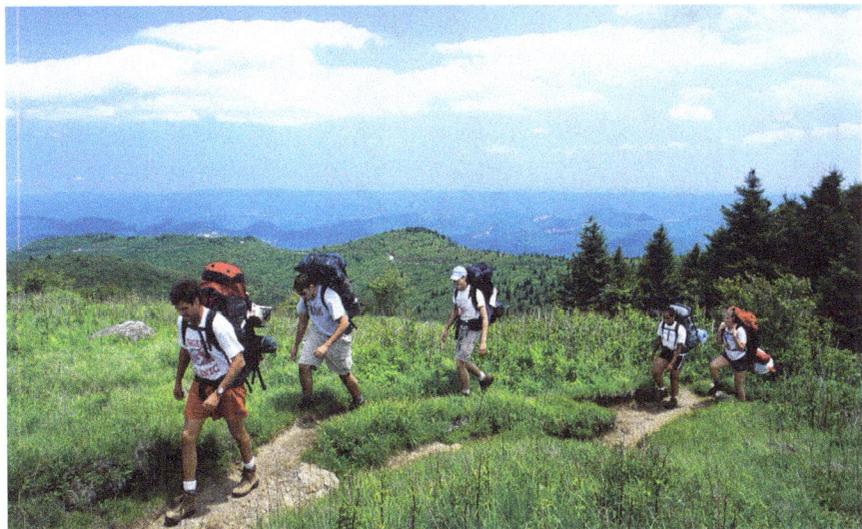

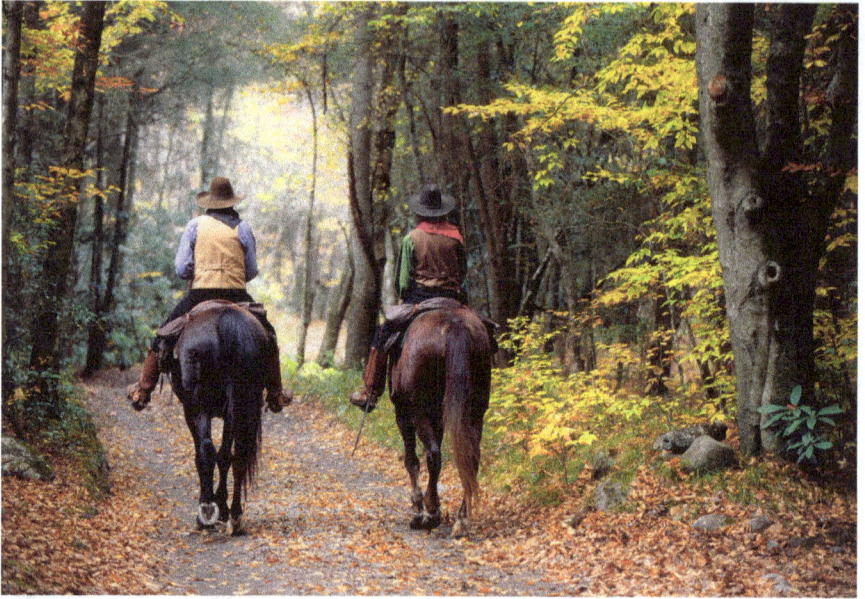

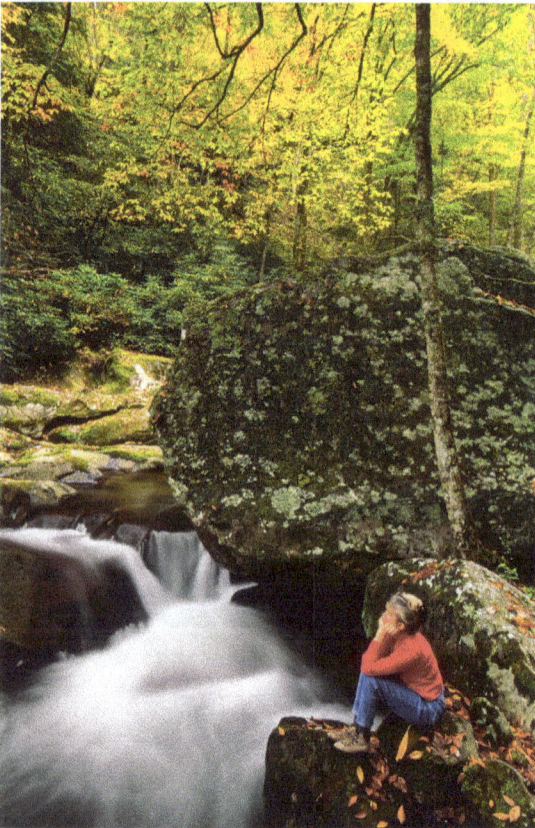

Above: All three of Pisgah National Forest's ranger districts offer excellent equestrian trails. *Photo by Bill Lea.*

Left: Pisgah Ranger District near Brevard has been called the "Land of the Waterfalls," but many spectacular waterfalls can also found in the Wilson Creek area of the Grandfather Ranger District. *Photo by Bill Lea.*

Above: Pisgah National Forest offers many family campground options, as well as primitive and group camping areas. *Photo by Bill Lea.*

Right: Local Boone climber Eric Hiegl ascends the remote Little Lost Cove Cliffs in Grandfather Ranger District, which affords incredible views over the canopy of trees all the way to Grandfather Mountain. *Photo by Lynn Willis.*

A family canoes on a quiet waterway. The creeks and rivers of Pisgah National Forest offer numerous swimming holes and sections for canoeing, kayaking, rafting and stand-up paddle boarding. *Photo by Lynn Willis.*

Boone-based photographer Lynn Willis takes a self-portrait while sitting on top of Hawksbill Mountain in Linville Gorge. Linville River is barely visible. The Gold Coast Cliffs highlight the West Rim. The Black Mountain Range rises in the distance. *www.LynnWillis.com.*

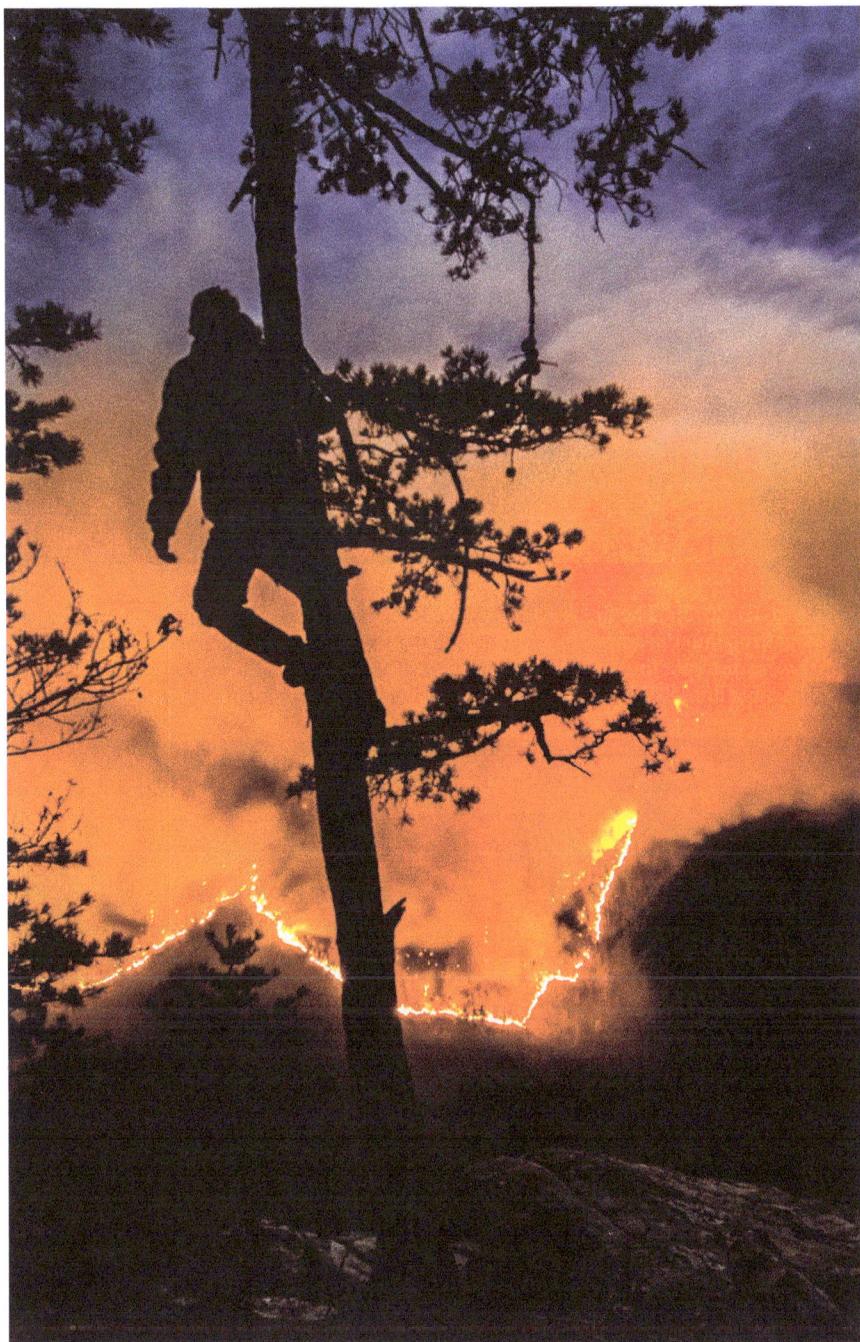

A prominent Linville Gorge rock climber gazes at the destructive yet mesmerizing November 2013 Tablerock Mountain fire from the West Rim of Linville Gorge. *Photo by Lynn Willis.*

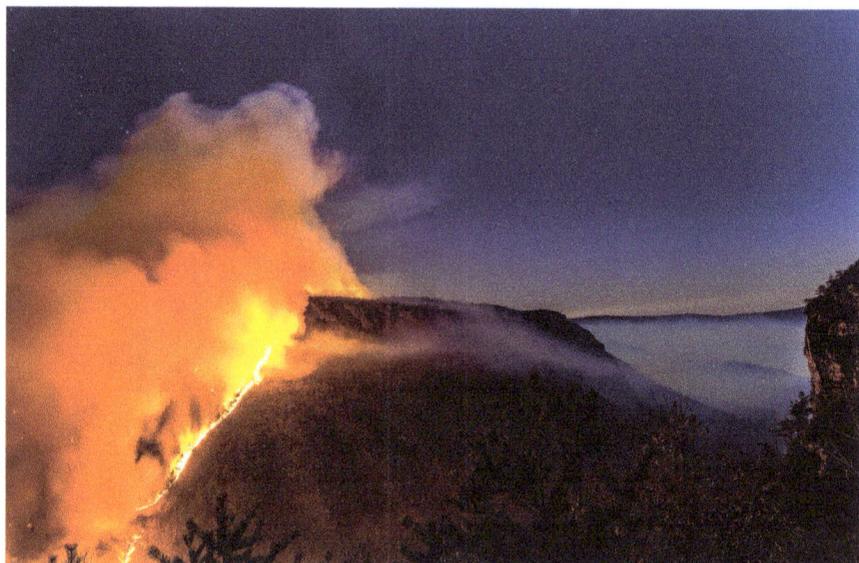

November 13, 2013: "The fire was from Table Rock and south to the Chimneys on the ridge and deep into the gorge, but not down to the river," wrote photographer Lynn Willis. "There were also spot fires in the Northern part of the gorge near lower Spence Ridge Trail. It's a big fire…Many thanks to those working hard to put it out." *Photo by Lynn Willis.*

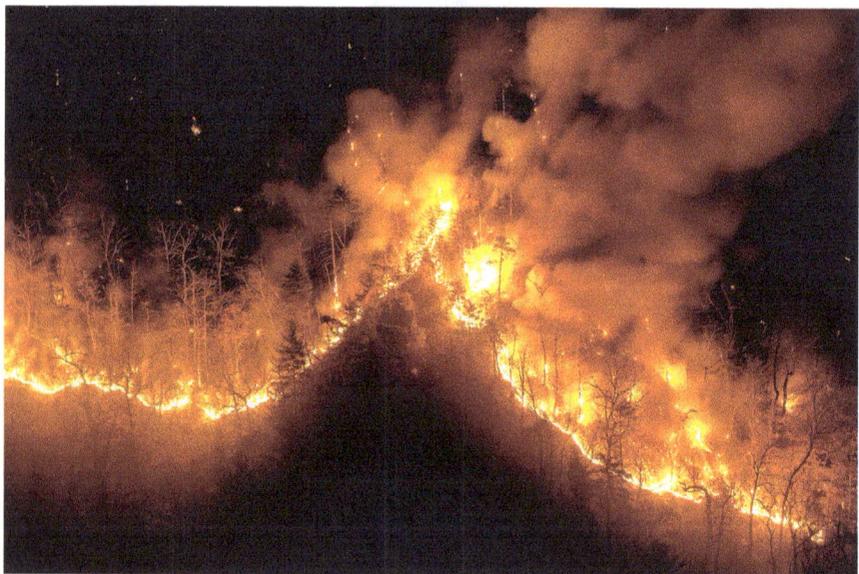

Lynn Willis: "I went out…in chilly conditions and photographed the fire from the end of the Rock Jock Trail on the West Rim…the sounds were crazy with falling trees and two large rock falls. Somewhere up in the blaze cliffs were tumbling down into the gorge… The winds were constantly changing directions…making the smoke do some amazing formations." *Photo by Lynn Willis.*

Matt Powell enjoys the sunset from atop the Chimneys after a day hike in Linville Gorge. Tablerock Mountain is in the distance. *Photo by Lynn Willis.*

Jim Toomey pops some air while riding the Raspberry Trail, which starts along the Tablerock Road and drops down into Pisgah National Forest. *Photo by Lynn Willis.*

Nicole Hiegl worked hard to reach the high ramparts of the Appalachian Trail on Hump Mountain of the Highlands of Roan, Appalachian Ranger District. *Photo by Lynn Willis.*

Right: Mike Flannigan snowshoes through the coniferous forest of Roan Mountain on a chilly and clear winter day. *Photo by Lynn Willis.*

Below: Pete Pickering drops into "hydro" rapids deep in a river gorge. For experienced boaters, white-water rapids offer thrills in Pisgah National Forest on such waterways as the French Broad River, Wilson Creek and the Nolichucky. *Photo by Lynn Willis.*

American black bear (*Ursus ameicanus*). *Photo by Brooke Lyda.*

Yellow-fringed orchid (*Platanthera ciliaris*). *Photo by Scott Dean.*

Shortia, or Oconee Bells (*Shortia galacifolia*). *Photo by Scott Dean.*

The soul is quieted by a walk in the woods on a misty day. So is the forest itself—except, perhaps, for the lone, penetrating serenade of a wood thrush. *Photo by Bill Lea.*

White-tailed deer (*Odocoileus virginianus*). *Photo by the author.*

A couple departs the Barnard River Access on the French Broad River in the Appalachian Ranger District to spend a quiet afternoon paddling to Stackhouse. *Photo by the author.*

Flame azaleas are blooming on Roan Mountain in June 2014 in the Appalachian Ranger District. *Photo by Brooke Lyda.*

Anglers enjoy many rivers and streams throughout Pisgah National Forest. *Photo by Bill Lea.*

A fisherman drops a line in Wilson Creek in the Grandfather Ranger District. *Photo by the author.*

Chapter 7

APPALACHIAN
RANGER DISTRICT

The Appalachian Ranger District has some impressive neighbors. Hugging the Tennessee state line and Cherokee National Forest, the district stretches south to join Great Smoky Mountains National Park. Once part of Unaka National Forest, established in 1920, the Appalachian highlands joined Pisgah in 1936; the rest of Unaka was divided between Cherokee and Jefferson National Forests. Formerly called the French Broad River District, Pisgah's highlands are sliced by the French Broad River.

Also included in this district is an area once known as the Toecane Ranger District, which lies west of the Blue Ridge Parkway bordering Craggy Gardens and Mount Mitchell State Park. The region encircles the South Toe and Cane Rivers. North and South Toe Rivers join the Cane River to become the Nolichucky. The French Broad River receives the bounty of these spectacular rivers farther north. Also in this district, straddling both states, are the open balds of magnificent Roan Mountain. The former Toecane and French Broad Districts have now combined to form the Appalachian Ranger District.

The remote highlands of the Appalachian District provide miles of personal space to hear birdsongs, red squirrel chatter, falling leaves or pure silence. Open balds and rocky outcrops grant long-range views farther than the human eye can focus. A solitary stroll along a mountain trail lulls a mind into self-absorbed reflection, gazing one boot step ahead until a chipmunk crosses, his tail held erect like an antenna on a remote-control car, returning

thoughts to place. A lazy float or whitewater thrill offers an Appalachian experience from a river's perspective, while the district's human and natural history pacify inquisitive minds.

HOT SPRINGS/APPALACHIAN TRAIL/FRENCH BROAD AND NOLICHUCKY RIVERS

The Appalachian Trail (A.T.), a national scenic trail that traces the Appalachian Mountains from Georgia to Maine for more than 2,100 miles, crosses the highlands of Pisgah in this ranger district. A tour across Pisgah's portion of the A.T. presents an ideal opportunity to become acquainted with the district's history. With the A.T. intersecting Forest Service roads, state highways and downtown Hot Springs, the route offers easy access to day-hikers. Seven trail shelters (four built by the CCC) provide overnight options for backpackers. Guided by two- by six-inch white blazes, nearly 1,800 thru-hikers, attempting to hike the entire A.T. in one season, will pass through the district each year; about 500 are usually successful. Each year, in one of fourteen states, more than 2 million people visit the A.T.

After leaving Great Smoky Mountains National Park at Davenport Gap and crossing the Pigeon River on a concrete highway bridge (Waterville Exit 451 on I-40), the Appalachian Trail heads toward Pisgah. To cross the Pigeon River in 1948, the first thru-hiker, Earl Shaffer, bounced one ungraceful step after another across a swinging bridge. Shaffer also hiked the first A.T. southbound thru-hike in the 1960s and hiked his fiftieth anniversary trip at the age of seventy-nine.

Twenty-seven years before Shaffer's thru-hike, Benton MacKaye's journal article proposing an Appalachian Trail generated much interest. Within a year, outdoor clubs had begun trail construction. To oversee its development, the Appalachian Trail Conference (ATC) was formed two years later. By 1931, volunteers had constructed nearly 1,200 miles. Eventually, forest and park service staff, with CCC help, would build one-third of it. Over several years, Myron Avery pushed a measuring wheel from end to end, completing the project in 1936. One year later, after crews had completed the A.T. section between Davenport Gap and Waterville, the final segment was completed in central Maine. By 1969, fifty people had hiked the A.T. By 1996, the ATC had registered four thousand thru-hikers from around the world.

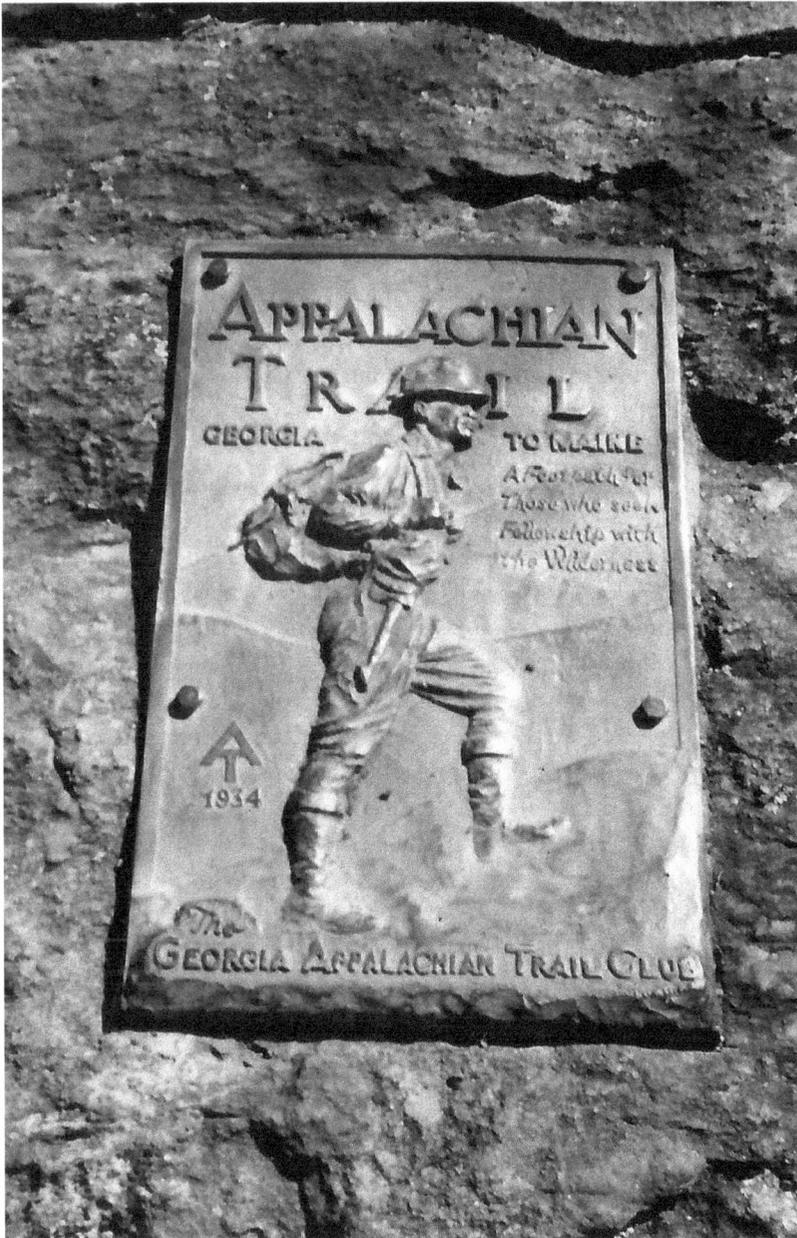

This Appalachian Trail plaque marks the southern terminus of the A.T. at Springer Mountain, Georgia. Most northbound thru-hikers start in Georgia in March or April hoping to complete the more than 2,100 miles across the Appalachian Mountain chain to Maine by October. Day-hikers can hike Pisgah's sections of the Appalachian Trail in the Appalachian Ranger District. *Photo by the author.*

Before President Lyndon Johnson signed the National Trails System Act in 1968, authorizing the Departments of Interior and Agriculture to establish protected trailside corridors, only "441.4 miles out of a total 592, or 75%" of the A.T. in the South, were protected "with an acquired right-of-way or scenic easement," reported *Mountaineers and Rangers: A History of Federal Forest Management in the Southern Appalachians.* Highways, resorts and private development threatened other areas. The Forest Service and other groups began to purchase property adjoining the A.T. By the mid-1970s, 110 miles in sixty-one southern tracts had been acquired under the Trails Act. Only four tracts required exerting the power of eminent domain, two of those in Pisgah. Nevertheless, continued inadequate trail protection and conflicting interpretations of the Trails Act regarding funding, acquisition and acreage prompted lawmakers to amend the original law.

In 1978, President Carter signed the Appalachian Trail Act and increased project funding. Management improved. The National Park Service was assigned supervision of the trail in consultation with the Forest Service; the Appalachian Trail Conference, now called the Appalachian Trail Conservancy (ATC), managed its use and conservation. General maintenance was embraced by volunteers. In 2013, nearly six thousand volunteers (including thirty-one hiking clubs) donated more than 240,000 hours toward the trail's upkeep. With its use increasing annually, the USFS Southern Research Station launched a 2007 pilot study to develop methods to more accurately determine A.T. visitor use.

After crossing the Pigeon River, hikers begin to climb, entering Pisgah's Appalachian District in about two miles. A hard climb ascends double-peaked Snowbird Mountain (4,263 feet). Wildcat Top forms its eastern peak. In 1964, the FAA erected a navigational tower on the western summit. Views from Snowbird Mountain extend down the crest of the Smokies, culminating at Clingmans Dome, the highest mountain in the national park. The Newfound Mountains stretch off the main ridge into a southern spur tracing the border of Madison and Haywood Counties. A tread-to-trail meeting of the Bald Mountains is directly ahead.

A steep descent off Snowbird introduces Groundhog Creek Shelter, constructed of native stone. Following the Cocke County, Tennessee and Haywood County, North Carolina boundaries, the trail rises above Harmon Den Valley, a bear sanctuary known for its popular equestrian trails and group campsites. Supposedly, Harmon lived as a hermit under a mountainside rock cliff. In Harmon Den, yellow, diamond-shaped blazes designate fourteen miles of trails and forty miles of gated Forest Service

roads for horseback riders. Rectangular markings invite hikers, too. Some trails follow old logging roads. Near the Harmon Den parking lot (accessed by a dirt road from I-40's Harmon Den Exit 7), Cold Springs Creek offers a perfect spot for a picnic. In May 2014, the picnic area and Harmon Den campground closed briefly due to a sixty-acre wildfire. In 1939, more than one hundred CCC corpsmen occupied Cold Springs Creek as a side camp for local projects. Foundations remain evident. From 1936 to 1939, corpsmen built this A.T. segment from the Smokies to Max Patch Mountain.

Max Patch Mountain (4,629 feet) is a wide, grassy meadow. A 1932 Winston-Salem newspaper article described its appeal:

[A] *high plateau…*[with] *excellent views of* [the] *Blue Ridge and Smokies visible from the top…towering 4,660 feet on the North Carolina–Tennessee line…has become the highest airplane landing field east of the Mississippi and the only mountaintop available for this purpose between White Top Mountain, Virginia and the foothills of northern Georgia… Airplanes from Asheville, Knoxville, Black Mountain and South Carolina cities have landed with ease on this natural table-top…sodded in rich grass. Too, it is easily accessible by automobiles and boasts of growing resort attractions. With Camp Alice on Mount Mitchell, Max's Patch shares the distinction of having the "highest bathtub" in the Southern Appalachians.*

No bathtubs, autos or airplanes are found on Max Patch today, only hikers. Plans to develop a 1980s ski resort also failed. Hikers approach Max Patch on the A.T. or a trail leading from a parking lot on graveled Max Patch Road. When Earl Shaffer passed this way in 1948, the A.T. bypassed the huge mound on a 3.6-mile roadway. Shaffer saw cattle grazing in the open meadow above a "weather-beaten house" at the mountain's base.

At the urging of Carolina Mountain Club (CMC), activists Arch Nichols and Jack Davis, in a fourteen-year campaign to protect the bald mountain and to relocate the Appalachian Trail off Max Patch Road, the USFS purchased 392 acres on and around Max Patch in 1982. Beginning in 1983, the 6.2-mile relocation across Max Patch summit to Lemon Gap was built almost exclusively by CMC volunteers. Jack Davis hired a team of mules from local farmers to cut through thick rhododendron. With assistance of the Appalachian Trail Conservancy (ATC) Konnorock work crew, CMC finished the relocation in 1984. Max Patch had been a scenic rider destination for years, but horses were not allowed on the A.T. USFS, ATC, CMC and the horseback-riding community met to discuss options for equestrians.

Tim Worsham climbs the grassy meadow of Max Patch Mountain with his sister, Christi. Appalachian Ranger District offers many rewarding day hikes for families looking to fish, picnic, identify wildflowers or fly a kite. *Photo by the author.*

Participants designed new horse trails and hitching posts around Max Patch, leaving the summit available to softer, hiker footsteps.

In November 2012, however, ATV riders ignored the environmental-protection policies. Removing Forest Service fencing and "No motorized vehicles" signs on Max Patch, drivers carved deep tire ruts and destroyed vegetation on its western slope. When CMC trail maintenance volunteers Dwayne Stutzman, Sara Davis and David Kendall discovered the incident, they helped USFS staff reassemble the fence and re-erect the signs. On a cold, wet January night in 2013, however, the perpetrators came back to Max Patch, spinning larger turns and digging deeper grooves. District law enforcement rangers launched a 240-hour investigation, arresting thirteen people for federal misdemeanor violations. Court convictions required each to pay $407.69 to cover repair costs. In addition to paying the fine, court officials ordered the ringleader to serve ninety days in jail.

Multiple concerned groups responded immediately. Proactive restoration to protect Max Patch from future abuse began without delay. USFS, ATC, CMC and the Appalachian 4x4 Club began repair work on Earth Day 2013. Within three weeks, the USFS had announced the completion of the trail and turf repair; $15,000 later, boulders lined the parking lot to discourage invasive vehicles. Crews removed barbed wire fencing and restored exhibits. Volunteers raked, tilled and reseeded deep ruts. Others planted native shrubs near the trailhead and parking lot.

By reducing successional growth of shrubs and seedlings, the USFS, NPS and ATC maintain the summit of Max Patch as a grassy bald. Hay permits in the 1980s allowed public harvesting to assist with maintenance. Now, as funding allows, Forest Service equipment mows the open meadow. Volunteers tend shrubby growth along this segment of the A.T.

After departing Max Patch summit, hikers reach Lemon Gap. From the gap to Hot Springs, the CCC built, in 1936, this twenty-mile section. In 1938, corpsmen crafted nearby Walnut Mountain Shelter from chestnut logs. Splendid views from Walnut Mountain and a trailside white pine plantation reward the hiker before a steep descent.

Sixty years ago, Earl Shaffer "fumbled" through a recently logged area along this section. Bulldozer tracks and logging debris made the footpath difficult to follow. Since enactment of the Trails Act, though, timber cutting has been restricted to areas outside the USFS A.T. Management Areas. Between 3,000 and 4,500 feet elevation, however, overgrown logging sites and shrubby abandoned fields provide perfect habitats for a species of concern: the golden-winged warbler. Although its numbers have seriously

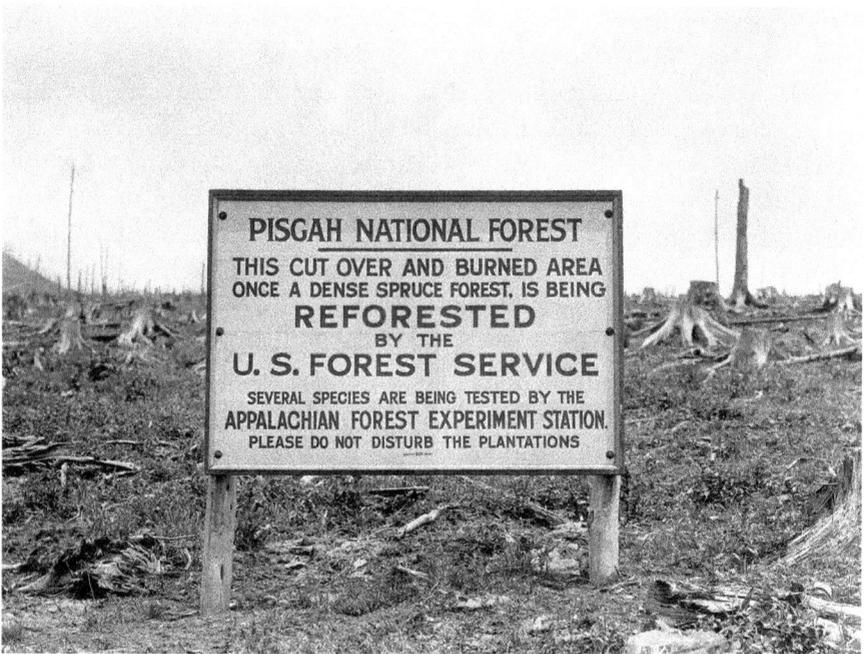

Cutover and burned site in Pisgah National Forest. *National Forests of North Carolina Historic Photographs, D.H. Ramsey Library, Special Collections, University of North Carolina.*

declined in the southern Appalachians, it inhabits Kale Gap on the A.T. near Bluff Mountain and old farmyards along Max Patch Road.

The forested slopes of Bluff Mountain (4,686 feet) provide ideal songbird and wildlife habitat but no views. During the summer of 2012, a CMC trail maintenance volunteer reported graffiti scribbled on several trail signs. The thru-hiker was later fined.

A two-thousand-foot, knee-aching descent drops into Garenflo Gap. Three and a half miles farther is the CCC's 1938 Deer Park Mountain Shelter, which was reroofed in 1989 by CMC volunteers. Directly ahead is Hot Springs. Three miles south of the town on NC-209, campers can stay at the USFS Rocky Bluff Campground, a former farm purchased in 1935 from Robert Brooks. A nature trail borders beautiful Spring Creek. The Accelerated Public Works program funded road, fireplace, picnic table and tent platform construction in the 1960s.

After entering downtown Hot Springs on the Appalachian Trail, hikers pass the Hot Springs Visitor Center, a place to view excellent exhibits depicting area history. Next door, the Hot Springs Library occupies the site

"THE JEWELS OF THE NC MOUNTAINS"

By Cathy Miller, French teacher with a passion for birding from the South Carolina Lowcountry, who visited the North Carolina mountains in the summer in pursuit of treasure and wrote about it in her blog, "Pluff Mud Perspectives" (http://pluffmudperspectives.blogspot.com). The following is an excerpt from her blog.

June 11, 2013, near Mount Mitchell on the Bald Knob Ridge Trail, phishing did not promote an in-your-face encounter with a Blackburnian warbler like last year, but we saw in the tree tops of spruce trees several golden-crowned kinglets and a few Blackburnians. There were also plenty of dark-eyed juncos. We mused on our desire to see red crossbills, a potential life bird for me. Suddenly a flock of twelve chupping birds flew overhead and alighted in the hemlocks. These birds were grossly backlit and distant for the reach of our lens, but we did indeed get photos that confirmed my ID—red crossbills! Thus, we completed our day with Life Bird #3 of this adventure.

Back at the cabin, I began plotting "Day Three" of a productive birding vacation in the North Carolina mountains. Following leads provided by a fellow birder, we determined a route to the top of one of our favorite balds in North Carolina—Max Patch Mountain. Along this route, we would pass through the perfect habitat for the golden-winged warbler. The population of this species has declined significantly in the Appalachian Mountains, reportedly down 98%! After reading an article in *Living Bird*, a magazine published by Cornell University's Lab of Ornithology, about the conservationist efforts to save this "species of special concern," we resolved to find this little treasure before it was too late.

The next day, we took the scenic farmland road, Highway 209, en route to Max Patch Road. We loved the scenery through old farm sites. A site near an old house with barn and pond looked promisingly birdy. Even before I got out of the car, I thought I heard a golden-winged warbler along with field sparrows, house wrens, chestnut-sided warbler, common yellowthroat and hooded warbler—quite the riot of birdsong! Sure enough, our target bird, the golden-winged warbler, Life Bird #4 of this trip, was there and feisty. We watched him run off the chestnut-sided warbler!

of the former French Broad District Ranger Station. The District Ranger Office now sits on a knoll near Mars Hill, a more centralized location between its combined French Broad and Toecane units. A.T. symbols etched in the Hot Springs sidewalk direct hikers across the French Broad River Bridge. There, on the downstream side of the bridge, the illustrious Mountain Park Hotel occupied the large green lawn nearly one hundred years ago. The Wana Luna, the Southeast's first golf course, stretched across the highway from the hotel to the site of the current Hot Springs Campground, making a perfect location for CCC Camp F-7. Although Camp Alex Jones provided better services than some other CCC locations, the camp conditions could not compare to the site's luxurious past.

In 1778, two Tennessee men chasing stolen horses waded across the French Broad River, discovering warm pools of water within the river's current. Reports of the water's soothing, curative powers enticed settlers and visitors to the area, creating the town of Warm Springs. Taverns became inns; trails along the French Broad River became part of the Buncombe Turnpike. In 1837, James Patton opened the elaborate Warm Springs Hotel. Future North Carolina governor Zebulon Vance worked as a hotel clerk, and future South Carolina governor Wade Hampton built a summer cottage on site.

By the start of the Civil War, Patton had sold the property to stagecoach company owner Colonel James H. Rumbough, who moved from Greeneville, Tennessee, to Warm Springs in 1862. By 1879, he had enlarged the hotel to serve 1,000 guests. By 1882, hundreds of guests were arriving on the Western North Carolina Railroad, which was extended from Asheville to Paint Rock. Rails at Paint Rock connected the train service to the East Tennessee Railroad. Despite its success, flames turned the grand hotel to ash in 1884. Rumbough sold out. In 1886, new owners built the massive Mountain Park Hotel, with its fine golf course, on the one-hundred-acre estate. During construction, northern developers learned that mineral spring temperatures were warmer than originally thought, changing the town's name from Warm Springs to Hot Springs. Bankrupt by 1890, investors sold Mountain Park Hotel back to Rumbough. During World War I, when tourism halted, the federal government operated the site as a German internment camp, lodging about 2,500 immigrants in tents, barracks and the large hotel. When the hotel burned in 1920, owners never rebuilt it. The open premises created a perfect area for a CCC encampment.

Hot Springs is a central location for exploring other areas of the national forest. Forest Service roads provide fall color driving tours. Profuse wildflowers

bloom along Laurel Creek. On the border of Pisgah and Cherokee National Forests, historic Paint Rock, described in journals by 1799 state-line surveyors, was later used as a blockade house for Indian raids. The CCC built Murray Branch Picnic Area on the French Broad River. Gentle currents between Hot Springs and Murray Branch invite canoeists to join kayakers and rafters along this section.

Bordering the national forestlands from Stackhouse Launch to Hot Springs, the three-mile section of Class II–IV rapids on the French Broad River thrills whitewater rafters. RiverLink of Asheville posts maps, conservation reports and other information on exhibit boards at river access areas.

From 1871 to 1878, Amos Stackhouse, attracted to the area by the medicinal benefits of its mineral springs, established a Buncombe Turnpike drover's stand across from the Mountain Park Hotel. About four miles upstream from Hot Springs, he purchased six hundred acres alongside the French Broad River to build his sawmill and store. In 1883, he built a post office, named "Stackhouse." When the railroad replaced the turnpike in the 1890s, railroad mail clerks plucked "posted" mailbags hanging on rail-side poles and tossed out mailbags addressed to the community of Stackhouse.

In 1904, a network of deep shafts, narrow tunnels and open, hand-dug pits tapped into a large barite mine. Carolina Barytes Company opened a mill at Stackhouse to process the barite, constructing a small wooden dam across the French Broad River to divert water for power. The Flood of 1916, however, destroyed both the mine and sawmill. Dam debris remains in the riverbed. Built by Amos Jr. in 1905, the stately Stackhouse home stands above the river-launch area acquired by Pisgah National Forest in 1991.

Just downriver at the confluence of Laurel and French Broad Rivers, the Laurel River Logging Company built a logging village called Runion in about 1909. Narrow-gauge railroads followed major streams through mountain coves to transport large loads of timber to its huge band saw mill. After logging the region extensively and suffering severe damage during the Flood of 1916, the mill was closed in the 1920s.

The Barnard River Access was part of a 3,400-acre land grant received by Job Barnard in 1794. Boaters may choose to launch at Barnard and exit at Stackhouse or ride the currents all the way to Hot Springs. Some French Broad River sections are not for novices, though, and require experienced boaters to scout ahead. In addition, the river's character changes during

heavy seasonal rains or periods of drought. For instance, a 1982 French Broad River map states:

> *Warning! Frank Bell Rapid Class IV (normal water levels) Class V (above normal levels)…this is undoubtedly the most deceptive and dangerous spot on the French Broad River. Here the river constricts to about a third of its normal width. Three concentric ledges funnel the river into a giant whirlpool at the bottom. Two small islands divide the channel into narrow, shallow, but comparatively safe* <u>*left*</u> *side approach and a wider, wilder difficult* <u>*right*</u> *side approach. Beach your boat on the island and walk to the end to get a good look.*

For current French Broad River conditions, visitors should inquire at a local outfitter company or consult the U.S. Geological Survey website http://waterdata.usgs.gov/nc/nwis/rt). In the 1920s, a French Broad River expedition (with plans to run the rivers all the way to the Mississippi) included Frank Bell, one of the first paddlers to navigate the rapids through Madison County. The largest rapid on the French Broad now bears his name. The 117-mile-long French Broad River, whose headwaters rise near Rosman in the Pisgah Ranger District, reaches greater width, depth and strength in the Appalachian District before leaving North Carolina at Paint Rock. Flowing north through Tennessee, the French Broad and Holston Rivers unite near Knoxville, forming the Tennessee River. Tennessee and Ohio Rivers merge to feed the Mississippi and the Gulf Coast.

The Appalachian Trail leaves Hot Springs and, since its relocation in 1998, follows the banks of the French Broad River. A one-thousand-foot climb leads to Lovers Leap Ridge, overlooking the town and its river valley. After crossing US-25/70 on a designated hiker's bridge, the A.T. follows the ridge of the Bald Mountains, with fine views from Rich Mountain Lookout Tower. The tower, reportedly, was built in 1934 by the Forest Service and CCC enrollees at Camp Alex Jones. Like Frying Pan Fire Tower in the Pisgah District, Rich Mountain tower is listed on the National Historic Lookout Register. Located south of the tower since the 1950s, ten-foot-high letters, "NS," span a seven-and-a-half-foot-wide ground space as aerial markers. Vandals removed an informative sign in 2005.

Three miles ahead, hikers bunk at the CCC's Spring Mountain Shelter or continue a few miles farther to overnight at the 1967 Little Laurel stone shelter. A few miles later, a spur trail climbs a quarter mile to the Camp Creek Bald Lookout Tower. Built in about 1929 by Cherokee National

Forest and refurbished in the 1960s with a round, glass-enclosed observation cab, Camp Creek Lookout was transferred to Pisgah's management in 1986. For eleven years, fire warden Ed Tweed manned the lookout tower. On assignment in 1948, he greeted Earl Shaffer on his "Long Cruise." Since the district ranger in Hot Springs had radioed ahead, Tweed was expecting him. During introductions, the tower's phone rang. When a fire warden farther south missed Shaffer while he was bushwhacking through the "logging mess," he called to check up on the "Lone Trail-Hiker." For the next five hundred miles to Shenandoah National Park, rangers radioed tower to tower to announce Shaffer's approach. Shaffer accepted the warden's invitation to spend the night inside Camp Creek tower. "On the ridge eastward," he reported, "was an open field used during war for an emergency landing strip." When Shaffer returned on his anniversary hike in 1998, he noted that the A.T. then bypassed the Camp Creek Bald.

Farther along the A.T., the USFS relocated the Jones Meadow section in 1967 off the state-line ridge and into Pisgah National Forest to avoid

A U.S. Forest Service dispatcher responds to messages. *North Carolina Historic Photographs, D.H. Ramsey Library, Special Collections, University of North Carolina.*

a private lodge development in Tennessee. Beyond a rock shelter with a fireplace and a raised floor, built by the Forest Service in 1968, the trail crests Big Butt Mountain, part of Coldspring Mountain. Shaffer photographed a ridge-top pasture here in '48. Now protected by the USFS as an Appalachian Trail corridor, the summit is beautifully forested. When two Union soldiers returned home to visit families on Coldspring Mountain during the Civil War, Confederates killed them. In the 1860s, relatives buried William and David Shelton, an uncle and nephew, and a little boy who stood lookout, in a communal grave. Carried by ox sled up the steep mountain slopes, preachers placed head- and footstone markers on the single grave in 1915. Only Shelton names are engraved on the tombstone. Federally funded for soldiers in war, the grave marker omits the brave civilian boy's name. However, years later, descendants of the family of that little boy, Millard F. Haire, placed a marker on his grave. The Appalachian Trail passes nearby. Jake and Cynthia Blood of the NC High Peaks Trail Association maintain that section of the A.T.

In 1948, Shaffer passed a "root-digger" near here. Locals often collected ginseng and various medicinal herbs. "Goin' galackin'" was common too. To augment household incomes, families collected and sold galax (*Galax urceolata*) leaves to floral markets. The low-growing plant with thick, shiny, rounded deep-green leaves grows in dense colonies. In May and June, a six-inch white spike holds several tiny white flowers. By fall or winter, leaves may turn a deep wine or copper color.

Early in 2000, when the USFS noticed dramatic increases in requests for galax permits, the agency asked the Southern Research Station to study the harvesting impact on galax regeneration. The National Park Service had already launched its own study, with research plots along the Blue Ridge Parkway. Parkway poaching prompted several arrests, including repeat offenders, who had bagged thousands of galax leaves. In an effort to reduce poaching, NPS officials developed an encoded, micro-marker dusted onto adhesives applied to galax growing in protected areas. Tagged galax sold to markets could be traced back to the area of illegal activity. The Forest Service initiated a similar program in its protected wilderness areas.

Unlike traditional harvesters, who cut or picked individual leaves, modern galackers began pulling up entire plants. Disrupted habitats delayed regeneration. Experienced harvesters can take five thousand leaves per day. Depending on leaf size, quality and color, floral markets pay two to three cents per leaf. Almost 99 percent of the nation's galax harvests come from North Carolina's forests, generating annual harvest revenue between $10 million and $25 million. Permits issued by the USFS enforce current policies.

Beyond Flint Mountain Shelter, replaced in 1988 by the Carolina Mountain Club after a fire, hikers enter Sams Gap at US-19/23 (future I-26). From the Smokies to Sams Gap, seventy-seven A.T. miles span the Appalachian District. Like a trophy awarded after an athletic challenge, fantastic views atop grassy Big Bald (5,516 feet) compensate for a long, hard climb. From Big Bald Development Corporation, the USFS acquired its summit and the ridgeline of Little Bald in 1977. USFS agreements allow the development company a dirt road access to the top. Wolf Laurel Ski Resort now occupies Big Bald's eastern and southern flanks.

Southern Appalachian Raptor Research manages Big Bald Banding Station, collecting data on songbirds, raptors and owls. In 2013, volunteers banded about two thousand songbirds and one hundred raptors during migration. Annually, birders count more than three thousand raptors during autumn's Big Bald Hawkwatch. Located within the A.T. corridor, the banding station hosts youth programs to promote environmental education.

In 2012, Chris Kelly, with the NC Wildlife Resources Commission, partnered with fourteen other states in the Eastern Golden Eagle Working Group, studying the winter distribution and habitat requirements of golden eagles in the Appalachian Mountains. Coordinating the working group project since 2010, researcher Dr. Todd Kaztner reported that a small population of the species breeds in northeastern Canada and migrates south to spend winter in the central and southern Appalachians. Scientists, biologists and wildlife managers are collecting data on their winter habits to determine the migration range that needs to be protected to preserve the dwindling populations of eastern eagles. Between November 2012 and March 2013, Chris Kelly reported, nine camera trap stations in high, remote areas of the North Carolina mountains were baited with roadkill white-tailed deer. Golden eagles were detected at five of those stations. Some sites in Pisgah National Forest included areas near Big Bald Mountain and across the Unaka Mountain range, north to Roan Mountain. In a 2014 partnership with Tennessee Wildlife Resources Agency, an adult golden eagle was fitted with a GPS transmitter. (For more information, go to http://egewg.org or www.appalachianeagles. org.) During an awards ceremony on March 27, 2013, in Arlington, Virginia, the U.S. Forest Service awarded the Eastern Golden Eagle Working Group the Wings Across the Americas Award, recognizing its valuable contributions to the conservation of this important species.

A steep descent leaves Little Bald Mountain for Spivey Gap. From the Smokies to Spivey Gap, the Carolina Mountain Club provides trail upkeep. The 128-mile section from the gap to Damascus, Virginia, has been adopted

by the Tennessee Eastman Hiking and Canoeing Club. Switchbacks ease the descent to the Nolichucky River, where rafters and paddlers navigate the ole 'Chucky from Pisgah's Poplar Launch area. After crossing the Nolichucky River near Erwin, Tennessee, the A.T. returns to the state-line ridge and Pisgah National Forest eight miles later at Indian Grave Gap. From here, the bright white blazes of the Appalachian Trail lead across Beauty Spot and the red spruce–clad summit of the Unaka Mountains to Roan Mountain. At the northern end of the Highlands of Roan at Doll Flats, the A.T. leaves Pisgah. Nine miles later, the trail visits Pisgah for one last brief segment at Elk River before heading on north to Maine.

MOUNT MITCHELL AREA/TOECANE/BIG IVY

Mount Mitchell, a North Carolina state park, includes nearly 1,500 adjoining acres at the crest of the Black Mountain Range, but its forested slopes and valleys belong to Toe River communities to the east, Cane River Valley to the west and Pisgah National Forest. Mount Mitchell (6,684 feet), the highest mountain in the East, is named for Dr. Elisha Mitchell, who explored and measured mountains in the area. Nearly 4,000 feet above the valley floor, like contiguous, rounded pyramids in an open desert, the fifteen-mile Black Mountain Range, with seventeen named peaks more than 6,300 feet high, rises in sharp relief.

Six of the ten highest peaks in the East dominate the Black Mountains. From the state park picnic grounds, a trail crosses their crests on a rugged, rocky trail bed, roller-coastering over twelve 6,000-foot peaks in six miles. In one mile, hikers cross Mount Craig, named for North Carolina governor Locke Craig, who helped establish the state park. It rises 6,645 feet as the second-highest peak in the East. One-tenth of a mile later, hikers reach Big Tom Mountain (6,593 feet), named for the bear hunter Tom Wilson, who found Dr. Mitchell after he fatally fell over a waterfall in 1857. Until the two mountains were renamed in 1947, both peaks on one summit were known as the Black Brothers. After crossing Balsam Cone (6,611 feet), a backpacker enters Pisgah National Forest two and a half miles from the trailhead. Cattail Peak (6,583 feet) and Potato Hill (6,475 feet) are crossed before descending to Deep Gap (5,700 feet), the only point below 6,000 feet on the hike. Deer (6,200 feet) and Winter Star (6,203 feet) Mountains, as well as Celo Knob (6,327 feet), are summited before entering a 3,300-foot descent on a former logging road that passes an old mine at Bowlens Creek near Burnsville.

Foresters wait for the train at Camp Alice near Mount Mitchell. *From left to right*: J.S. Holmes, state forester of North Carolina; Verne Rhoades, supervisor for Pisgah National Forest; and F.A. Perley, lumberman of Black Mountain, North Carolina. The fourth man is not named. *North Carolina Historic Photographs, D.H. Ramsey Library, Special Collections, University of North Carolina.*

The seasonal growth of sprawling, sun-loving shrubs and other understory plants can spread quickly across the open crests of the Black Mountain range, obscuring the trail. Admirably, North Carolina High Peaks Trail Association, a nonprofit organization in Burnsville, North Carolina, has adopted the Black Mountain Crest Trail and other rugged sites in the Mount Mitchell/ Toecane region to monitor and maintain. Finding Mike Williams, volunteer with the club, on the Green Knob Fire Tower Trail on Labor Day weekend in 2014, sweat on the brow and weed-eater in hand, he explained that he hikes up two hours to the crest of the Black Mountain Range at Deep Gap, weed-eats for three and descends in two. He'll return later to finish. (Great interactive maps and more information, including guided hikes among the high peaks, can be found at the association's website, www.nchighpeaks.org.)

Several deserted mines are nearby. In 1869, Garrett Ray sank a shaft in pegmatite to mine mica in this area. Becoming one of the most well-known mica mines in the area, Ray Mine produced high-quality sheets of muscovite, or sheet, mica. In 1858, when Senator Thomas Clingman stayed with the Silver family at Bandana, north of Celo and Micaville communities,

he noticed clear mica sheets forming windowpanes in their home. Clingman explored nearby Sinkhole Mine, one of the oldest in the country. Returning after the Civil War, Clingman sank a new shaft in the old mine. Wanting silver, not mica, Clingman left disappointed.

Mica, however, would become one of the region's most valuable resources. Strong but lightweight and flexible and heat-resistant, with insulating and reflective qualities, mica served many purposes. Sheet mica has been used in electronics, optics and stove windows. Ground mica is a filler for drywall compounds and plastics and an anti-sticking agent in rubbers, roofing and automobile braking systems. Years ago, Robert Dent's young son used ground mica, not the standard powdered talc, to reduce friction between bike tube and tire. Convincing Goodyear Tire and Rubber Company to try the substance in its products, tons of ground mica were shipped to Akron, Ohio. Wet ground mica is included in paints, toothpaste, makeup and birthday balloons. In 1903, Carolina, Clinchfield and Ohio Railroad's service to Spruce Pine boosted the transport of the area's mineral resources to markets.

Miners routinely discarded feldspar in spoil piles when they discovered it during mica mining operations. Testing samples that were shipped north in 1911, an Ohio pottery factory ordered the first commercial load from Penland's Deer Park Mine on the North Toe River. Feldspar was also used in tiles, glass and scouring powders. Until the 1940s, manufactures of fine dinnerware ordered "china clay," or kaolin, from England. Now the Toe region is the nation's largest kaolin producer.

Toe Valley kaolin created a fine set of White House dinnerware; Harris Clay Company displayed a dinner plate from the service at the 1959 North Carolina Mineral and Gem Festival in Spruce Pine. Some locals claim that Spruce Pine mined and shipped clay minerals to Wedgwood in England, where the company designed a set of fine dinnerware for George Vanderbilt. England then shipped Spruce Pine's crafted minerals back to the Biltmore House.

Abandoned in 1944, the Ray Mine at Celo is now part of Pisgah. Open pits, some hundreds of feet deep and covered with vegetation, warrant extreme caution in this area. Consult the USFS office for the most current rock-hounding and collection policies. Beryl crystals, garnet, tourmaline, feldspar and aquamarines can be found in spoil piles and along the creek. Short-wave UV lights turn fluorescent apatite and zoisite into brilliant colors after dark. In years past, local children collected aquamarine at Ray Mine for dollhouse furniture and shot garnets off tree limbs with slingshots.

Scenic South Toe River Valley is explored on NC-80, paralleling the lofty Black Mountain Range. Forest Service Road #472 leads to Black Mountain Campground on the banks of the South Toe River. A small road, FR-472-A, detours left to a trailhead for Roaring Fork Creek Falls. From the campground, Mitchell Trail (also part of the Mountains-to-Sea Trail) climbs 3,500 feet up to Mount Mitchell, leaving hardwood forests to enter the spruce/fir zone above 4,500 feet. Fraser firs and red spruce, affected by Perley and Crockett's nine-thousand-acre logging practices from 1913 to 1921, now struggle to survive the invasion of nonnative balsam woolly adelgids and the impact of air pollutants.

Trails connect Black Mountain Campground to the group camp at Briar Bottoms. The one-fourth-mile Setrock Creek Falls Trail begins near the gate. The eighteen-mile Buncombe Horse Range Trail is the longest equestrian trail in the district. Strenuous Green Knob Trail leads to the National Historic Lookout Tower on the Blue Ridge Parkway, the same tower with access from Curtis Creek. Built by the Forest Service in 1931, manned until the late 1970s and restored by the USFS in 1996, Green Knob sports a classic "dunce cap," a pyramidal roof common in southern national forests—one of the very few remaining examples. Repairs to both the lookout tower and the Black Mountain Campground were required after the hurricane of 2004.

Farther north on NC-80, Carolina Hemlocks Recreation Area was built by the CCC on the banks of the South Toe River. Volunteer campground hosts Jerry Hall and Harold Grindstaff grew up in this area. Hall's father, Eugene Ray, began working here for the CCC at age seventeen. The Great Depression was especially hard on the isolated valley; his family was grateful for a little income from the Corps. Supposedly, the camp cooks served food "chuck wagon style" on the rock-bordered surface now used as tent pad no. 3. With its smooth, polished, rocky banks, summer visitors tube on the Toe or soak in the South Toe's swimming hole, its waters now clearing after years of mica jig mining.

Anglers fish for trout. Campers stay under large Carolina hemlocks (*Tsuga caroliniana*), a species that is native only to the southern Appalachians. Its relative, the common eastern hemlock (*Tsuga canadensis*), produces larger, flat needles growing from the sides of the twigs; Carolina hemlock needles emerge at angles. Both species are treated for the invasive pest the hemlock woolly adelgid, which is devastating southern hemlocks. Picnic tables are located by the river. Built in 1976 by the Older American Project Group, a large, well-constructed shelter with a grill and rock fireplace accommodate

A CCC enrollee/attendant explains the Carolina Hemlocks Campground to a visitor. *North Carolina Historic Photographs, D.H. Ramsey Library, Special Collections, University of North Carolina.*

large gatherings. The Forest Service offers nature programs and hikes along the Toe's riverside trail.

South of Burnsville lies the Cane River Valley, Big Tom Wilson country. In 1925, Wilson's grandson built a toll road through the valley along a former logging railroad bed for an alternative tourist route to Mount Mitchell. During construction of the Blue Ridge Parkway, the toll road was closed in 1939.

From Burnsville, NC-197 crosses Cane River, enters and leaves Pisgah National Forest, passes the headwaters of Ivy Creek and arrives at Barnardsville. On Dillingham Road, USFS CCC Camp F-8 operated at the site of the current Big Ivy Community Center and Historical Park. The original officer's headquarters, possibly the only one left intact, and other concrete foundations remain at the site. CCC exhibits detail its local work projects, including construction of the Blue Ridge Parkway and Craggy Gardens Picnic Area. Where corpsmen held boxing matches, ate mess hall meals and organized the next day's labor, children now toss beanbags onto game boards, pass footballs to older siblings, volley large balls with grandparents or spin reckless Frisbees into

couples seated in the shade of giant trees. Nearly eighty years later, as a gesture of that same proud, patriotic CCC-generated brotherhood, the community of Big Ivy offers an invitation to come visit its October Heritage Festival or watch its Fourth of July fireworks display.

Big Ivy Historical Park is the new home of Little Snowball Fire Tower, originally built by the CCC in 1934, removed from the Great Craggy Mountains above Big Ivy in about 1988 and reassembled at the park in 2007. The National Historic Lookout Register claims that it is "the most historically accurate restoration in western North Carolina." After purchasing the tower for $300, Lloyd Allen and friends restored its noble, symbolic heritage. Following the Pisgah National Forest boundary, a hiking trail leads from the entrance road to Craggy Gardens Picnic Area over Big Snowball to Little Snowball Mountain. Wildflowers in season are prolific.

In Big Ivy (or Coleman Boundary), turn right onto Stony Fork Road, constructed by the CCC as a route to Craggy Gardens Picnic Area, or continue on Dillingham Road to Forest Road #74. Eight roadway miles pass wildflowers, rocky cliffs and rushing streams. At Corner Rock picnic area, a large chestnut tree grows beyond the forest's edge, prompting interesting debates. Is it an American chestnut that survived the destructive wipeout blight of the 1930s or a planted hybrid resisting the dreaded disease? Shortly down FR-74, visitors hike or horseback ride the Elk Pen Trail, built for elk used in the 1992 filming of *The Last of the Mohicans.* A few curvy miles later, Walker Falls tumble beside the road near a small pull-off at Walker Creek Trail. Abandoned and overgrown, Walker Mine guards fine examples of blue-bladed kyanite in its remote setting.

The road dead-ends at Douglas Falls Trailhead. Named for Supreme Court justice William O. Douglas, an environmentalist and outdoor enthusiast (even hiking the two-thousand-mile Appalachian Trail), this lovely seventy-foot waterfall drops amid hemlocks overcome by persistent adelgids. Visitors can backtrack to the trailhead or find a rock near the falls, unlace tight boots and stay a while.

ROAN MOUNTAIN AREA

Roan Mountain is just plain unforgettable. Every superlative term available in print has been used to describe Roan Mountain's Rhododendron Gardens in late June when all's a-bloom: "magnificent," "outstanding,"

"unparalleled," "fantastic," "fabulous," "superb," "sensational," "best" and "greatest in the world"—even "exquisite," "unrivaled," "tops" and "A-1." But to put it simply, Roan Mountain is unforgettable.

Roan's beauties have mesmerized botanists, scientists and explorers alike. Botanical discoveries in the 1730s made by John Bartram and son William enticed French botanist André Michaux. Traveling throughout the South, Michaux collected thousands of plant specimens for the king of France. During his journeys, he discovered and named many plant species new to science. Michaux named the rhododendron (*Rhododendron catawbiense*). His genus name for flame azalea later changed to rhododendron, but his species name remains *calendulaceum*. In 2003, the Carolina lily (*Lilium michauxi*), named for Michaux, was designated North Carolina's official wildflower.

The 1790s also brought the Scotsmen John Fraser to Roan Mountain, collecting specimens for his London nursery and the Russian government. Joint botany excursions with Michaux ended when rival ambitions parted the pair. Catawba rhododendron and Fraser firs (*Abies fraseri*), named for the one who found it, sailed overseas to be sold in European markets.

American botanist Asa Gray visited Roan Mountain three times in the mid-1800s. Gray identified a new lily, now called Gray's lily (*Lilium grayii*). The color for extroverts, adventure and warning, Gray's lily boldly waves its bright-orange bloom above its grassy stage, dancing in rhythm to Roan's unpredictable winds. Orange-colored flame azaleas border Roan's meadows, perfectly tinted by nature's blend of special pigments and capturing the attention of butterflies and human eyes. Neither butterflies nor human eyes forget those brilliant blossoms. Both come back.

University of North Carolina–Chapel Hill professor and geologist Dr. Elisha Mitchell came to Roan Mountain. So did naturalist John Muir of Yosemite and Sierra Club fame. In 1898, Muir visited Roan Mountain, as well as Dr. Carl Schenck, chief forester for Biltmore Estate. Schenck wrote in his memoir, "[A] man who looked almost as beardy, as unkempt, and as rough as any mountaineer in North Carolina…came to lunch. [When this]…queer individual made some bright and lyric remarks," Schenck recognized him immediately. Later, when Muir sent him a signed copy of *The Mountains of California*, Schenck relished the gift: "There is no book in my library dearer to me."

Rediscovering John Muir's loving letter mailed to his wife from Roan Mountain must have been a memorable, euphoric moment similar to finding the wildflower Shortia after one hundred years. Bob Fulcher of Tennessee State Parks would know. Reviewing microfilm storing Muir documents, Mr. Fulcher uncovered a precious piece of Roan Mountain

"1998 CAPITOL CHRISTMAS TREE CAME FROM ROAN MOUNTAIN, PISGAH NATIONAL FOREST"

By Pat Momich, retired USFS interpretive specialist for North Carolina and 1998 Capitol Christmas Tree coordinator.

It all started in the fall of 1997 when my boss, the Public Information Officer of the National Forests in North Carolina, asked me if I liked Christmas trees. "Sure," I said, "I love Christmas trees!" So began my yearlong involvement with the Capitol Christmas Tree.

Since 1970, a giant Christmas tree from a state or national forest has decorated the west lawn of the U.S. Capitol. In 1998, that special tree came from Roan Mountain in Pisgah National Forest. Since no federal funds could be spent for this project, we first put together a committee made of up the NC Forestry Association, the NC Christmas Tree Association, the NC Department of Environment and Natural Resources, the NC Governor's Office, the Cradle of Forestry Interpretive Association and the National Forests in NC.

The flurry of planning began in January. By February, we had a lovely logo recognizing that the Capitol Christmas Tree honored the centennial of the birthplace of American forestry: the Cradle of Forestry in Pisgah National Forest. In March, North Carolina's First Lady agreed to be the honorary head of the effort to gather 4,000 handmade ornaments to decorate the tree. In April, the Capitol Landscape Architect personally chose a 50-foot Fraser fir from high on Roan Mountain to be *the* Capitol Christmas Tree. In May, artist Teresa Pennington agreed to draw our tree and make prints that would be sold. By June, Teresa had completed a magnificent winter scene of our Capitol Christmas Tree flanked by two other Fraser firs.

To involve children in our project, we invited 4th graders to compete in a contest to write a story about "North Carolina's Terrific Trees." We sent the contest packet to all NC elementary schools in August at the beginning of school year. Three contest winners—from the coast, the Piedmont and the mountains—were selected in October. The three 4th graders and their parent received a train ride and three nights in Washington, D.C., to witness the lighting of NC's Capitol Christmas Tree.

In mid-November, a Forest Service chainsaw crew cut the Capitol Christmas Tree while it was held by a giant crane. The tree was carefully wrapped for protection, then lifted off Roan Mountain by helicopter and set down on the waiting Mack truck. Now the fun began.

We took twelve days to transport the Capitol Christmas Tree to Washington, D.C. I led our caravan in front of the Capitol Christmas Tree truck and a second Mack truck carrying 50 smaller Fraser firs and 4,000 ornaments. We toured North Carolina, with stops and events each day. The 50-foot signboards enclosing the Capitol Christmas Tree served as a giant Christmas card. At every stop, we invited everyone to sign the "card." Highlights of the tour included a wonderful send-off from Bakersville, a spin around the track at the Charlotte Motor Speedway and riding in the Asheville and Raleigh Christmas Parades. At each stop, we were met by U.S. Marines, who received donated Mack stuffed bulldogs for Toys for Tots.

I presented North Carolina's Capitol Christmas Tree to the Architect of the Capitol on November 30. The Capitol "elves" secured and decorated the Fraser fir with 10,000 lights and the 4,000 beautiful ornaments made by North Carolina Extension Homemakers, garden club members, schoolchildren and artists. They made the tree spectacular! The yearlong odyssey came to its climax on December 8 when the Speaker of the House threw the switch to light the 1998 Capitol Christmas Tree. This splendid Christmas tree made North Carolina proud and grateful to the hundreds of people, organizations and businesses that made the whole thing possible.

history. Dated September 25, 1898, on Cloudland Hotel stationery, a new lodge on the state-line summit, Muir's letter to his wife, Louise, extols Roan's forests, landscapes and endless views. Shorter summers in higher altitudes colored autumn leaves earlier than in the valleys below. He yearned to send his wife a bouquet of fresh fall leaves of purple and gold. Even to a man who knew the majestic mountains of the Sierra Nevada, Roan Mountain was unforgettable.

In celebration of the 100th anniversary of John Muir's visit, nearly one hundred people who had "contributed to the conservation, management and study" of Roan Mountain gathered on Round Bald on September 25,

1998. Protecting its unique ecosystems, studying its wildlife inhabitants and uncovering the mysteries of Roan's natural communities had captivated most of them for a lifetime.

Forestry officials, conservation leaders and scientists attended the event. Researchers who had studied Roan's saw-whet owls, northern flying squirrels and spruce-fir moss spiders came. The moss spider found on Roan Mountain that day was the first ever recorded there. Thomas Maher, great-grandson of John Wilder, whose descendants sold his seven thousand Roan acres to the Forest Service, arrived from Pennsylvania.

An early researcher, Dr. D.M. Brown, studied growth patterns of trees on Roan Mountain. Intrigued with Roan's grassy balds, he planted and observed a stand of trees on Round Bald, with no conclusive explanations. The origin of southern highland balds has never been completely understood. Fires, grazing, clear-cutting, soil composition and other causes have been suggested.

In the late 1980s, when 2,500 acres of Roan's grassy balds were reduced to 1,641 acres from successional growth, long-term goals and management options were urgently discussed. Unprecedented inventories of flora and fauna in 925 plots on seven of Roan Mountain's balds tallied the region's rare and endangered species. Team members walking several feet apart surveyed the balds, marking their positions on aerial maps.

"Should We Save the Vanishing Balds?" a 1993 *Blue Ridge Country* article began. It continued, "The Forest Service Says 'Yes.'" Tennessee and North Carolina national forest officials developed a new Forest Service management plan in 1991. Addressing characteristics unique to each bald, some with more threatened and endangered species than others, foresters devised specific plans for each one. Beginning in 1992, from June to September, in a three-year Langston University study, twenty-five angora and twenty alpine goats from Oklahoma, guarded by Great Pyrenees dogs, grazed in two pens on Round Bald. Like deer and elk, goats browse and move rather than forage heavily in one area. And unlike other grazers, goats eat briars and berry bushes. Botanists monitored the grazing effects on native flora.

Maintaining the treeless, bramble-free meadow remains Forest Service policy. Rare species such as the Gray's lily depend on it. Previous projects, like selling Roan's firs for Christmas, ended years ago. A 1951 journalist reported a USFS income of $1,029 from fir sales that year. Foresters tagged selected firs, and dealers bid on prices. Many of Roan's firs celebrated Christmas in Alabama.

Maintenance methods today include mowing, trimming and using grazing goats or African Watusi cattle. Sponsored by the Friends of Roan Mountain

A father and son spend time on the Appalachian Trail on Roan Mountain. *Courtesy of Christi Worsham.*

in 2008, researcher Jamey Donaldson began the Baatany Goat Project, an experimental study in the management of grassy and alder balds. Three types of balds exist on Roan: grassy, heath (with shrubs, like rhododendron) and alder. Southern green alder balds exist nowhere else in the world and thrive primarily on the ridge between Jane Bald and Grassy Ridge. Angoras browse on woody plants during the summer season, while goat herder Donaldson collects data for Roan Biodiversity Lists.

Annually, since the 1990s, the Southern Appalachian Highlands Conservancy (SAHC) has hosted a Grassy Ridge Mow-off. Volunteers camp on the summit for a weekend of bald maintenance. Another group camps at Engine Gap to clear the Appalachian Trail corridor. Protecting the Highlands of Roan has been SAHC's signature mission. Under the leadership of the organization's founder, Stan Murray, SAHC has campaigned for Roan's acquisition by the Forest Service.

When the National Trails Act of 1968 mandated that the USFS must purchase lands to protect the Appalachian Trail corridor, the Appalachian Trail Conservancy and other conservation groups worked with the Forest

Service to acquire thousands of acres across Roan's ridge. But families raised on Roan found its balds unforgettable, too. Descendants inherited sentimental attachments. Deep ancestral roots, nurtured by southern pride and hard work, made it difficult to sell. Some tense negotiations with property owners, whose Roan Mountain roots dated back to 1856, took more than twenty years. In the winter of 1911, when Verne Rhoades scouted the area for potential purchase by the Forest Service and sketched the view from Roan Mountain, he was unaware that he was illustrating what Pisgah's landscape would be one hundred years later.

National forest visitors now pack a picnic and slice a melon where 1885 guests bowled or golfed on the lawn of General John T. Wilder's Cloudland Hotel. After earning much of his wealth by mining iron ore nearby, Wilder built Cloudland Hotel astride the state line amid his seven thousand Roan Mountain acres. Enticed by the mountain's natural beauty and recuperative powers of its clean mountain air, guests departed Johnson City, Tennessee, by train; stayed overnight at the Roan Mountain Inn at the mountain's base; and traveled by coach, carriage or hack over a steep, winding road to the top. Until it closed in 1914, Cloudland Hotel pampered guests with only the finest amenities. General Wilder died three years later.

Wilder's descendants sold timber rights to lumber companies eager for Roan's hardwoods and spruce. Champion Fibre Company of Canton was one of the largest operations. Circling Roan's slopes, Champion built a board road, elevated on decapitated live trees as posts, to move heavy timber. In the 1930s, when logging was coming to an end, rhododendron rootstock and shrubs were sold for landscaping. On November 22, 1941, the *Asheville Citizen* reported that the USFS "gets a famous mountain…[in] a deal by which Roan Mountain, home of the famous red rhododendron, will become a great recreation area as part of Pisgah and Cherokee National Forests." In a special event in Johnson City, conservation and forestry officials celebrated the purchase of Roan's seven thousand acres.

In his regular newspaper column series, "Around the Mt. Mitchell Forest Service District," printed in the *Yancey Record*, U.S. Forest Ranger George Vitas updated readers on May 10, 1951, on the "final examination and approval of the new location of the proposed road which the U.S. Forest Service will build from Carvers Gap to the old hotel site on the Roan. All the road stakes are in and as soon as the specifications are drawn up, the contract for the construction of this road will be opened for bids." The new two-lane, hard-surfaced highway from Bakersville to Carvers Gap was already under construction.

A 2011 national forest newsletter announced, "$700,000 in Recovery Funds Boost Roan Mountain." Economic Recovery Act dollars in 2009 were appropriated for Roan Mountain upgrades. Pisgah's parking area at the Cloudland Inn site received new sidewalks, restroom facilities and picnic tables. A new sewer system reduced environmental impact. Designed by Forest Service engineers, "green-concept" features included solar panels to power the flush toilets, drinking fountains and the motion-sensitive, fluorescent bathroom lighting. From a reservoir at the rhododendron gardens, water is gravity-fed to Cloudland's historic site.

Picnic tables fill up quickly at the Rhododendron Gardens. Recovery Act funds helped pave new parking lots and rebuild accessible walkways to the garden's new observation deck. Each June since 1947, Roan Mountain has celebrated a Rhododendron Festival during the peak blooming season of six hundred acres of Catawba rhododendron. The Cloudland Trail to Roan High Bluff Overlook (6,267 feet) features views of the surrounding Unaka Mountains. There, a quiet perch may offer meditative silence or a place to read. To become better acquainted with the Roan, readers may find its biography, *Roan Mountain: History of an Appalachian Treasure*, written by former Roan Mountain State Park ranger Jennifer Bauer, to be an engaging story of the mountain's cultural and natural history. On summer weekends at the Rhododendron Gardens, the small visitor center might be open to view exhibits that provide a deeper glimpse into Roan Mountain's plants, animals and history.

Northbound hikers on the Appalachian Trail pass the Cloudland Hotel site near Roan High Knob (6,286 feet), the highest point on Roan Mountain massif, and may choose to take a blue-blazed detour to the top. The twelve-mile-long massif is a ridge of consecutive rounded peaks. Several broad summits (Roan High Knob, Round Bald, Jane Bald, Grassy Ridge, Big Yellow Mountain, Little Hump and Big Hump) make up the five-mile-wide Roan Mountain. Roan High Knob's shelter—a former fire warden's cabin, renovated in 1980 by the Cherokee National Forest—is the highest of all the more than 250 shelters along the A.T. The lookout tower built by the CCC is now gone.

In less than two A.T. miles, Carvers Gap welcomes thru-hikers, traveling 370 miles from the A.T.'s southern terminus on Springer Mountain, Georgia. Roan's high balds are considered by some hikers to be the most memorable portion of their journey. Motorists come to Carvers Gap on TN-143 or NC-261. Come early morning in late June. Find a place to park on the Pisgah/Cherokee National Forest boundary and start climbing

Round Bald. Pass a barbed wire fence, where goats occasionally browse, pruning brambles to help maintain the bald's grassy nature. Enter a shady remnant of Dr. Brown's experimental conifer forest. Reach Round Bald's open-air stadium. Clear days offer rewarding 360-degree views. Cloudy ones highlight blooming flame azaleas and rhododendron. See a sunset, sunrise or long-range views. Picnic or lounge on open balds or beside boughs of rhododendron. Experience unexplained mysteries, like "mountain music," sounding like the humming roar of swarming bees; a full-circle rainbow; or one's own shadow under clouds. Look down on rain showers in the valley below.

Cross a bald and hear the greeting of an eastern towhee, a suggestion to "Drink your tee-e-e!" in the hot sun. From mounded blueberry bushes, trimmed by nature like hedges in an English garden, a brown thrasher borrows the songs of others, rearranged into his clever two-parted phrases. From a high perch, fearless juncos chime out ringing tones. "Witchety" notes of yellowthroat warblers call faintly from brushy edges while ruby-throated hummingbirds sip blooming azaleas.

Birders recall hearing saw-whet owls or seeing snow buntings and golden-winged, Canada and Blackburnian warblers. Visitors remember fogs, rains, winds and endless blue skies filled with cumulus clouds. Cross-country skiers remember Roan's mid-January winter coat, returning to ski seven snow-covered trails through spruce-fir forests and rhododendron groves.

Flower seekers find wildflower specialties like Appalachian avens, pink turtleheads and thyme-leaved bluets. They identify Roan Mountain roseroot and Roan Mountain goldenrod. From year to year, between Round and Jane Balds, Gray's lily teases naturalists and photographers. In mid-June 2014, photographers loaded with camera gear searched for Gray's lily in vain. "The Gray's lily bloomed two or three weeks later than usual last year," one said. "We came up here from Spartanburg, South Carolina, in late June. It was so cloudy you couldn't even see the close mountains, but the Gray's lily was everywhere. We photographed them for hours."

Answer the call of blooming rhododendron on yonder bald. Jane is waiting. White blazes and a well-worn path take you there or on toward Maine. At the high pass of Yellow Gap, the Overmountain Victory Trail intersects the A.T. on its way to Linville Gorge and Kings Mountain near Charlotte.

On the balds of Roan Mountain, day-to-day burdens fade further than the haziest, most distant mountains. Natural instincts ease the breath and calm

the spirit. Here on top of the Appalachian highlands of Pisgah National Forest, the world is at peace. When it's time to leave, life may or may not provide a way back, but one always remembers the Roan.

Chapter 8
PISGAH RANGER DISTRICT

I s there any question you would like to ask?" a ranger inquires. Questions like: How much timber is harvested annually in the Pisgah District? What wood products are made from harvested trees? What endangered species does Pisgah protect? Who was Davidson? How many people slide down Sliding Rock each year? Where's the best place to fish or take an easy one-mile waterfall walk in street shoes?

In the Pisgah Ranger Station on Davidson River Road (US-276), exhibits, displays, staff and volunteers answer questions. Information is also available at the Pisgah Center for Wildlife Education, roadside exhibits and the Cradle of Forestry in America. Find answers to questions and learn more than you expected.

Combine education with recreation in Pisgah District. Learn about forestry management, trees, wildlife, logging operations, fish hatcheries, wildflowers, fly-fishing, watershed protection and local history. Buy a map and explore. Drive old logging railroad beds and follow horse and hiking trails cut by Dr. Schenck's forestry students or built by the CCC.

Within its 160,000 acres, Pisgah District offers nearly 400.0 miles of trails. Designated a National Recreational Trail in 1979, 30.0-mile Art Loeb Trail is the longest trail, much of it following George Vanderbilt's old property line. Departing Davidson River Campground, the trail crosses Pilot Mountain (5,020 feet), Black Balsam Knob (6,214 feet) and Shining Rock Wilderness before ending at Camp Daniel Boone Boy Scout Camp. A 1.5-mile spur trail leads to Cold Mountain (6,030 feet).

A forester uses a diameter tape to measure the diameter of a tulip poplar. *North Carolina Historic Photographs, D.H. Ramsey Library, Special Collections, University of North Carolina.*

Pisgah District is nationally recognized, protecting two of North Carolina's eleven national wilderness areas, Shining Rock Wilderness and the Middle Prong Wilderness. The state's only national historic site located in a national forest, the Cradle of Forestry, preserves America's first forestry school campus. Pisgah's seventy-nine-mile Forest Heritage Scenic Byway is one of two national scenic routes in North Carolina.

In 1921, the USFS chose Pisgah to be home for the Appalachian Forest Experiment Station (now Southern Research Station). On lands once owned by Vanderbilt, Pisgah set aside 1,100 acres for the research center's forest laboratory. The Bent Creek Experimental Forest, the nation's third, received 5,200 more acres from Pisgah in 1935. Scientists continue valuable research to help maintain healthy, sustainable forests for the future.

DAVIDSON RIVER/FOREST HERITAGE SCENIC BYWAY

In 1916, rock masons formed two square columns near the Brevard entrance of the new eastern national forest. Engraved with large capital letters, a

smooth concrete arc spanned the roadway from pillar to pillar, welcoming visitors to "PISGAH NATIONAL FOREST." Symbolizing American pride, a bronze bald eagle landing on the arc's peak lifted its wide wings in a patriotic salute. Transylvania County schoolchildren helped raise money for its purchase. Two organizations, the Brevard Betterment Association and National League for Women's Services, provided two plaques commemorating the county's World War I veterans.

In 1936, when officials widened US-276 and removed the gateway arch, the eagle was perched on the right column. By about 1953, the bird had gone missing. Thirty-five years later, in a 1988 *Transylvania Times* article, Art Rowe, chief district ranger, told reporters that "someone in possession of the eagle may arrange an anonymous drop-off" by contacting him. "The eagle, if returned, could find a new nest at the Cradle of Forestry." The eagle never came home.

Visitors begin the Forest Heritage National Scenic Byway on US-276. A free brochure details historic stops along the way. Although buckeye trees now offer more shade than sycamores at Sycamore Flats, it's a great place for

Pisgah National Forest entrance. *Illustration by Tim Worsham.*

a picnic. Once the site of Davidson River Mill, harnessing river power for corn and iron products, it offers quiet solitude on misty mornings. Bankside fishermen wait, relaxed and unhurried. A silent couple walk with a dog; a gentleman re-circles the lot for cardiac or, perhaps, mental fitness.

Only the birds of Davidson River compete with the soothing comfort of the river's constant chatter of interrupted currents. Here primitive vocalists, like Acadian flycatchers and belted kingfishers, cannot match experienced songsters like black-throated green warblers, wood thrushes or scarlet tanagers. Hidden by dense canopies, tiny blue-gray gnatcatchers murmur insect-like whispers, claiming, "It's me. It's me." Heed hyper warnings from a Carolina wren. Is that its nest on the beam under the roof of the trailside exhibit? Highest of all, proudly exposed on a tip-top branch, an indigo bunting teases, "Fire, fire…here, here…hurry! hurry! hurry!"

Identify a large Carolina silverbell on the riverbank; look for its four-winged, club-shaped fruit. Find a maple, birch, oak, ironwood, locust, cherry, hickory, basswood, black gum, dogwood or hemlock. Trace its leaf and bark. Inspect its twig shape, size and buds.

Funded by the Forest Service, a picnic shelter at Sycamore Flats was built by twenty-three Youth Conservation Corps (YCC) members in 1974. That year, President Ford amended the original 1970 act creating a pilot YCC program to engage fifteen- to nineteen-year-olds in conservation projects on public lands. Approved on September 3, 1974, Public Law 93-408 read:

> *The Congress finds that the Youth Conservation Corps has demonstrated a high degree of success as a pilot program wherein American youth…have benefited by gainful employment in the healthful outdoor atmosphere…and by their employment have developed, enhanced and maintained the natural resources of the United States…the youth have gained an understanding and appreciation of the Nation's environment and heritage equal to one full academic year of study…the purpose of this Act to expand and make permanent the Youth Conservation Corps…to prepare them for the ultimate responsibility of…managing these resources for the American people.*

In national forests, the YCC removes exotic plants, restores campsites, repairs trails and performs numerous other duties. Other Pisgah District YCC improvements include the Wolf Ford shelter at South Mills River, Andy Cove Trail behind Pisgah Ranger Station, steps down to Looking Glass Falls, bridge over Davidson River, trout habitat restoration in Pigeon Creek and an observation deck on Mount Pisgah.

In 1977, fifty YCC workers upgraded the Pink Beds picnic area, building two retaining walls, digging drainage ditches to control erosion, digging foundations for picnic tables, replacing in-ground grills with pedestal ones and forming a stone trail to the bathrooms. The picnic shelter, constructed of chestnut logs by the CCC in the 1930s, was dismantled; each log was numbered as it was removed. Removing the nails was a difficult process, one youth noted. "They didn't have heads on them." With a new roof, the shelter was reassembled "like tinker toys," one said, maintaining CCC authenticity. Although the YCC has not served at Pisgah since the early 1990s, several other service organizations and volunteers perform these tasks with the Forest Service.

In 2002, North Carolina State University's Stream Restoration Program partnered with Pisgah National Forest and other agencies to rehabilitate six hundred feet of Davidson River at Sycamore Flats. Frequent visitor use had caused bankside erosion, stream sediment buildup and loss of aquatic habitats. Workers improved stream flow, stabilized the riverbanks and created low-impact river access for visitors. Two years later, when remnants of a hurricane severely damaged the area, the Pisgah Chapter of Trout Unlimited restored the picnic grounds and river again. Elevated wooden fishing piers, a paved walkway, split-rail fencing, vegetative buffer zones and rock vanes redirecting floodwaters now protect eroding riparian zones and aquatic habitats. Plastic tubes collect waste fishing line. Educational exhibits inform the public.

Beyond Sycamore Flats Picnic Area, the Schenck Job Corp Corps facility, educating young adults for technical careers, lies in a valley across from the Davidson River Campground. On August 25, 2014, the U.S. Forest Service celebrated the fiftieth anniversary of the Schenck Job Corps. Participants planted a dogwood tree in front of the administration building, local forestry officials spoke and students provided a tour of the campus. A special appearance by "Dr. Carl A. Schenck," an actor portraying the headmaster of the first forestry school in America and the man for whom the center is named, highlighted the event.

Davidson River Campground makes a perfect base camp from which to explore the district. Flowing through the campground, the river provides both gentle currents to float on a tube or catch a fish and a deeper swimming hole for dipping. Campers can walk to English Chapel, founded in 1860. Other family campgrounds are located at North Mills River and Lake Powhattan.

Past the ranger station, Pisgah Riding Stables, a privately owned company, leads guided trips. FR-475 follows an old railroad bed to Looking Glass Rock

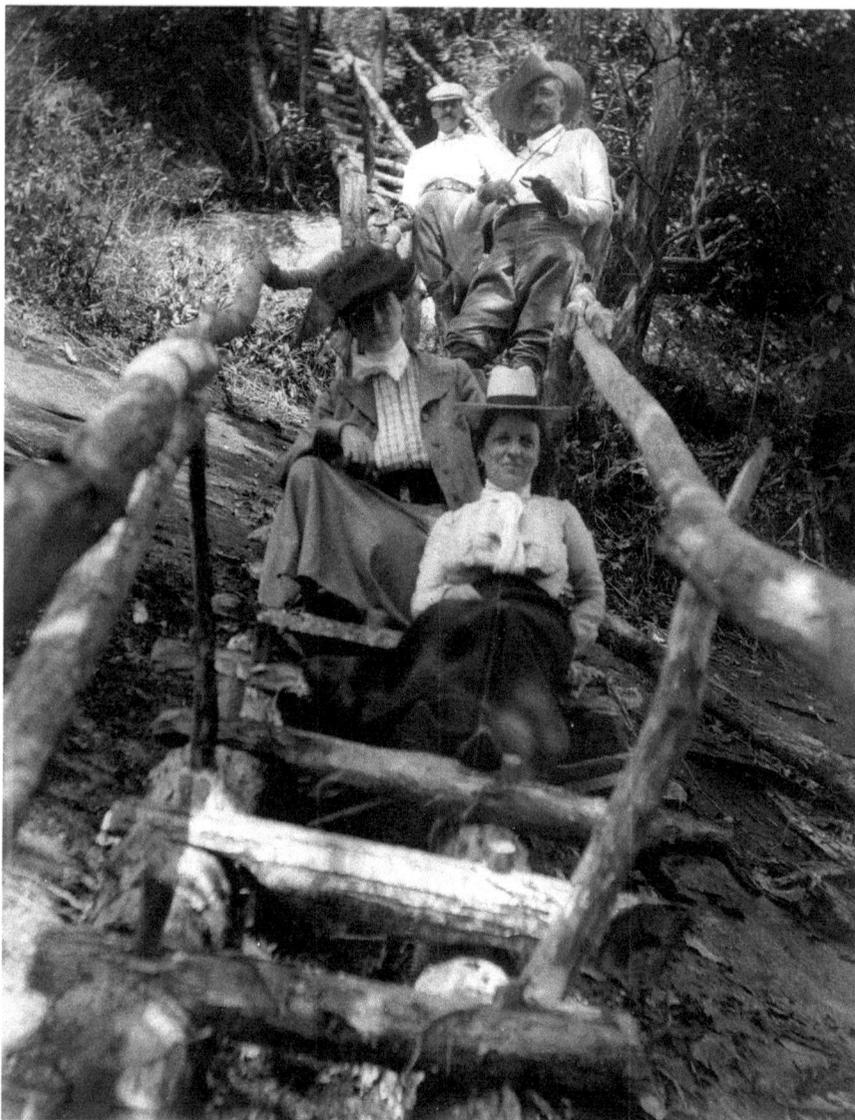

The Vanderbilts and friends descend a ladder on Looking Glass Rock. *From top to bottom*: George Vanderbilt, Dr. S. Westray Battle, Mrs. Edith Vanderbilt and either Miss Marion Olmsted or Mrs. Adele Schenck (Carl Schenck's first wife, as identified by Verne Rhoades). *North Carolina Historic Photographs, D.H. Ramsey Library, Special Collections, University of North Carolina.*

trailhead, a popular place for hikers, rock climbers and peregrine falcons. In about 1902, at the headwaters of Davidson River, Carl Schenck's men built Vanderbilt a cabin in three days near Looking Glass Rock. "Three-

Day Camp" had six bedrooms, a dining room with kitchen and a shed for livestock. Dr. Schenck wrote in his autobiography:

One single red oak tree furnished all the split lumber required for floors, sides, roofs, and doors, the stump of the oak forming a huge table for teas... At this lodge, I had one of my most happy outings with the Vanderbilts... we had capital trout fishing and some glorious excursions over new trails to Pisgah Ridge, to the Balsam Mountains...and we climbed to the top of Lookinglass Rock on a series of rustic ladders.

By 1936, the CCC had improved roads to permit better public access to Looking Glass Rock. The Blue Ridge Parkway, then under construction, would pass nearby offering grand views of the monolith. A 1936 Asheville newspaper reported:

The Asheville Chamber of Commerce plans to publicize [Looking Glass Mountain]...*as one of the wonder spots in Western North Carolina. The spot's principle publicity in past years has come through the routine folders issued by the national Forest Service...The Chamber plans to stress the beauties of the location and put it on the list of outstanding scenic attractions.*

For a close-up view of Looking Glass Rock, consider circling around its base on graveled, sometimes rutted, FR-475-B. First, visit the Pisgah Center for Wildlife Education and Bobby N. Setzer Fish Hatchery at the John Rock Scenic Area. Managing Pisgah's fish and wildlife, the North Carolina Wildlife Resources Commission (NCWRC) offers interpretive trails, wildlife gardens and indoor exhibits at its educational center. Near the site of the original fish rearing stations, built by the CCC in the 1930s, today's fish hatchery raises thousands of trout in fifty-four raceways to restock North Carolina streams. At 3,500 gallons per minute, cold Davidson River and Grogan Creek water is diverted into raceways, simulating native aquatic requirements.

NCWRC manages six hatcheries in North Carolina, with four located near districts of Pisgah National Forest. Warm-water hatcheries are operated in Eastern North Carolina. Tablerock Hatchery near Linville Gorge is the state's only cool-water hatchery, raising muskellunge, walleye and smallmouth bass. Setzer Hatchery and the Armstrong and Marion Hatcheries near Grandfather Ranger District operate as cold-water hatcheries, raising more than 500,000 brook, brown and rainbow trout each year.

Below the dome of John Rock, the wildlife center occupies the former site of a Black Forest Lodge built by Dr. Schenck, the Carr Lumber Mill, two Camp John Rock CCC encampments and a Boy Scout camp. Beginning in the 1920s, a Scout camp also operated for fifteen years at Bent Creek. After moving the camp to Old Fort for three years, R. Lee Ellis purchased a former logging camp near Canton in 1939 to establish Camp Daniel Boone. In 1941, 5,200 soldiers marched from Fort Bragg in a fifty-mile-long parade through Western North Carolina to camp beneath John Rock for two nights. During Pisgah's early years, a Transylvania County newspaper reports, an army camp in a valley west of John Rock harvested black walnut trees for World War I airplane propellers.

After returning to US-276, an opportunity to go rock surfing is about two miles ahead. Fanning out over a smooth, granite, sixty-foot-high dome, Looking Glass Creek creates Sliding Rock, a natural water slide, polished smoother over the years by thousands of bold, jean-clad bottoms. The slide looks more daunting than it really is. Adults slide, too. The eight-foot-deep, forty- to fifty-degree splash pool at its base can be a cold, startling surprise.

Did Dr. Schenck's forestry students take the plunge in 1898 when they supposedly visited the site? Lassie did. When her fourteen-year-old fictitious co-star, Timmy Martin, left the television series, producers cast the famous collie in successive episodes with U.S. Forest Service rangers. Robert Bray, a former CCC corpsman and Seattle lumberman, was cast as Lassie's owner, Ranger Corey Stuart. In a 1960s episode filmed in Pisgah, Lassie went down Sliding Rock.

By 1973, the Forest Service had appropriated funds for improvements at Sliding Rock. In 1991, when numbers grew to five to six hundred sliders per day, Pisgah upgraded the attraction with better safety measures, bathroom facilities and parking spaces. Today, Pisgah reports that between one thousand and two thousand people slide the rock on peak summer days.

Visit one of Pisgah's many waterfalls. The most photographed, Looking Glass Falls, drops sixty feet over a rock ledge beside US-276. To preserve its beauty, George Vanderbilt excluded twenty-five acres surrounding the falls in his logging contract with Carr Lumber Company. Motorists follow Carr's railroad bed as the highway winds up past the falls.

The Forest Heritage Scenic Byway continues past the Cradle of Forestry and under the Blue Ridge Parkway to its intersection with NC-215. Here, outside the boundaries of the district, NC-215 heads south past Camp Daniel Boone and Lake Logan, covering the site of the historic Sunburst community since 1933. Motorists reenter Pisgah National Forest at Sunburst

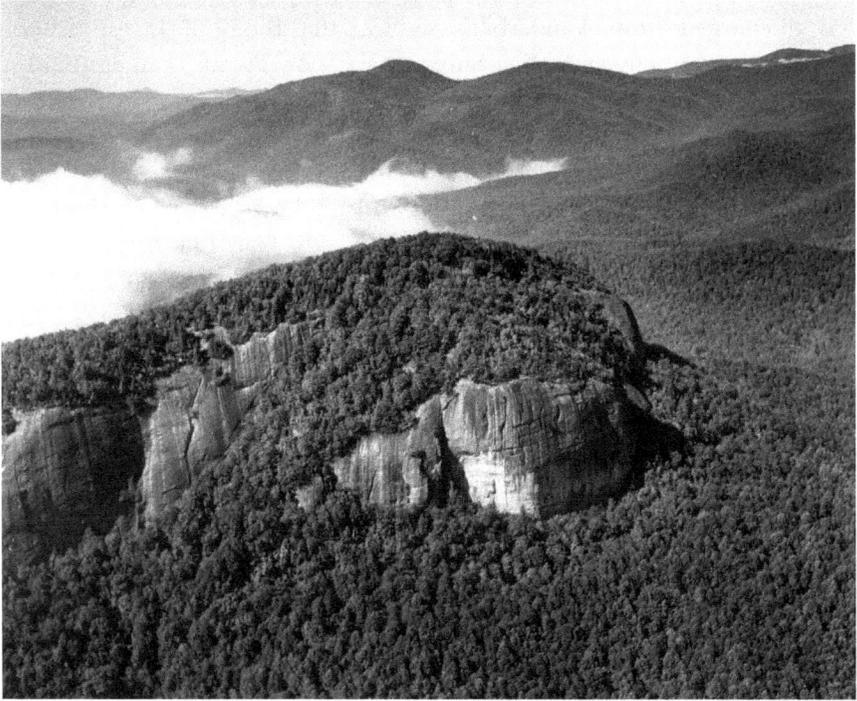

Looking Glass Rock. *North Carolina Historic Photographs, D.H. Ramsey Library, Special Collections, University of North Carolina.*

Campground. When Reuben Robertson moved from Ohio to oversee the Carolina division of Champion Paper and Fibre Company, he built Sunburst, one of the finest, most productive logging operations in the country.

Earlier, Robertson's father-in-law and the owner of the company, Peter Thomson, came south to locate a profitable logging site to supply wood for his pulp and tannin factory fifteen miles away in Canton. Standing in a valley near the three forks of the Pigeon River, while the morning sun burst over the mountain ridge, he found his place. "We'll call it 'Sunburst,'" he said.

Until Sunburst, Thomson bought wood to process into paper. Now, he owned his own ready supply of spruce, fir and chestnut trees. Impressed with the papermaking process, Carl Schenck visited Champion's paper mill in Ohio. "I could not help admiring," Schenck wrote, "a huge sheet of wet paper, some fifty feet long, floating between blasts of hot air as it was sprinkled with a fine crust of chalk, which in turn was pressed into the sheet from above and below by a series of heated cylinders." When Dr. Schenck

was discharged from Vanderbilt's service, the Biltmore Forest School headquartered briefly at the first Sunburst site, now Pisgah's campground.

The surrounding woodlands were part of a 1796 state land grant to David Allison, who had sold it to three families. Initially purchasing one thousand of those rugged acres in 1905, Champion eventually owned nearly thirty thousand acres in the region. According to Jerry Ledford, well-known train and logging historian and descendant of one of the Carr Lumber Company owners, the Whitmer Company of Pennsylvania purchased the Pigeon River Lumber Company at Mount Sterling, North Carolina, to create the Crestmont logging community. Located near the current Waterville exit off I-40, where the Appalachian Trail leaves the Smokies to cross the Pigeon River into the Appalachian Ranger District of Pisgah National Forest, Crestmont processed timber logged in the Big Creek area from 1911 to 1919. The area is now part of Great Smoky Mountains National Park.

In 1911, Whitmer formed a partnership with Champion Fibre to create Champion Lumber Company, processing saw logs for Whitmer and pulpwood for Champion's mill in Canton. With the timber resources at Crestmont dwindling rapidly, Champion Lumber decided to build a new double-band sawmill on the west fork of the Pigeon River to access huge stands of timber. Expanding operations required more space. They built the new mill and village in the area now submerged under Lake Logan, naming it Sunburst. The original Sunburst sawmill site was then called Spruce and is now known as the USFS Sunburst Campground. By 1913, Pigeon River Railway, leased by the Tennessee and North Carolina Railroad, provided service to Sunburst.

Early success encouraged the company to boost operations, expand production and purchase more logging equipment. However, profits fell short; impulsive decisions created excessive debts. In addition, the U.S. government cancelled a major contract. In 1918, when the Germans and Allied forces signed their peace treaty "on the eleventh hour of the eleventh day of the eleventh month," the government no longer needed Champion Lumber Company's spruce for World War I airplanes. Bankruptcy led to the reorganized company called Suncrest Lumber Company. When the Sunburst sawmill burned in February 1920, crews rebuilt the mill. Another fire in 1925, however, destroyed more than twenty-five thousand acres of timberland, ending Sunburst's logging operations. A regenerated forest has shielded any signs of log flumes, debris piles, giant logs waiting a band saw, log ponds and railroad tracks. A Forest Service campground and a trail access to Middle Prong Wilderness greet visitors instead.

NC-215 follows the border between Middle Prong and Shining Rock Wilderness and crosses the scenic cascades of the West Fork of the Pigeon River that some call "Sunburst Falls." The cascades tumble under a stone, arched highway bridge supposedly built in about 1937 by the CCC. After passing under the Blue Ridge Parkway, the highway traces the Jackson/ Transylvania County line (also Pisgah's boundary with the Nantahala National Forest). Balsam Grove is home to Pisgah Astronomical Research Institute (PARI). As a NASA tracking station in 1962, it was the "only one of its kind outside of Alaska." *The State* magazine in 1964 reported that this site was chosen "because of the quiet, peaceful environment, with a minimum of outside noises, airplane traffic and radio interference to confuse the delicate apparatus." In 1981, the center became the Rosman Research Station, tracking intelligence signals for the National Security Agency. When it closed in 1995, the Forest Service considered dismantling it. However, in 1999, scientists converted the facility into an educational research site. Weekly guided tours, night sky camps, citizen science projects and student programs involve the public.

Off Tanasee Gap Road at Balsam Grove, a small sign reads, "Old CCC Camp Road." Now a small residential community beside the North Fork of the French Broad River, the area once housed Camp Gloucester, Balsam Grove CCC Camp, F-14. Arriving by train in Brevard from Fort Bragg, some recruits went to the North Mills River CCC camp; others were trucked to Balsam Grove. Balsam Grove men quarried stone to improve roads and build rock bridges on NC-215 between the camp and the Parkway. CCC Camp F-25 at Sunburst continued the project on the opposite side of the ridge.

In 1938, the camp's newsletter, *Balsam Breeze*, announced that the camp was closing: "F-14 is the last CCC camp in this division of the Pisgah Forest." Fifty men were dispatched to a side camp "for a long stay across the mountain at abandoned Camp F-25 at Sunburst…By the end of the summer, we will be widely scattered…at fawn farms, campgrounds" and at Camp John Rock. Camp John Rock, F-1, the first CCC camp in North Carolina (and, according to CCC documents, a former camp hideout "used by a band of raiders in the Civil War"), had closed a year or so earlier; the barracks had been dismantled. Moving buildings from the closed, temporary CCC camp at Bent Creek, officials established the second Corps encampment at John Rock, Camp F-28.

Men at the new Camp John Rock built roads, trails and fish hatcheries. Bank mulching and reseeding reduced erosion. The most prized assignment was caretaker of the Pink Beds Family Campground. One season, supervisors

chose George E. Buchanan for campground duty. In his 1985 booklet *My CCC Days*, he wrote:

> *I spent the winter of 1935–36 at Balsam Grove, where I worked at a number of different jobs. Among other things, I helped build concrete bridges on the road leading to the present Parkway; helped clear roadside of underbrush…helped to fight numerous forest fires—most of which got started late at night or in very remote areas. The rumor was that many of these fires were started by locals needing a job…local men were hired to help put out the fires. I shall always have a lot of respect for firemen and fighters of forest fires.* [I have] *memories of the blood-shot eyes from the smoke, and the loss of sleep, the long treks by truck and then on foot…the danger of the wind changing, turning the fire back on you with falling limbs…and coming across a rattlesnake awakened by the fire.*
>
> *In the Spring of 1936, I worked with a CCC crew on campground clean-up and preparation projects. When the season for summer visitors arrived…Clinton Thomas and myself were established as care-takers of the family campground at Pink Beds in Pisgah National Forest…located right beside the "The Cradle of Forestry."…The Forest Service established a fawn farm near the campground…*[and] *rented Holstein cows from Brevard College…the men milked them and then fed the milk to the little deer…they were fed by a baby bottle until they learned to drink directly from a pail…a man could feed 3 or 4 at a time.*

Enrollees have returned to share memories at Balsam Grove CCC camp reunions and at the 1983 fiftieth-anniversary reunion at Pink Beds.

The Forest Heritage Scenic Byway arrives at Rosman, the site of Joseph Silversteen's industries. Silversteen purchased twenty thousand acres in the "Gloucester Township" from Vanderbilt in 1911 and opened a lumber mill and tanning business. The highway from Balsam Grove to Rosman follows his old railroad bed. Eventually, Pisgah acquired nineteen thousand of his logged acres.

CRADLE OF FORESTRY AND PINK BEDS

"These are the inducements…," Carl A. Schenck promoted in 1908, publicizing the first Forest Festival. More than one hundred years later, visitors attend the Cradle of Forestry's annual Forest Festival Day,

Physically limited after a stroke, Dr. John Spencer found the Forest Festival Trail at the Cradle of Forestry in America easily accessible. *Photo by the author.*

perpetuating Schenck's educational vision. Families follow a similar path, learning scientific forestry principles like 1908 participants did. They stand where Biltmore Forest School students discussed forestry regeneration.

Celebrate a twenty-first-century Forest Festival Day, not only commemorating a tradition but also celebrating cultural history, forestry education and wildlife management. Observe craftsmen demonstrating spinning, blacksmithing, wood carving and pottery. Cheer on forestry students cutting, chopping, rolling and splitting logs the old-fashioned way. Learn about logging railroads. Tie a fly and cast it. Hold a bow; shoot an arrow. Make a "tree cookie" with a crosscut saw.

Designed by a USFS landscape architect, the Forest Festival Trail opened in 1983 with designated educational stops along the way. After the restored 1914 Climax engine and log loader arrived, crews placed them halfway down the trail on narrow-gauge railroad tracks outside a portable sawmill. Workers then hard-surfaced the trail and added informative exhibits.

Floyd Rose was there on opening day. He was an old "locomotive man… firin' a lokey [shoveling coal]…keeping the steam on 'er" when he was fifteen years old. At age eighteen, he was a fireman for Blackwood Lumber Company in Jackson County, North Carolina. As a retired resident of Brevard at age seventy-two, he learned that the Forest Service was bringing a Climax engine to place on the Forest Festival Trail. After applying for the job, officials chose Rose to be the caretaker of the Cradle's Climax historical exhibit. Once again, he was a "locomotive man."

Based at Smokemont in the Great Smoky Mountains, Climax Engine no. 3, designed to navigate steep mountainous terrain, began her career in 1914 pulling loaded logging cars for Champion Fibre Company. In 1930, Champion put her to work in forests near Robbinsville. The engine was sold in 1947 and relocated to logging operations for Ely-Thomas Lumber Company in Jettsville, West Virginia, where she was retired in 1955. Two Michigan railroad historians purchased the engine but never had the funds to restore her. A Mars Hill College student, on assignment for the Forest Service, found Engine no. 3 in Ann Arbor, Michigan. In 1973, the Forest Service paid $13,000 for the Climax engine, an American Steam log loader, four log cars and about four hundred feet of rails.

After a failed arrangement in Georgia, officials shipped the rusted hull to Tweetsie Railroad Restoration Center. Sandblasted once and primed twice and then painted with industrial paint, followed by automotive coats, Climax Engine no. 3 was ready for the Cradle two and a half years later. Meticulous in detail, train restoration experts used the labor-intensive hot-riveted

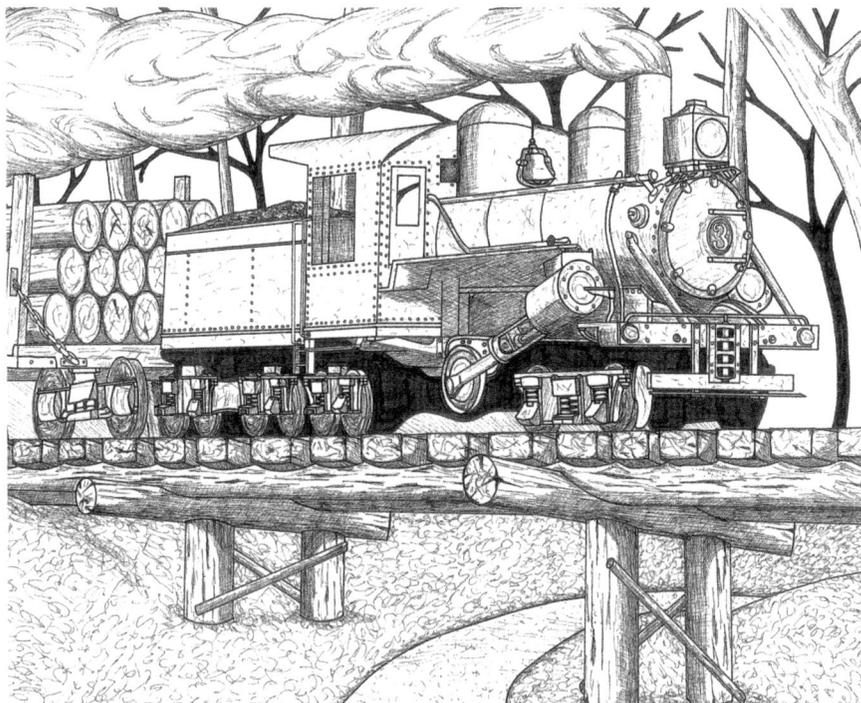

Climax Engine no. 3 pulls a logging load. *Illustration by Tim Worsham.*

method to repair metal parts rather than modern welding techniques. On dedication day, on the Forest Festival Trail, engineer Floyd Rose provided a spit-shine or two.

Each annual Forest Festival Day brings new opportunities. In June 1990, Gifford Pinchot's grandson Gifford Pinchot III spoke at Forest Festival Day before visiting George Vanderbilt's grandson William Cecil at the Biltmore House. In 1992, a groundbreaking ceremony on Forest Festival Day launched the Forestry Discovery Center project. That same year, the schedule included a helicopter water drop by the North Carolina Forest Service. In the past, military pilots have practiced firefighting water drops over Forest Service lands. Flying the large, low and slow C-130s dropping three thousand gallons of water, pilots aimed targeted water drops in a dozen or so practice flights per day. In the management of wildfires during the past ten years, properly equipped C-130s dropped an average of 910,000 gallons per day.

Twenty years earlier in the southern Appalachians, Secretary of Agriculture Orville Freeman celebrated the fiftieth anniversary of the Weeks Act, during which "he toured the slopes of Mount Pisgah" and the site of

the first forestry school. This historic site should be preserved, he believed. Turning idea to spade on September 26, 1961, Secretary Freeman and Chief of the Forest Service Richard McArdle hosted the groundbreaking ceremony for the Cradle of Forestry in America.

In Pisgah, "systematic forestry took some of its significant first steps—steps that since have become giant strides," said Assistant Secretary of Agriculture John Baker in October 1964, dedicating the cornerstone for the original Cradle of Forestry Visitor Center. The cornerstone placed by Chief of Forestry Edward P. Cliff and other officials contained a time capsule (to be opened in one hundred years) with letters from President Johnson, Freeman and Cliff.

More than seven hundred people attended the ceremony, including members of the American and the North Carolina Forestry Associations. On the previous day, during the Eighty-ninth Annual Meeting of the American Forestry Association at the Battery Park Hotel in Asheville, members heard Verne Rhoades, Pisgah's first superintendent and a graduate of Biltmore Forest School, speak on the history of forestry in America. By 1966, the historic site had opened for visitors. On July 12, 1968, Congress passed Public Law 90-398, officially creating the "Cradle of Forestry in America."

The *Greensboro Daily News* of August 1969 noted: "The sun's rays fought their way through the blanket of greenery knitted by the trees. The cone of light spotlighted the old school house. It was not difficult to recognize that structure belonged to another era." Biltmore Forest School alumni had collected money to reconstruct their old schoolhouse. With the aid of old photographs and the firsthand knowledge of Biltmore graduates, particularly Verne Rhoades, other campus buildings were opened for visitors to learn about student life under the tutelage of Carl Schenck. The first visitor center held forest history displays and old tools and showed a movie on forestry practices.

In 1974, U.S. Forest Service chief John R. McGuire visited the Cradle of Forestry. He toured Sliding Rock and Pisgah Ranger Station and lunched at Schenck Conservation Center. That afternoon, at the Biltmore Estate, he spoke at a ceremony honoring the republication of Dr. Schenck's book, *Birth of Forestry in America*.

To assist the Forest Service in its environmental education efforts through programs and outdoor recreation, the Cradle of Forestry in America Interpretive Association (CFAIA) was formed in 1972—one of the first associations of its kind in the Forest Service. Partnering with other organizations, the USFS and CFAIA seek to increase public awareness of conservation issues.

By the late 1970s, only two of the fourteen Black Forest Lodges built by Dr. Schenck remained in Pisgah. Constructed in a typical German style, the lodges housed Schenck's forest rangers. Behind a truck, the Forest Service towed the Rock House Creek Lodge to the Cradle of Forestry Campus Trail. During the winter of 1978, when vandals threatened the survival of Cantrell Creek Lodge, the Young Adult Conservation Corps dismantled the historic structure. Section by section, a helicopter ferried the heavy, hand-hewn chestnut lumber five miles from creek to Cradle. The Verne Rhoades estate furnished the funds. In the reassembled structure, a plaque in tribute to Rhoades—the author, some say, of the title "Cradle of Forestry"—is displayed in the Cantrell Creek Lodge.

The morning news on April 18, 1985, shocked the local community. During the night, a fire had destroyed the Cradle's visitor center. The news spread quickly, but not as fast as the intense flames, ignited by electrical sparks, that had consumed the building. Art Rowe, the new Pisgah District ranger, had barely moved into his new role. He had only been to the center once. But rebuilding the visitor center became an instant priority. In the interim, the Biltmore Forest Schoolhouse functioned as the center. The groundbreaking for a new visitor center was held in 1987, and it opened the following year. CFAIA worked with the Forest Service, campaigning to raise more than $1 million to help with funding.

The new Visitor Interpretive Center had grown into a new exhibit hall by 1997 and the state-of-the-art Forest Discovery Center by 1999. Hands-on displays, films and ranger-led activities detail natural history, environmental issues and forestry management principles. Children can simulate a firefighting helicopter flight in the museum.

In the Carl A. Schenck Education Hall, German forestry books authored by Dr. Schenck, his combination walking and sitting cane, his unique hearing aid and a seventeenth-century hunting knife presented to him by the president of West Germany are on display. A coveted Biltmore Forest School pipe, donated by 1909 graduate Gustav A. Schultze, is also preserved.

Schenck's birding telescope is another treasured artifact. In 1992, John Palmer, retired board member of CFAIA, presented Schenck's scope to Art Rowe. While in Belgium for a forestry conference, Mr. Palmer, retired from Haywood County Community College's forestry department, had taken a detour to Dr. Schenck's hometown, Lindenfels, Germany, to meet his family. Schenck's niece, Ollie von Schenck, gave Palmer the telescope and other items now on display in the Education Hall.

"BALLAD OF TOMMY HODGES"

Lyrics by Jere Brittain, grandson of Minnie Sitton and John Gillespie, cook and gamekeeper at the forestry school. Tune: "Pretty Saro," an English ballad from the early 1700s, sung by many, including Judy Collins, Bob Dylan and Jean Ritchie, who scored the tune for the mountain dulcimer. Jere learned the tune from his music mentor, Ken Schoewe of Mountain Music School, Hendersonville, North Carolina.

At the foot of Mt. Pisgah
Near the springs of South Mills
Lives a legend that's told
Through these valleys and hills.
His name was Tommy Hodges;
That's all that I know.
Where did he come from?
And where did he go?

One of Doctor Schenck's boys
At the forestry school
He was a bright scholar
But a hard one to rule.
He could ride like the north wind
And bark-shoot the squirrels;
He fought like a panther
And danced with the girls.

One night at the Hell Hole
Schenck's boys parted late;
Tommy said he was leaving
For a mystery date.

He went to the stable
And saddled his horse;
By sunrise next morning
There would be great remorse.

Tommy met Mary Lindsey
Down by the shed;
She climbed up behind him
And the young lovers fled.
Old Silas ran out
Of his house with his gun;
He fired shots in anger
But the deed had been done.

Tommy Hodges and Mary
Were ne'er seen again.
Can anyone tell
How their story did end?

His name was Tommy Hodges
That's all that I know.
Where did he come from?
Where did he go?

On the Campus Trail Tour, visit the commissary, Schenck's office, Black Forest Lodges and the King House. Built in 1882 by Hiram King, the oldest preserved structure at the Cradle served as a ranger's residence. When it received a new roof in 1990, Pisgah's red oak trees furnished a Burnsville, North Carolina craftsman with the wood to create authentic replacements. Once split and then dipped to darken and preserve, new shakes covered a second-level plywood rooftop raised above the original. One roof foundation spaced above another permitted wet shakes to dry to prevent rotting in rainy weather. The King House has been designated as a historic site on the National Register of Historic Places.

On the campus, listen to audio systems describing activities at each site. Go to school. See the students' quarters. Nailed to the wall near a snakeskin is a winning poker hand. In October, participate in an imaginary tale. For more than eighteen years, the Cradle of Forestry has presented an outdoor drama, *The Legend of Tommy Hodges*, each year's tale told with a different twist. Character personalities and the play's script are based on original Biltmore student diaries.

At the Cradle of Forestry, indoor educational exhibits enrich outdoor experiences in the surrounding forest. In June 2006, *Our State* magazine quoted Cindy Carpenter of the USFS Education and Interpretation Curator: "I try to help people make the connection to the land and to the resources, and to tell the story of what the Cradle of Forestry means in our lives today…This is a place where people can fall in love with the forest."

The Cradle of Forestry occupies a portion of the 6,500-acre property known as the Pink Beds, a "great bowl with mountains for the rim," wrote Gifford Pinchot in his autobiography, "and in the middle, in their seasons, the white and rosy blossoms of impenetrable thickets of the Laurel and Rhododendron which gave the place its name." Others claim that rosy-pink phlox and other wildflowers gave the valley its name. At the Pink Beds Picnic Area, the CCC-constructed picnic shelter has received upgrades. In 2010, the American Recovery and Reinvestment Act funded renovations on the picnic shelters, three Cradle of Forestry buildings, the English Chapel Bridge across Davidson River and the Frying Pan Fire Tower. The Pink Beds Loop Trail passes though multitudes of wildflowers, including some specialties at a mountain bog.

In 1973, "the good doctor ordered us to bed," a journalist wrote, "the Pink Beds in Pisgah Forest, that is." When Dr. Harley Jolley, president of Mars

The Pink Beds Picnic Area provides ample opportunities to teach the next generation. Max Lance helps his granddaughter, Christi Worsham, identify a bird species. *Photo by the author.*

Hill College and seasonal interpreter for the Cradle of Forestry, offered a class at Asheville-Buncombe Community College entitled "Local History Research Methods," attendance overfilled the assigned classroom. So, he announced a change of venue. The class was moved to the Pink Beds. Dr. Schenck would have been amused.

Mount Pisgah/Bent Creek Experimental Forest

In the year Pisgah National Forest was born, Asheville held an art competition. The city needed a seal, an emblem that best reflected its character, community values and local heritage. The seal of the City of Asheville would eventually be engraved in marble and hang above the brass entrance doors of city hall. A jewelry store engraver designed the winning entry. For a twenty-five-dollar prize, Harry Sage centered an image of Mount Pisgah and the Rat in a circular emblem enclosed by the words *Levo oculos meos in montes* ("I will lift up"). Residents of Asheville, Hominy Valley and surrounding areas have lifted up their eyes toward Mount Pisgah for inspiration. Schools, churches and private businesses have adopted its name.

Pisgah, the Hebrew word for "summit," first appeared in reference to Mount Pisgah in 1808. Dr. F.A. Sondley wrote that "in the act of creating the county of Haywood...there is a call for a line along the ridge dividing the waters of Pigeon and the French Broad River to the top of Mount Pisgah." At 5,271 feet, Mount Pisgah rises above the valley floor like a beacon signaling the way to safety. "Stand where you will on almost any elevation [in the area]," a 1951 Asheville newspaper noted. "Mount Pisgah is within view—an ancient landmark, beautiful in its form and ever mindful of the peace and quiet of the hills."

George Weston, an architect and former superintendent for Biltmore Estate, wanted to be close to Pisgah. About two miles south of George Vanderbilt's Buck Spring Lodge on Pisgah Ridge, Weston designed and built his Pisgah National Forest Inn between Big Bald and Little Bald Mountains at Flat Laurel Gap. Breaking ground in 1918, Weston constructed the inn on land leased from the Forest Service. A 1920s postcard labeled "Mt. Pisgah Inn" shows a luxurious interior lobby, with a central staircase, a stone fireplace and a grand piano. A butter churn sat beside the hearth.

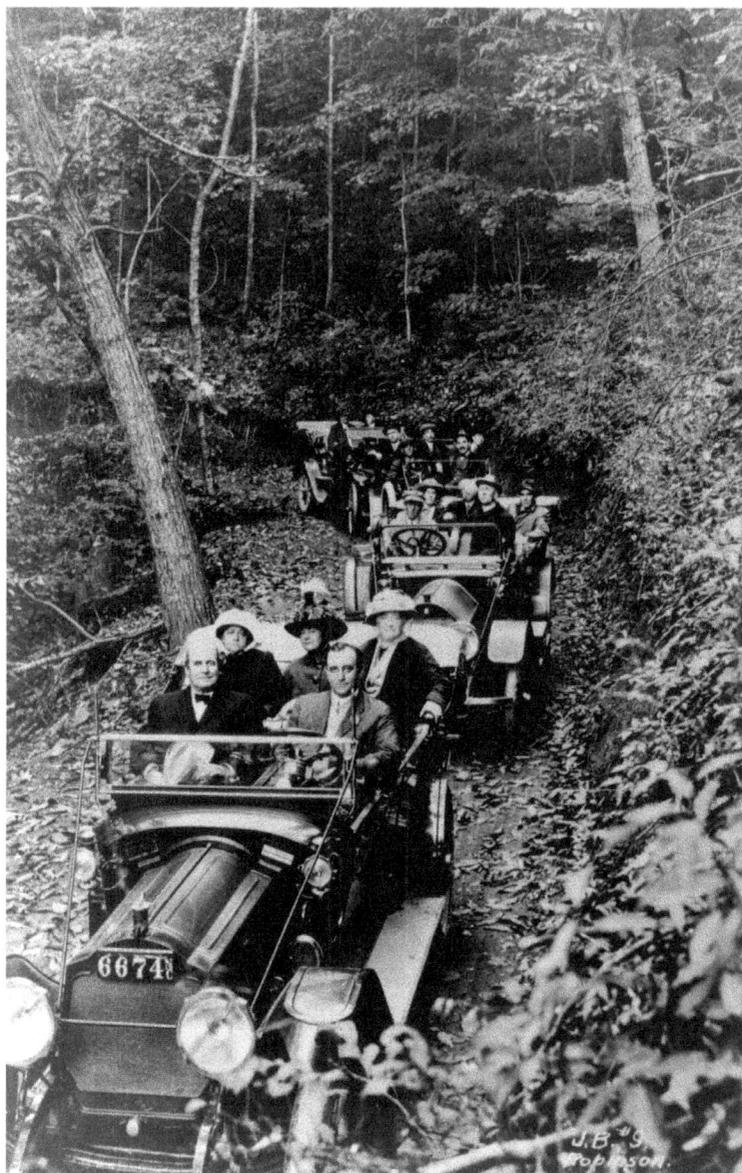

Secretary of State William Jennings Bryan took a road trip to Mount Pisgah about 1918. W.J. Bryan (left) and Fred Loring Seely are in the front seat in the first car; their wives and another woman ride in the backseat. Congressman and Mrs. James M. Gudger, Harry A. Durham, Donald Gillis and a driver ride in the second car. The third car holds Frank M. Weaver (president of the board of trade) and four others. W.J. Bryan purchased Blue Briar Cottage on Sunset Mountain near Asheville from E.W. Grove of the Grove Park Inn in about 1914. *North Carolina Collection, Pack Memorial Public Library, Asheville, North Carolina.*

As landlord, the Forest Service leased its lands to small, private businesses, summer camps, the Boy Scouts, churches, companies needing a right-of-way for power lines and other uses. At one time in Transylvania County, the board of education leased lands in Pisgah to operate a school. In September 1934, the USFS formally established a "special-use fee" policy charging tenants slightly less than personal property taxes would have cost. Like Point Lookout roadside concessions near Old Fort in the Grandfather District, privately owned Pisgah Inn served national forest visitors. When Pisgah Inn opened in 1920, some patrons traveled by the old Vanderbilt Motor Road. Under the management of the new Pisgah National Forest, the route became known as Pisgah Motor Road (now NC-151).

Weston operated Pisgah Inn for eighteen years. During the war years, business slowed; the national conscience, focused on global concerns, found little time for personal pleasures. Pisgah Inn deteriorated from disuse. In 1952, new owners refurbished it. After the new Blue Ridge Parkway tunneled through Little Pisgah Mountain, curved past Mount Pisgah at Buck Spring Gap and followed Pisgah Ridge on its way to the Smokies, the National Park Service became the inn's new landlord. A more modern Pisgah Inn was opened just north of the original one.

"Last of the Vanderbilt Lands Acquired by the Parkway," announced a Transylvania newspaper on August 20, 1959. George Vanderbilt's widow and owner of Buck Spring Lodge died in 1958. Parkway officials began earnest negotiations with her descendants. The location of the lodge on narrow Pisgah Ridge complicated plans for the roadway's construction. After many discussions and difficult decisions, agreements were reached. Parkway leaders instructed North Carolina to purchase Buck Spring Lodge and its 471-acre estate. The state would direct the demolition of all of Buck Spring's buildings, except the "Honeymoon Cottage" and springhouse, before transferring ownership to the National Park Service.

In August 1990, the national park decisions, unpopular with preservationists, resulted in the demolition of the rustic, original Pisgah Inn. "The inn's doors, fireplace mantle, staircase and chestnut paneling were kept for future use," reported a local newspaper. "The rest is in the Haywood County landfill." The current proprietors have managed Pisgah Inn for twenty-eight seasons, but their ten-year contract expires on December 31, 2014. In April 2014, the National Park Service issued a "prospectus for a concessions business opportunity...at Pisgah Inn."

In 1953, Asheville's new television station, WLOS-TV ("Wonderful Land of the Sky") moved its transmitter antenna from West Asheville to the

summit of Mount Pisgah. At the time, the East's second-highest television antenna (behind WMTV-TV on Mount Washington, New Hampshire) rose above Pisgah's peak 339 feet.

UHF signals normally allow only limited reception in mountainous terrain. But WLOS-TV's new UHF tower atop Pisgah could transmit unhindered providing service to one of the widest coverage areas in the country. Transmitters for an FM radio station, a University of North Carolina educational station and a Greenville/Spartanburg weather channel for the National Weather Service have shared space on WLOS-TV's antenna. In 1972, a Federal Bureau of Investigation (FBI) transmitter was installed on the tower.

Facing Cruso and hidden from Blue Ridge Parkway visitors, a three-thousand-foot-long cable car railroad plows straight up Pisgah's steep slope, reaching grades of up to 56 percent to transport TV tower engineers and equipment. One maintenance man, employed for more than fourteen years servicing the tower on Pisgah, enjoyed the magnificent views, a working environment almost unmatched in spectacular beauty. It had its own unique workplace hazards, though. Snow fell in every month except August. Ice on transmitters could freeze a foot thick, and snowdrifts could mound twenty feet deep. Lightning strikes were frightening. The most alarming hazard, however, was being trapped in the transmitter station with a nosy black bear.

Climb Pisgah. If you can, you must. Views of Pisgah National Forest to the north and east are superb. On a clear day, the Biltmore Mansion near Asheville can be seen. To the west, Shining Rock Wilderness and the graceful folded slopes of massive Cold Mountain dominate the landscape. Despite the fact that decades ago, ladies from Buck Spring Lodge and Pisgah Inn climbed the rocky path in long skirts and heels, laced-up boots or sturdy walking shoes and a trekking pole or two aid loose footholds on the return descent.

From the trailhead at the Mount Pisgah parking lot on the Parkway, a level pathway crosses national parklands before entering Pisgah National Forest near the first ascent. The climb becomes steeper approaching the top. Lower-elevation northern hardwoods relinquish rooted land claims to dense, heath-covered communities near the summit. Entangled rhododendron, laurel and fetterbush cross branches above shiny, deep-green gardens of wavy-edged galax. High-elevation songbirds like Canada and chestnut-sided warblers add a splash of gold. A veery's eerie song, like a musical flute echoing in a hollow chamber, penetrates forest coves and the human spirit.

Visit the Buck Spring Lodge site. From the south side of Mount Pisgah's parking lot, climb the rock steps to the ridge where the main lodge sat or walk

straight ahead past the rock retaining wall built along the lodge entrance. Profuse wildflowers bloom in spring and summer. Find the springhouse. Find remnants of the lodge foundation and the root cellar. Look east into Big Creek Valley, the site of Pinchot and Schenck's splash dam project; the North Mills River area below Laurel Mountain, known for its excellent backcountry hiking, biking and horse trails; and the Pink Beds, home of the Biltmore Forest School. Gifford Pinchot stood here once surveying the land for George Vanderbilt. Dr. Schenck stood here, too, planning scientific forestry methods for Pisgah Forest. The six-mile walk on Buck Spring Trail follows Dr. Schenck's primary route from Mount Pisgah to the Pink Beds.

South on the Parkway, Pisgah Inn and Pisgah Restaurant are located across from the Pisgah Recreation Area. Frying Pan Lookout Tower, built by the CCC, still claims a mountaintop near the campground. The Blue Ridge Parkway bisects the district, with overlooks that offer extraordinary views of Pisgah's Shining Rock and Middle Prong Wilderness, Looking Glass Rock, John Rock and Courthouse Creek Valley. Yellowstone Falls and other trails entice visitors at Graveyard Fields. Painted trilliums profusely bloom there in late spring. Devil's Courthouse, where high rocky cliffs made ideal perches for reintroduced peregrine falcons in the 1980s, rises above the headwaters of the French Broad River. Pink-shell azaleas bloom in May.

North of Mount Pisgah near the Blue Ridge Parkway, the Bent Creek Experimental Forest is located on land that was once part of George Vanderbilt's estate. According to the USDA Forest Service booklet *Introduction to the Southern Research Station*, the Forest Service purchased land in the Bent Creek Valley for one dollar per acre. In 1921, the Forest Service created the Appalachian Forest Experiment Station in Asheville to study reforestation and erosion control and to demonstrate forest management methods. After combining Asheville's station with the Southern Forest Experiment Station in New Orleans, the organization became the Southern Research Station, headquartered in Asheville. Part of the largest forestry research organization in the country, Southern Research Station serves thirteen states. One of its many living laboratories, the Bent Creek Experimental Forest was its first, opening in 1925 on 150 acres in the Pisgah Ranger District.

From the mid- to late 1920s, the Forest Service established the Bent Creek Experimental Station, extending the area to 1,100 acres, building a laboratory, mapping the experimental forest and building concrete reservoirs. In the 1930s, when the CCC improved the facility through projects, such as building the four-mile Hardtimes Road though the experimental forest, the Forest Service expanded the area to 6,300 acres. Cutting chestnut for

beams and oaks for shingles, other public-relief workers built laboratories, a bunkhouse, an insectory and other buildings. It retains its rustic history today; in 1993, the National Register of Historic Places recognized its significance.

With its history of traditional logging practices located in an important watershed and its mix of upland forest hardwoods (oak, hickory, yellow poplar and pine), the site for the Bent Creek Experimental Forest was perfect for southern Appalachian forestry research. Its early research, under the guidance of its first director, Earl H. Frothingham, included studies on restoring deteriorated hardwood forests. Scientists began studied reforestation techniques, timber management, insects, erosion control to protect watersheds and the effects of prescribed burning. In a nationwide effort to find methods to reduce resource damage from forest fires, researchers at Bent Creek developed a "fire danger measurement rating system" and a fire visibility meter.

By the 1960s, researchers had responded to a change in the social and governmental focus on ecosystem management. Plants and animals that depend on the forest became as important as a forest full of healthy trees. Researchers study such things as the effects that understory thinning have on wildlife and the effects that forestry practices have on acorn production. By reducing the size of research plots at the Bent Creek Experimental Forest, scientists could conduct studies on the natural regeneration of hardwoods with a more detailed understanding of each site's characteristics. Currently, researchers concentrate their studies on the regeneration of the northern red oak, site classification, hard and soft mast (nuts and acorns) production and the effects that natural disturbances, prescribed burns and timber management have on wildlife.

Since the late 1980s, Bent Creek Experimental Forest has provided demonstration programs and forest trails for the public. At the education and training building, published information is available and staff are available to answer questions. By appointment, groups are provided guided tours of the experimental forest.

The Forest Service set aside three hundred acres in Bent Creek for recreational purposes from the 1940 to the 1960s, leaving six thousand acres for the experimental forest. Exhibits along graveled roads and trails explain silvicultural treatments. Out of respect for the ongoing scientific studies, the Forest Service asks that visitors stay on designated trails. Hardtimes Road is a popular route for cyclists. Many Bent Creek hiking trails also support bike and hoof traffic. In season, Bent Creek's trails are also open to hunters.

"Trees of Pisgah"

By Ila Hatter, interpreter/naturalist for Great Smoky Mountains Institute, author of Edibles and Medicinals of Southern Appalachia *and host of* UNC-TV (PBS) Folkways *program.*

Trees have been the object of reverence and symbolism for centuries. That's because a tree has more gifts beyond firewood and furniture. They are as unique as people, with as many stories to tell. Take a walk among the "Tree People" and experience their gifts of peace and regeneration.

1. 125,000 red spruce trees (*Picea rubens*), donated by the NC Division of the United Daughters of the Confederacy in memory of 125,000 North Carolina soldiers in the Civil War, were planted by the Forest Service between 1942 and 1943 on 125 acres near Milepost #422 on the Blue Ridge Parkway. The area had been a site of extensive logging before the USFS acquired it.

2. Sweet Birch (*Betula lenta*), or "Cherry Birch": Since the sap contains methyl salicylate, molecularly close to aspirin, it has been added to medicinal formulas. The sap also tastes like wintergreen and has been commercially sold for that flavoring. Old-time toothbrushes were often birch twigs with a flattened end. "Birch Beer" was a mildly fermented beverage made when the sap could be tapped in the spring.

3. Tulip Poplar (*Liriodendron tulipifera*): Indians knew it as the "Ga nu tree" or canoe tree. Others called it the "Pom-a-Gilly" tree, mistaking it for the true poplar, which made a salve from leaf buds called "Balm of Gilead." The large, colorful flowers are still one of the greatest sources of nectar for honeybees.

4. Mountain Ash (*Sorbus americana*): Known in Europe as the "Rowan" tree. Here it is found only in the "Canadian" zone. Its leaves turn yellow-gold in autumn. Every three to four years, it produces clusters of bright orange-red berries. The English make a preserve of rowan berries and crabapples to serve with meat dishes. Appalachian black bears relish the berries as well.

5. Serviceberry (*Amelanchier arboreum*): Locals called it "Sarvis." Its early white blossoms told residents that the circuit-riding

preacher could arrive for the first church service, or "sarvis," of the year. The fruits vary in sweetness but are gathered for jelly.

6. Sourwood (*Oxydendrum arboretum*): The name comes from its sour leaves. A tea from the leaves treated urinary problems. White flowers resemble lily of the valley. Bees love the blooms. Sourwood honey is highly prized for its light color and taste. Arching trunks and limbs made runners for sleds.

7. Basswood, Linden (*Tilia americana*): Bees love its fragrant flowers. The flowers also make a nerve-calming tea. From the bark, pioneers made a strong cordage or a poultice for snakebites. The wood is lightweight and a favorite with Cherokee carvers. On the farmstead, it was ideal for food containers and crates.

8. Sassafras (*Sassafras albidum*): Called "the Good News out of the New World," it was the first export from American colonies. Indians knew the healing powers of its leaves and roots. Settlers made a tea for a "spring tonic" to "cleanse the blood." As the first medicine to treat hypertension, it is a blood thinner. Powdered leaves were used to heal wounds and to thicken broth.

9. White Pine (*Pinus strobus*): The needles of this pine species grow in bundles of five. Since the needles contain vitamin C, they were used in teas to treat colds and flu. As a tall, straight tree, the wood is used in construction millwork, trim and pulpwood. The pinecones are used in natural crafts.

10. Dogwood (*Cornus florida*): When dogwood blooms are the "size of a mouse's ear," it's a sign for farmers to plant above-ground crops. Migratory birds benefit from its red berries in the fall. Its shock-resistant wood makes great axe handles, log-splitting wedges and weaving shuttles. In the Civil War, the bark was substituted for quinine to treat malaria.

The nature trail and boardwalk at Lake Powhattan offer excellent birding opportunities. Anglers fish from lake banks. Swimmers enter at a sandy beach, reconstructed in 1978 of terraced, "pure white sand." To reduce erosion, Youth Conservation Corps members built the rock retaining walls

to hold the sand. The U.S. Forest Services manages the campground and the North Carolina Arboretum located in Bent Creek Valley.

SHINING ROCK WILDERNESS AND
MIDDLE PRONG WILDERNESS

In the heart of steep, rugged terrain, milky-white quartz forms massive boulders, crowning the top of 5,940-foot Shining Rock Mountain like enormous, hard-packed snowballs pushed aside by snowplows, hardened and smoothed by the elements of time. "An immense mass of quartz so white as to resemble loaf-sugar," wrote Senator Thomas Clingman in 1878, "standing like an immense edifice of snowy marble." On Shining Rock, nature mounded up crystalline quartz, the earth's second-most abundant mineral, into vast, ivory-colored monuments, drawing hikers to pay tribute.

Between Wagon Road and Beech Gaps on the Parkway, the wilderness of Shining Rock spans the north slopes of Pisgah Ridge into the Great Balsam Mountains. US-276 and NC-215 roughly define its eastern and western boundaries. Graveyard Fields, escaping wilderness designation, lies between the Parkway and Shining Rock Wilderness. Many hikers and backpackers enter the wilderness from the Black Balsam Parking Area on FR-816.

Like Linville Gorge in the Grandfather District, Shining Rock received its protective certification in 1964, when President Johnson signed the National Wilderness Act to protect wild environments from human impact. Only hoofs and boots leave trail imprints in wilderness areas. Map and compass aid orientation. Although Forest Service posts identify trailheads, painted markers along the trails are absent. Uncut timber grows wild again. Rocks and plants remain in nature's care; only berries, nuts and scientific data may be collected.

Beginning in 1905–6, Champion Fibre Company purchased spruce and fir forests of the Great Balsam Mountain range in the wilderness regions now known as Shining Rock and Middle Prong. After Champion Fibre joined the Whitmer Company to create Champion Lumber Company, crews built huge networks of railroads, now converted to hiking trails. In 1925, a logging railroad sparked a wildfire, scorching nearly twenty-five thousand acres of life dirt deep. Regeneration was slow. Logging ended. In 1926, Sherwood Forests Inc. of Asheville bought the property for

development but sold it in 1936 to the USFS. Like other abused southern lands that nobody wanted, those forty-four thousand acres received asylum as part of Pisgah National Forest.

Foresters planned to restore dense stands of spruce trees that once covered these slopes by planting trees. And yet, another fire covering thirteen thousand acres in 1942 hindered recovery efforts and re-burned five thousand acres healing from the previous fire. In 1943, the project was abandoned.

Shining Rock's scenic wild landscapes and its rich biodiversity of plants and wildlife within its two-thousand-foot elevation range prompted conservationists to take action. Bare mountain balds, rare and uncommon wildflowers, scattered remnants of the unique southern spruce-fir forest and distinctive geologic formations fueled Carolina Mountain Club's (CMC) passionate campaign to protect the region as a designated wilderness area. Working in cooperation with the Forest Service, mutual trust and respect fostered open, honest communications.

Since World War II, public interest in national forests had increased dramatically. Natural areas offered a wide range of outdoor recreational activities and a place for respite and relaxation. Forest Service goals expanded beyond conservation of natural resources and a commitment to sustainable forestry to meeting the interests of a diverse recreational community. When President Eisenhower created the Outdoor Recreation Resources Review Commission in 1958, officials began surveying the recreational resources of Western North Carolina forests. After the Multiple-Use Sustained Yield Act of 1960 directed the Forest Service to equally balance the management of wildlife, water and timber with outdoor recreation, one area proposed for recreational development was Shining Rock.

Other organizations, like the Nature Conservancy and the Wilderness Society, joined CMC's campaign. Knoxville attorney Harvey Broome, who led political campaigns to create the Wilderness Society and Great Smoky Mountains National Park, provided guidance. In 1962, an advocate for the Wilderness Bill, U.S. Supreme Court justice William O. Douglas, hiked trails at Shining Rock, intensifying his energetic backing.

By 1964, the Forest Service and conservationist groups had agreed to a final proposal. Although a compromise did not include the highest mountain in the district, Black Balsam Knob (6,214 feet), within the wilderness boundaries and allowed a small parking lot nearby, the chief of the U.S. Forest Service officially set aside 13,400 acres as Shining Rock Wilderness. The North Carolina Wilderness Act of 1984 expanded the area to 18,000 acres.

That year, the North Carolina Wilderness Act also designated 7,900 acres west of Shining Rock Wilderness as the Middle Prong Wilderness. NC-215 divides the two areas. Trailheads for exploring this remote region are located at Sunburst Campground and on its southern border with the Blue Ridge Parkway. Two prominent mountains, Mount Hardy and Richland Balsam, border Middle Prong but officially belong to the Parkway. Wilderness trails lead through coves of wildflowers and lush blueberry thickets.

In the late fall, from Mount Pisgah's observation deck or the Wagon Road Overlook on the Parkway, soft, pale colors can be seen blanketing Pisgah's vast wilderness. Cold Mountain, the cone-shaped master of Shining Rock Wilderness, enhances the scene. Its mountain slopes, once densely covered with spruce and fir, now support gardens of fall wildflowers, a magnificent maze of columbines, asters, black-eyed Susans, yarrow, angelica, Queen Anne's lace, firepink, goldenrods, bellflowers, stiff gentian and bull thistle. Goldfinches gathering thistle rise and dip as if rolling over gentle, invisible waves. Pressed for time, flower heads hum with busy bees tending nature's business. The day ends soon. So does the season. Winter comes early at six thousand feet.

As the September sun retires for the evening, sliding below the shoulders of Cold Mountain, a golden glow outlines its proud silhouette. A quiet peace softens conversation into whispers or fades into mute respect. See a sunset or explore its wild nature. Take a friend.

In 2010, the USFS Southern Research Station completed its "Western North Carolina Report Card on Forest Sustainability," detailing issues that are affecting the health of Blue Ridge Mountain forests. Although its overall health was stable, officials noted a number of concerns: invasive species; stream and bank erosion; increased recreational use; loss of native species and natural communities; fragmented forests; and threats from fire, insects and disease. Prioritizing the areas of concern direct future scientific projects and help create prudent land management policies to ensure a healthy forested future. In March 2012, the secretary of agriculture mandated new rules for land management plans that "emphasize collaboration, sound science, and protection for land, water and wildlife. This final rule strengthens the role of public involvement and dialogue."

Currently, Pisgah and Nantahala National Forests are revising their 1987 Land and Resource Management Plans and 1994 updates. In the fall of

2012, the assessment phase of the revision process began. More than eight hundred people attended fourteen public meetings and more than one thousand people submitted written suggestions. In March 2014, work on the Environmental Impact Statement began; before final approval, the Forest Service will solicit additional public response. Once adopted, the monitoring phase of the new management plan will continue until the next fifteen-year plan revision.

Participate in U.S. Forest Service public forums. The Forest Service and future forests depend on it. Have a voice; stay informed. Volunteer. Forestry has come a long way since oxen and splash dams. Be a part of it. Sustain the future. Keep it green. Get outdoors. Plant a seed in the minds of the future stewards of our forests. Teach the next generation. Like Dr. Schenck and his Biltmore "boys," let Pisgah National Forest become your classroom.

BIBLIOGRAPHY

Abshire, Martha. "A Prussian Voice in the Forest." *Asheville Citizen-Times*, November 18, 1974.

Adams, Binkie. "Col. Daniel Adam' Engineering Skills Provided Old Fort's First Electric Power." *Old Fort Dispatch*, August 13, 1986.

Adams, Daniel W. *Methods and Apparatus for the Prevention and Control of Forest Fires: as Exemplified on the Arkansas National Forest.* Washington, D.C.: Government Printing Office, 1912.

———. "Preliminary Report on the Burke-McDowell 10,000 Acre Tract, Mt. Mitchell Unit," May 5, 1911. On file at Mountain Gateway Museum, Old Fort, North Carolina.

Adams, Kevin. *North Carolina Waterfalls: Where to Find Them, How to Photograph Them.* Winston-Salem, NC: John F. Blair, 1994.

Adams, Shelia, descendant of Daniel Adams. Phone conversation with author, February 2014.

Alexander, Bill. "History of the Road: Asheville, North Carolina and the Cradle of Forestry." *Forest History Today* (Spring/Fall 2011).

Allen, Lloyd, and Imajean Allen. Interviews, meetings, phone calls and tour of Little Snowball Fire Tower, July–August 2014.

American Forestry 17. "The Appalachian Forests, Putting the New Law into Operation" (May 1911): 288–93.

——— 20. "Pisgah Forest Purchased" (June 1914): 425–29.

American Lumberman. "Forestry School at Biltmore to Hold Unique Celebration." September 12, 1908.

———. "Three Days' Forest Festival on the Biltmore Estate." December 5, 1908.

Appalachian Trail Guide to Tennessee–North Carolina. 9th ed. Harpers Ferry, WV: The Appalachian Trail Conference, 1989.

BIBLIOGRAPHY

Appalachian Voices. "Eastern Golden Eagle Working Group." December 21, 2011. http://appvoices.org/tag/eastern-golden-eagle-working-group.

Arthur, John Preston. *A History of Watauga County, North Carolina*. Richmond, VA: Everett Waddley Company, 1915.

Asheville Citizen. "Biltmore Ranger Is Killed by Huntsman." November 4, 1916.

———. "Carr Lumber Company Makes Improvements." January 20, 1916.

———. "Early Forest School Being Restored." September 18, 1966.

———. "Fire Protection for Linville Forest." February 28, 1916.

———. "First Hard-Surfaced Road in NC Built by Mr. Vanderbilt." April 30, 1927.

Asheville Citizen-Times. "The Bride and Groom in Full Splendor." December 22, 1982.

———. "Mile-High Roan Is Mountain of Beauty and Mystery." January 25, 1961.

———. "10 More Acres to Hike: Thanks to Foothills Conservancy." November 14, 2013.

Asheville Daily Gazette. "The President Southward Bound." September 6, 1902.

Asheville Times. "Brigade from Fort Bragg 'Settles' in Pisgah Forest Area." September 10, 1941.

———. "An Unusually Capable Public Servant." August 21, 1925.

———. "Verne Rhoades Naturalist Dies." January 23, 1969.

Atto, O.O., et al. *The North Carolina Flood: July 14, 15, 16, 1916*. Charlotte, NC: W.M. Bell, 1916.

Axelson, Gustave. "A Golden Plan for a Turnaround." *Living Bird* (Spring 2013).

Balsam Breeze. "Deer Drives" (February 1935). CCC camp newsletter, on file at Renfro Library, CCC collections, Mars Hill University, Mars Hill, North Carolina.

———. "Fifty Men Detached from Camp F-14: Side-Camp Established at Sunburst" (March 1938). CCC camp newsletter, on file at Renfro Library, CCC collections, Mars Hill University, Mars Hill, North Carolina.

——— 2, no. 2. "Selected 10 Boys Out of This Company to Attend 5 Different Summer Tourist Camps" (April 1936). CCC camp newsletter, on file at Renfro Library, CCC collections, Mars Hill University, Mars Hill, North Carolina.

———. "Unique Job for F-14, Building Rearing Ponds on Davidson River" (February 1935). CCC camp newsletter, on file at Renfro Library, CCC collections, Mars Hill University, Mars Hill, North Carolina.

Barker, Don. "Veteran Wildlife Pilot, James, Has Faced Many Perils." *Newton Observer-Enterprise*, March 17, 1987.

Barnhill, William A. "Story of the Toll Gate House at Pisgah View Ranch, Candler, NC," September 1978. Report on file at Pack Library, Asheville, North Carolina.

Barr, Peter J. *Hiking North Carolina's Lookout Towers*. Winston-Salem, NC: John F. Blair, 2008.

Bauer, Jennifer A. *Roan Mountain: History of an Appalachian Treasure*. Charleston, SC: The History Press, 2011.

Beane, Wayne, President of Collettsville Historical Society. Personal interview with author, summer of 2014.

Biltmore Immortals: Biographies of 50 American Boys Graduating from the Biltmore School. Vols. 1 and 2. "Verne Rhoades Autobiography," 1957. Verne Rhoades Collection, D.H. Ramsey Library, UNC–Asheville.

Blake, Christopher. *Linville Gorge Wilderness Area*. Charleston, SC: Arcadia, 2009.

————, ed. *River of Cliffs: A Linville Gorge Reader.* Boone, NC: Parkway Publishers Inc., 2005.

Blake, Christopher, Linville Gorge author and historian. Home interview with author, June 2014.

Bramwell, Lincoln, and James G. Lewis. "The Law that Nationalized the U.S. Forest Service." *Forest History Today* (Spring/Fall 2011).

Brevard News. "Elk and Buffalo Coming." February 16, 1917.

Brittain, James E. *Gun Fights, Dam Sites & Water Rights.* Columbus, NC: Living Archives, 2001.

Brower, Nancy. "Shut-in Trail." *Asheville Citizen,* July 13, 1978.

Bryan, John M. *G.W. Vanderbilt's Biltmore Estate: The Most Distinguished Private Place.* New York: Rizzoli International, 1994.

Buchanan, George E. "My CCC Days." Unpublished booklet, on file at the Transylvania County Library, Brevard, North Carolina, March 1985.

Buncombe County Register of Deeds, Asheville, North Carolina. Org/external/LandRecords/protected/v4/SrchName. Book 83, p. 446; Book 84, p. 287; Book 85, p. 599; Book 86, p. 369; Book 49, p. 67; Book 22, p. 87; Book 21, p. 466; Book 215, p. 365; Book 218, p. 459; Book: 249, p. 75.

Byrd, Mary Lacy. "Friend Helped Launch Politician." *Asheville Citizen-Times,* October 30, 1966.

————. "Silhouette of Bride and Groom Visible on Pisgah." *Asheville Citizen,* March 11, 1965.

Caldwell County Chamber of Commerce. Wilson Creek Visitor Center exhibits, summer 2014.

Caldwell County commissioners. "Wilson Creek: A Natural Resource, a National Treasure." Chronology of events in effort to secure wild and scenic river designation for Wilson Creek. Document on file at the Wilson Creek Visitor Center, June 1999.

Carley, Rachel. *Biltmore: An American Masterpiece.* Asheville, NC: Biltmore Company, 1994.

Carolina Connections. "Help Plan the Forests' Future" (Spring 2013).

————. "National Forest Recovery Gets Recovery Fund Boost" (Spring 2010).

Carolina Mountain Club. "Max Patch Documents from 1970s–1980s" and "Shining Rock Wilderness: 1960s." D.H. Ramsey Library, UNC–Asheville. http://toto.lib.unca.edu/findingaids/mss/CMC/default_carolina_mountain_club.htm.

Carolina Nature. "Oconee Bells (*Shortia galacifolia*)," December 2, 2013. www.carolinanature.com/trees/shga.html.

Carrington, Lydia. "Catawba Falls Becomes Part of Pisgah Forest." *McDowell News,* September 12, 1989.

Carter, Ted. "Pupils Sent to Bed—Pink Beds." *Asheville Citizen-Times,* November 2, 1973.

Cecil, George. *George Cecil Shares His Memories of Buckspring Lodge.* Video, 2011. http://vimeo.com/15228055.

————. Phone conversation with author. Asheville, North Carolina, October 1, 2013.

Cecil, George, and William H. Cogburn Jr. Transcript of interview at Buck Spring Lodge site, by Philip E. Coyle. Provided by Walt Weber, Carolina Mountain Club, September 28, 2006.

BIBLIOGRAPHY

Chapman, Ashton. "Minerals Aid Mitchell Economy." *Asheville-Citizen Times*, January 26, 1969.

Chavez, Karen. "Walk through the Civil War; Celebrate Valley, History on Swannanoa Hike." *Asheville Citizen-Times*, November 29, 2012.

Clark, Cliff. "King House Gets New Roof." *Transylvania Times*, May 17, 1990.

Clingman, Thomas Lanier. "Mount Pisgah, North Carolina." *Appleton's Journal* 10, no. 249 (December 27, 1873): 817.

Coffey, Sandra Cloer. "Mortimer/Edgemont: *Lenoir News* 1900–1919." Unpublished spiral-bound manuscript, Colletsville Historical Society Inc., 2007.

Cogburn, William Harrison, Jr. Transcript of video interview by Houck Medford, Asheville, North Carolina, January 18, 2008. Provided by Walt Weber.

Cohen, Alice. "700,000 in Recovery Funds Boosts Roan Mountain." *Carolina Connections* (Spring 2011).

Compton, Stephen C. *Early Tourism in Western North Carolina*. Charleston, SC: Arcadia, 2004.

Covington, Howard E., Jr. *Lady on the Hill: How Biltmore Estate Became an American Icon*. Hoboken, NJ: John Wiley and Sons Inc., 2006.

Cox, Joe. "Carl Alwin Schenck Memorial Forest." NC State University, Department of Forestry and Environmental Resources. http://cnr.ncsu.edu/fer/about/schenck_forest.php.

Crews, Eric. "Cradle Visitor Center Celebrating 25 Years." *Transylvania Times*, July 29, 2013.

Currie, Carole. "Grandson of First U.S. Forester Visits Biltmore Estate, Pisgah Forest." *Asheville Citizen-Times*, June 21, 1990.

Daughtridge, Lillian "Dee," branch manager. Interview, Marion Davis Memorial Branch Library, Old Fort, North Carolina.

De Hart, Allen. *North Carolina Hiking Trails*. 3rd ed. Boston: Appalachian Mountain Club Books, 1996.

Department of the Interior, National Park Service. "A Quick History of the Land and Water Conservation Fund Program." http://www.nps.gov/ncrc/programs/lwcf/history.html.

Deyton, Jason Basil. "The Toe River Valley to 1865." *North Carolina Historical Review* 24, no. 4 (October 1947).

Dykeman, Wilma. *The French Broad*. Knoxville: University of Tennessee Press, 1955.

Eastern Golden Eagle Working Group. http://egewg.org.

Egan, Timothy. *The Big Burn: Teddy Roosevelt and the Fire that Saved America*. Grand Haven, MI: Brilliance Audio on Compact Disc, 2009.

Ellis, Harold. "Dr. Schenck Meets Good, Bad, Beautiful and Ugly." Four-part series published in unknown newspaper, filed in Transylvania County Library, October 23, 1975–December 4, 1975.

Ellwood, Eric L. "A History of School Forest Resources 1929–1979." North Carolina State University. cnr.ncsu.edu/fer/about/documents/HistoryoftheDepartmentofForestryandEnvironmentalResourcesatNorthCarolinaStateUniversity1929-.pdf.

Farrell, Patrick. "The Future of the Golden-Winged Warbler in Western North Carolina." *Upland Gazette: Wildlife Conservation and Habitat Management* 19, no. 1 (Spring 2014). North Carolina Wildlife Resources Commission. Raleigh, North Carolina.

Fire Lookout. "North Carolina Fire Towers," June 22, 2013. www.firelookout.org/lo-northcarolina.html.

Foothills Conservancy. "Foothills Conservancy Sells Catawba Falls Trail Property to US Forest Service." March 31, 2010. http://foothillsconsevancy.wordpress.com/2010/03/31/foothills-conservancy-sells-catawba-falls-trail.

Forest History Society. "Chronology of National Forests Established under the Weeks Act." http://www.foresthistory.org/ASPNET/Policy/WeeksAct/WeeksActForests.aspx.

———. "Flowers for the Living: Reunion of the Alumni of the Biltmore Forest School, May 28–31, 1950." www.foresthistory.org/research/biltmore_project/flowers.pdf.

———. "The Land We Cared For…A History of the Forest Service's Eastern Region." http://www.foresthistory.org/ASPNET/Publications/region/9/history/index.aspx.

———. "Weeks Law Purchase Units, 1911–1932." http://www.foresthistory.org/ASPNET/Policy/WeeksAct/PurchaseUnits.aspx.

Foster, Eden. "Friend of the Forest." *Our State* (June 2006).

Frank, Bernard. *Our National Forest.* Norman: University of Oklahoma Press, 1955.

The French Broad River. Map, Land of the Sky Regional Council, 1982.

Garretson, Martin S. "Report of the Establishing of a National Bison Herd in the Pisgah National Forest." *Report of the American Bison Society*, 1920. http://archive.org/stream/report191920amer/report191920amer_djvu.txt.

Gillis, Donald. "The Newest National Forest." *Forest and Stream* (May 1917).

Grandfather Ranger District, Pisgah National Forest. "Wilson Creek Wild and Scenic River." Wilson Creek Comprehensive Management Plan. On file at Wilson Creek visitor center, August 13, 2002.

Graves, Henry S. "The New National Forests of the East." *Southern Lumberman*, December 18, 1915.

Greer, Gary, retired USFS fire management officer. Phone conversation, July 2014.

Hairr, John. *North Carolina Rivers: Facts, Legends and Lore.* Charleston, SC: The History Press, 2007.

Happy Days CCC Newsletter. "It's Great to Be a CCC Man!" (December 24, 1938).

Harshaw, Lou. *Asheville, Mountain Majesty.* Fairview, NC: Bright Mountain Books, 2007.

Henderson, Ida Briggs. "Pisgah Forest's Wonders Offer Allure to Many." *Asheville Citizen*, July 30, 1930.

Hicklin, J.B. "Max Patch Table-Topped Mountain Named for Nag, Landing Field for Planes." *Winston-Salem Journal*, July 31, 1932.

Hill, Chester A. Home interview with author, Hominy Valley, North Carolina, November 16, 2013.

Hill, Chester, and Dr. Ken Israel. "Mary Mabel Israel, South Hominy's Grandma Moses." *South Hominy Community Tidbits*, no. 22 (Spring 2010). Enka-Candler Library.

————. "Peabody Schools and the Schools at Pisgah Meeting House, Glady Branch and Stoney Fork." *South Hominy Community Tidbits*, nos. 2, 3, 4 and 5 (December 2010). Enka-Candler Library.

Hogan, A.C. (Bud), Old Fort historian. Phone conversation with author. July 12, 2014.

Homan, Tim. *Hiking the Shining Rock and Middle Prong Wilderness.* Atlanta, GA: Peachtree Publishers, 2012.

Hot Springs Tourism. "History of Hot Springs, NC." http://hotspringsnc.org/about/history.

Hunter, Elizabeth. "The Goats of Roan." *The State*, July 1993.

————. "Visiting the Roan: Celebrating Muir's Visit 100 Years Later." *Mitchell News-Journal*, October 7 1998.

The Ivy Squall 1, no. 8 (March 2, 1934). CCC Camp F-8, Company 409, Barnardsville, North Carolina, on file at Renfro Library, CCC collections, Mars Hill University, Mars Hill, North Carolina.

Jacquot, Richard James, Jr. *Rock, Gem and Mineral Collecting Sites in Western North Carolina.* Alexander, NC: Land of the Sky Books, 2003.

James, Glynis, curator at the Wilson Creek Visitor Center. Interview, May and June 2014.

James, Joe, Lieutenant, retired NCWRC flight officer. Interview, Wilson Creek Visitor Center, May 2014.

Jeffrey, Thomas E. *Thomas Lanier Clingman: Fire Eater from the Carolina Mountains.* Athens: University of Georgia Press, 1998.

Jenkins, Charles F. "Asa Gray and His Quest for *Shortia galacifolia*." *Arnolda* 2, nos. 3–4 (April 12, 1942).

Johnson, Becky. "Volunteers Attempt to Rediscover Buck Springs Lodge's Elegant Era." Carolina Mountain Club Weekly Trail Maintenance News. http://carolinamountainclub.org/enews%20archive/041117-e-maintnews.htm.

Johnson, Randy. "Should We Save the Vanishing Balds?" *Blue Ridge Country* (July/August 1993).

Johnson, Tyler. "Earl Frady Recalls Tales from the 1930s Appalachians." *Transylvania Times*, June 27, 1996.

Jolley, Harley. "The Cradle of Forestry." *Forest History Today* (1998).

————. *"That Magnificent Army of Youth and Peace": The Civilian Conservation Corps in North Carolina, 1933–1942.* Raleigh: Office of Archives and History, North Carolina Department of Cultural Resources, 2007.

Kelly, Christine. Current reports on status of peregrine falcons and golden eagles in Pisgah National Forest. Communications via e-mail with author, July 24, 2014.

————. "Trapping and Tracking Golden Eagles." Presentation on wintering golden eagles in Western North Carolina, UNC–Asheville, October 15, 2013.

Kirchner, Mathew. "The Carolina Mountain Club's Campaign to Create Shining Rock Wilderness Area." Unpublished research paper presented to Faculty at UNC–Asheville, November 2003.

Lauterer, Jock. "The Return of the Little Engine that Could." *Transylvania Times*, July 28, 1983.

Ledford, Jerry, regional logging and train historian. Phone conversations with author, August 2014.

BIBLIOGRAPHY

Lenoir News. "Lenoir Is Marooned." July 18, 1916.

———. "Ranger Monroe Coffey Retires After 28 Years Work in Pisgah Forest." April 17, 1945.

Lewis, James G. *The Forest Service and the Greatest Good: A Centennial History.* Durham, NC: Forest History Society, 2005.

Lin, Stanford M. Transcript of interview with Bill Vines, USDA Forest Service, July 19, 1988.

———. Transcript of interview with Mary Adams, USDA Forest Service, August 12, 1988.

Lovelace, Jeff. *Mount Mitchell, Its Railroad and Toll Road.* Johnson City, TN: Overmountain Press, 1994.

Marion Progress. "Buck Creek CCC Camp Is Closed; Boys Transferred to Other Camps." July 3, 1941.

———. "Camp for Conscientious Objectors to Open Next Week on Buck Creek." August 21, 1941.

———. "CCC Benefits in State Cited by Officials: Cause of Conservation in W.N.C Advanced by Generation." 1942.

———. "Linville Gorge to Be Bought by Federal Service." September 26, 1935.

———. "Visitors to Camps Find Conservation Men Healthy, Happy." N.d.

Martin, C. Brenden. *Tourism in the Mountain South: A Double-Edged Sword.* Knoxville: University of Tennessee Press, 2007.

Mashburn, J.L. *Asheville & Buncombe Co.: Once Upon a Time.* Enka, NC: Colonial House, 2012.

———. *Hominy Valley, Revisited: A Journey Back to Our Favorite Times.* Enka, NC: Colonial House, 2009.

———. *Hominy Valley: The Golden Years.* Enka, NC: Colonial House, 2008.

Massey, Kevin. "The Linville Gorge Plants." Friends of Linville Gorge, March 25, 2014. http://friendsoflinvillegorge.org/tiki-index.php?page=Linville%20Gorge%20Plants.

Mastran, Shelly S., and Nan Lowerre. *Mountaineers and Rangers: A History of Federal Forest Management in the Southern Appalachians 1900–81.* Washington, D.C.: USDA Forest Service, April 1983.

McCoy, George. "Mount Pisgah: Asheville's Most Famous Landmark." *Asheville Citizen-Times*, March 24, 1951.

Meace, C.N. "Report on 10 Year Operation of Game Refuges, This Section." *Marion Progress*, 1937.

Mead, Martha Norburn. *Asheville in Land of the Sky.* Richmond, VA: Dietz Press, 1942.

Memories of District "B": Camp John Rock. Booklet. Little Rock, AR: Parke-Harpe Company, 1934. On file at Renfro Library, CCC collections, Mars Hill University, Mars Hill, North Carolina.

Message from the President of the United States Transmitting a Report of the Secretary of Agriculture in Relation to the Forests, Rivers, and Mountains of the Southern Appalachian Region. Senate Document 84. Washington, D.C.: Government Printing Office, 1902.

Momich, Pat, retired NC USFS Interpretation Specialist. History of Hot Springs and Madison County exhibits. Hot Springs Visitor Center, North Carolina, summer of 2014.

————. Phone conversation with author, July 2014.

Morley, Margaret W. *The Carolina Mountains.* New York: Houghton Mifflin Company, 1913.

Morrison, Clarke. "Demolition of Old Pisgah Inn Leaves Preservationist Bitter." *Asheville Citizen-Times*, September 1, 1990.

————. "What Does the Future Hold for Roan Mountain?" *Asheville Citizen-Times*, August 22, 1988.

Morrison, Clarke, and Julia Ball. "Linville Gorge Wildfire Covers 1800 Acres." *Asheville Citizen-Times*, November 15, 2013.

National Forest Reservation Commission. "Progress of Purchase of Eastern National Forests Under Act of March 1, 1911 (The Weeks Law)," 1920. Walter Julius Damtoft Collection, D.H. Ramsey Library, UNC–Asheville. http://toto.lib. unca.edu/booklets/progress_purchase_eastern_nat_forests/default_progress.

Ney, Amy. "First in Forestry." *Carolina Country.* July 2013.

Nichols, Bill. Personal interview with author, Old Fort, North Carolina, summer 2014.

Nicholson, Katherine Stanley. *Historic American Trees.* New York: Frye Publishing Company, 1922.

Noel, Mary. "Forest Service Celebrates Weeks Act." *Carolina Connections* (Spring 2011).

North Carolina State University, Biltmore Forest School. "Biltmore Doings," 1905–14. http://www.lib.ncsu.edu/specialcollections/forestry/schenck/series_vi/biltmore_doings.

North Carolina State University Bio & Ag Engineering Program. "NCSU Davidson River Restoration Program." www.bae.ncsu.edu/programs/extension/wqg/srp/davidson_river.html.

North Carolina Wildlife Resources Commission. Hatcheries 2014. www.ncwildlife.org/Fishing/HatcheriesStocking/NCWRCHatcheries.aspx.

Odell, John. "Partnership to the Max." *AT Journeys*, February 2014.

Official Annual for District A, Fourth Corp Area for 1936 Civilian Conservation Corps. Baton Rouge, LA: Direct Advertising Company, 1936.

Osborne, Clyde. "Lake Powhattan Gets Facelift." *Asheville Citizen-Times*, August 12, 1978.

————. "Young Conservationists Remodel Pigeon Creek." *Asheville Citizen-Times*, July 30, 1979.

Outward Bound. "North Carolina Outward Bound School," 2014. http://www.outwardbound.org/schools/north-carolina-outward-bound-school.

Parris, John. "Cradle of Forestry Cornerstone Is Laid." *Asheville Citizen-Times*, October 21, 1964.

————. "One of the World's Unique Shrines Shapes Up." *Asheville Citizen-Times*, June 27, 1965.

————. "Pink Beds Got Name from Downy Phlox." *Asheville Citizen*, July 26, 1966.

————. "Progress Erases a Landmark." *Asheville Citizen-Times*, August 27, 1962.

————. "Shining Rock Area Will Be a Haven." *Asheville Citizen-Times*, September 29, 1963.

Patterson, Jerry E. *The Vanderbilts.* New York: Abrams, 1989.

Pisgah and the Rat. Available at Sondley Reference Library, Asheville, North Carolina.

Pisgah National Forest Boundary Adjustment Act of 2009. House of Representatives Report 111-251. Washington, D.C.: Government Printing Office, September 10, 2009.

Pomeroy, Kenneth B., and James G. Yoho. *North Carolina Lands: Ownership, Use, and Management of Forest and Related Lands.* Washington, D.C.: American Forestry Association, 1964.

Queen, Sandra. "He's Alone at the Top." *McDowell News,* October 29, 1992.

———. "Old Fort Man Built First Fire Tower." *McDowell News,* October 29, 1992.

Reid, Christian. *The Land of the Sky, or Adventures in Mountain By-ways.* New York: D. Appleton and Company, 1876.

Rhoades, Verne. "Report on Burke-McDowell Tract." Washington, D.C.: USDA, April 1911 and June 1911.

Rice, Grace M. "Turnpike Hotel." *Asheville Citizen-Times,* December 1935.

Richards, Ken. "Little Snowball." *Big Ivy Historical Society Newsletter* (2007).

Rickman, Ellen Erwin. *Biltmore Estate: Images of America.* Charleston, SC: Arcadia, 2005.

Sakowski, Carolyn. *Touring the Western North Carolina Backroads.* Winston-Salem, NC: John F. Blair, 1990.

Satterwhite, Bob. "Curtis Creek Area Open to Auto Tour." *Asheville Citizen-Times,* June 1, 1975.

Schenck, Carl A. "Forestry on the Biltmore Estate," 1896. North Carolina State University Library. http://www.lib.ncsu.edu/specialcollections/forestry/schenck/series_v/gfi/gfi.html.

———. "General Working Plan for Pisgah Forest: 1898." North Carolina State University Library. http://www.lib.ncsu.edu/specialcollections/forestry/schenck/series_v/for_1898.html.

———. "Guide for an Excursion through Biltmore Forest, on September 17th and 18th, 1897." North Carolina State University Library. http://www.lib.nscu.edu/specialcollections/forestry/schenck/series_v/gfi/guide_1897.

———. "Lumber in Yard at Pisgah Forest, NC, May 1st, 1909." Forestry Department, Biltmore Estate. North Carolina State University Library. http://www.lib.ncsu.edu/specialcollections/forestry/schenck/series_v/for_1900_1909/for_1900_1909.html.

———. "Report on Resources Available within the Confines of Pisgah Forest: 1905 Management Plan." North Carolina State University Library. http://www.lib.ncsu.edu/specialcollections/forestry/schenck/series_v/for_1905/for_1905.html.

———. "The Tree Farms at Biltmore, North Carolina." North Carolina State University Library. http://www.lib.ncsu.edu/specialcollections/forestry/schenck/series_v/gfi/lgimage/page_01.

Schwarzkopf, S. Kent. *A History of Mt. Mitchell and the Black Mountains.* Raleigh: North Carolina Division of Archives and History, 1985.

Shaffer, Earl. *The Appalachian Trail: Calling Me Back to the Hills.* Englewood, CO: Westcliffe Publications, 2001.

———. *Walking with Spring.* Harpers Ferry, WV: Appalachian Trail Conference, 1983.

Shands, William E. "The Lands Nobody Wanted: The Legacy of the Eastern National Forests." *The Origins of the National Forests: A Centennial Symposium*. Durham, NC: Forest History Society, 1992. http://www.foresthistory.org/Publications/Books/Origins_National_Forests/sec3.htm.

Sharpe, Bill. "North Carolina's Mountains." *The State*, May 30, 1953.

———. "Through the Woods to Prosperity." *The State*, August 29, 1964.

Siler, Leon. "Dr. Schenck Led Way for American Forestry." *Asheville Citizen*, January 26, 1969.

Silver, Timothy. *Mount Mitchell and the Black Mountains: An Environmental History of the Highest Peaks in Eastern America*. Chapel Hill: University of North Carolina Press, 2003.

Skeate, Stewart. *A Nature's Guide to Northwest North Carolina*. Boone, NC: Parkway Publishers Inc., 2005.

Smith, C.W., retired USFS law enforcement officer, Grandfather Ranger District. Phone conversations with author, June–July 2014.

Smith, Etta. "Col. Adams Left a Legacy to Forest Service." *McDowell News*, August 1, 1986.

Smith, John, sawmill owner, Old Fort, North Carolina. Interview with author, April 2014.

Smucker, Becky. "Graffiti on the Trail." *AT Journeys*, February 2014.

Southern Lumberman. "Purchases Made Under Weeks Law." December 16, 1927.

Starnes, Richard D. *Creating the Land of the Sky: Tourism and Society in Western North Carolina*. Tuscaloosa: University of Alabama Press, 2005.

Starzell, Dave. "Grassy Ridge—A Case of 'Last Resort.'" *Appalachian Trail News*, September 10, 1986.

Steen, Harold K. *The U.S. Forest Service: A History*. Seattle: University of Washington Press, 2004.

Stevens, Martha. "An Interview with Mary Virginia 'Binkie' Adams." Marion, NC: McDowell Technical Community College, January 1997. Unpublished manuscript on file at McDowell County Library.

Strausberg, Stephen, and Walter A. Hough. *The Ouachita and Ozark–St. Francis National Forests: A History of the Lands and USDA Forest Service Tenure*. Booklet. Fayetteville: University of Arkansas at Fayetteville, June 1997.

Streeter, Michael. *A Rockhounding Guide to North Carolina's Blue Ridge Mountains*. Almond, NC: Milestone Press, 2003.

Swain, David, ed. *Cabins and Castles: The History of Architecture of Buncombe County, NC*. Asheville: North Carolina Department of Cultural Resources, 1981.

Tager, Miles. *Grandfather Mountain: A Profile*. Boone, NC: Parkway Publishing Inc., 1999.

Terrell, Bob. "The Father of Forestry." *Asheville Citizen*, February 1, 1976.

———. *Grandpa's Town*. Nashville, TN: Harris Press, 1978.

———. "On Top of Mount Pisgah!" *Asheville Citizen-Times*, June 13, 1972.

Tinsley, Jim Bob. *The Land of Waterfalls: Transylvania County*. Brevard, NC: Jim Bob and Dottie Tinsley, 1988.

Transylvania Times. "Black Forest Lodge Reassembled." April 13, 1978.

———. "Cantrell Lodge Dedicated." May 17, 1979.

———. "CCC Camp Operated at Balsam Grove." May 10, 1982.

———. "Original Entrance to Pisgah National Forest." August–November 1981.

BIBLIOGRAPHY

Trapp, Stella. "Schenck Telescope Is Given to the U.S. Forest Service." *Transylvania Times*, June 4, 1992.

U.S. Department of Agriculture, U.S. Forest Service. An Annotated Bibliography of Galax (*Galax urceolata*). 2005.

———. "Bent Creek Experimental Forest." September 5, 2013. http://www.srs.fs.usda.gov/compass/2013/09/05/1401.

———. *Bent Creek Research and Demonstration Forest*. Booklet. 1995.

———. *Cradle of Forestry Trail Guide*. Brochure 2014.

———. *Curtis Creek Auto Tour*. Brochure, 1975.

———. *Final Report of the National Forest Reservation Commission*. September 30, 1976.

———. "Fire Lookouts." http://www.foresthistory.org/ASPNET/Policy/Fire/Lookouts/Lookouts.axpx.

———. "Forest Threat Facts: Invasive Species." www.forestthrests.org.

———. "Grandfather Restoration Project." *Carolina Connections* (Summer 2012). www.fs.usda.gov/detail/jfsnc/news-events/?cid=STELPRDB536360.

———. "Green Concept." USFS Exhibits. Roan Mountain, June 2014.

———. *Harmon Den and Hot Springs Trail Map*. 2002.

———. *Introduction to the Southern Research Station*. Booklet. June 1996.

———. *Lookout Towers Documentation and National Register of Historic Places Evaluation*. Durham, NC: Edwards-Pittman Environmental Inc., December 2005.

———. "Military Planes to Conduct Wildland Firefighting Training over Pisgah District." May 2, 2012. http://www.fs.usda.gov/detail/nfsnc/news-events/?cid=STELPRDB5365976.

———. *The National Forest Reservation Commission: A Report on Progress in Establishing National Forests, Published on the Occasion of the 50th Anniversary of the Weeks Law*. 1961.

———. "Parking Lot Near Catawba Falls Now Open." April 16, 2012.

———. *Pisgah National Forest: Grandfather, Toecane, and French Broad Ranger Districts Map*. September 1994.

———. *Pisgah Ranger District*. Map, 2003.

———. *Shining Rock and Middle Prong Wildernesses*. Map, 2003.

———. *Shining Rock Wilderness and Middle Prong Wilderness*. Map, January 1988.

———. *South Toe River, Mount Mitchell and Big Ivy Trail Maps, NC*. February 2004.

———. "35th Tree Graces Capitol This Season." *USDA News*, November–December 1998.

———. "Timeless Heritage: A History of the Forest Service in the Southwest. Chapter 12: The Forests and Fire." http://www.fs.usda.gov.

———. "Tree Planting Marks Job Corps 50th Anniversary." August 2014. http://www.fs.usda.gov/detail/nfsnc/home/?cid+STELPRD3814311.

———. Treesearch. http://www.treesearch.fs.fed.us/pubs/2101.

———. "USDA Publishes Final Rule to Restore the Nation's Forests through Science and Collaboration." March 23, 2014. http://www.fs.usda.gov/detail/nfsnc/news-events/?cid=STELPRDB5359679.

———. "Volunteers Help Restore Max Patch in Pisgah National Forest." May 13, 2013. http://www.fs.usda.gov/detail/nfsnc/news-events/?cid=STELPRDB5419922.

———. "The Western North Carolina Report Card on Forest Sustainability." 2010.

———. *Wilson Creek National Wild and Scenic River Trail Guide*. Map, 2013.

Vanderbilt, Arthur T., II. *Fortunes Children: The Fall of the House of Vanderbilt*. New York: Quill Press, 1989.

Vanderbilt, Edith. Letter to Secretary of Agriculture, May 1, 1914. On file at the Transylvania County Library, Brevard, North Carolina.

Verne Rhoades Collection. "Biographical Notes of Verne Rhoades, Asheville, North Carolina." D.H. Ramsey Library, UNC–Asheville, January 22, 2009. http://toto.lib.unca.edu/findingaids/mss/rhoades_verne/default_rhoades_verne.xml.

View from the Highlands. "Honoring 40 Years of Service to the Roan" (Spring 2014). Newsletter of Southern Appalachian Highlands Conservancy.

Vitas, George. "Around the Mt. Mitchell Forest Service District." *Yancey Record*, series of articles, 1951.

Walker, Frances Crump, descendant of Mortimer residents and CCC enrollee. Interview with author, Wilson Creek Visitor Center, May 2014.

Warren, Harold. "Conservationist Mount Campaign to Save Mile-High 'Bloomin' Balds." *Charlotte Observer*, June 29, 1975.

Warren, Sabian. "Linville Gorge to Reopen to Public After Fire." *Asheville Citizen-Times*, November 24, 2013.

Watauga County Roads and Weather Conditions. "Forest Service Fighting Wildfire in Linville Gorge." November 13–21, 2013. http://wataugaroads.com/forest-service-fighting-wildfire-linville-gorge.

Watts, Bryan. "Eastern Golden Eagle Working Group Receives Award." Center of Conservation Biology, March 1, 2013. http://www.ccbirds.org/2013/03/01/eastern-golden-eagle-working-group-receives-award.

Weber, Walter. "Guide Book of the Buck Spring Lodge: A Walking Tour." Asheville, NC: Carolina Mountain Club, 2009.

———. Guided hike to Buck Spring Lodge historical site. Blue Ridge Parkway, October 18, 2013.

Weber, Walter, for Carolina Mountain Club. *Trail Profiles: The Mountain to Sea Trail, from Beech Gap to Black Mountain Campground*. Alexander, NC: WordComm, 1999.

Wellman, Manly Wade. *The Kingdom of Madison: A Southern Mountain Fastness and Its People*. Chapel Hill: University of North Carolina Press, 1973.

West, Terry L. "Centennial Mini-Histories of the Forest Service," July 1992. http://www.foresthistory.org/ASPNET/Publications/centennial_minis/index.htm.

Whiteside, Dorothy Dixon. "The Bride and Groom on Mount Pisgah." *Southern Tourist*, June 1925.

Whitmire, David, owner of Headwaters Outfitters, Rosman, North Carolina. Interview with author, May 2014.

Wikipedia. "WLOS." http://en.wikipedia.wiki/WLOS.

WLOS-TV News. "Linville Gorge Wildfire Update." November 15, 2013.

Zamplas, Pete. "Groundbreaking Held for Cradle's Expanded Center." *Transylvania Times*, June 15, 1992.

———. "Where Is the Eagle?" *Transylvania Times*, August 11, 1988.

Zeigler, Wilbur G., and Ben S. Grosscup. *The Heart of the Alleghanies or Western North Carolina*. Raleigh, NC: Alfred Williams and Company, 1923.

INDEX

A

Adams, Daniel W. 78, 89
Adams, Mary Virginia 79, 121
Ambler, Chase 125
American Bison Society (ABS) 85, 87
American chestnut 149
American Forestry Association 62, 70, 174
Appalachian Trail Conservancy (ATC) 132, 133
Art Loeb trail 159
Asheville 23, 33, 65, 86
Avery, Myron 130

B

Balsam Grove 96, 169
barite mine 139
Barnardsville 97, 148
Bartram, John and William 150
Battery Park Hotel 29, 33, 47, 53, 66, 174
Battle, S. Westray 33
Beadle, Chauncey 36, 42, 74
Big Bald Mountain 143
Big Creek 38, 50, 85
Big Creek Valley 38, 183
Big Ivy 97
Biltmore Estate 66, 85, 174, 179

Biltmore Forest School 51, 168, 172
Biltmore House 33, 45, 146
Black Balsam Knob 159, 188
Black Forest Lodges 175
Black Mountain Campground 147
Blowing Rock 29, 81, 105
Blue Ridge Parkway 42, 45
Boone 74, 82
Boone Fork Campground 117
Brevard 55, 57, 160
Broome, Harvey 188
Brown Mountain 118, 119
Buck Creek 97
Buck Spring Gap 38, 43
Buck Spring Lodge 38, 179, 181
Buncombe Turnpike 26, 138
Burke-McDowell Lumber Company 74
Burnsville 129, 144, 177

C

Caldwell and Northern Railway 113
Camp Alex Jones 96, 140
Camp Creek Bald Lookout Tower 140
Camp Daniel Boone 159
Camp Globe 97
Camp Gloucester 169
Camp Jim Staton 97, 126

Camp John Rock CCC 166
Camp McCloskey 97, 127
Campus Trail Tour 177
Candler Speculation Lands 67
Candler, Zachariah 37
Cane River Valley 144, 148
Canton 60, 167, 169
Cantrell Creek Lodge 175
Carl Alwin Schenck Memorial Forest 62
Carolina, Clinchfield and Ohio
 Railroad 146
Carolina Hemlocks Recreation Area 147
Carolina Mountain Club 61, 143, 188
Carr Lumber Company 45, 68, 72, 87,
 92, 94
Carver's Gap 156
Catawba Falls 89, 120
Catawba rhododendron 150, 156
Catawba River 51, 79
Celo 144
Champion Fibre Company 155, 172
Champion Lumber Company 88
Champion Paper and Fibre Company
 167
Cherokee National Forest 129, 141, 156
Civilian Conservation Corps 94, 98
Clarke-McNary Act 74
Clingmans Dome 116, 132
Clingman, Thomas 145, 187
Cloudland Hotel 29, 152, 155, 156
Coffey, Monroe 118
Cogburn, Hardy 40, 43
Cogburn, John 51
Cogburn, William H., Sr. 43
Cold Mountain 25, 159, 182, 189
Colletsville 112, 113
conscientious objectors 97
Cradle of Forestry in America
 Interpretive Association (CFAIA)
 174
Craggy Gardens 97, 129
Craig, Locke 88, 144
Croatan National Forests 74
Cruso 40, 42, 45, 51, 182
Curtis Creek 74, 78, 88, 92, 97

D

Daniel Boone Game Refuge 92
Davidson River 94, 162
Davidson River Campground 163
Devil's Courthouse 25, 88, 183
Douglas Falls 149
Douglas, William O. 149, 188

E

Eisenhower, Dwight 188
elk 85, 92, 149

F

fawn farm 92
feldspar 146
Forest Festival Day 170
Forest Festival Trail 172
Forest Heritage Scenic Byway 160, 170
Forestry Discovery Center 173
Fraser firs 62, 147, 150
Fraser, John 150
Freeman, Orville 173
French Broad River 26, 85, 88, 138,
 139, 169
Frying Pan Lookout Tower 95, 183

G

Garretson, Martin 85, 87
German internment camp 138
Good Enough Cabin 38
Grandfather Mountain 26, 92, 102,
 112, 119
Graves, Henry 72
Gray, Asa 124, 150
Gray's lily 150, 153
Great Depression 94, 147
Great Smoky Mountains National Park
 61, 116, 129, 188
Green Knob Lookout Tower 125, 147

H

Harmon Den 132
Harrison, Benjamin 66

Hawksbill 102, 107
Haywood County 175
Hill, Chester 43
Holmes, Joseph 88
Hominy Valley 23, 38, 85
Hot Springs 26, 81, 96, 97, 130, 136
Hough, Franklin 66
Hunt, Richard Morris 34, 38

J

John Rock 94, 165
Johnson, Lyndon 132, 155, 174
Jolley, Harley 177
Jonas Ridge 102

K

kaolin 146
Kennedy, John F. 121

L

Lake James 101, 112
Lake Powhattan 163, 186
Lance, Martin Luther 37
Land and Resource Management Plan 189
Land and Water Conservation Fund (LWCF) 120
Lassie 166
Laurel River Logging Company 139
Lenoir 97
Lindenfels 61, 62, 175
Linn Cove Viaduct 102
Linville Gorge 97, 105, 112
Linville River 101
Lipe, J.C. 43, 45
Little Snowball Fire Tower 149
Looking Glass Falls 68, 162, 166
Lusk, Mary 67

M

MacKaye, Benton 130
Marion 79, 97
Mars Hill 172
Max Patch Mountain 133

McArdle, Richard 174
McKinley, William 66
McNamee, Charles 37, 65
Methods and Apparatus for the Prevention and Control of Forest Fires, as Exemplified on the Arkansas National Forest 89
mica 145, 147
Michaux, André 124, 150
Middle Prong Wilderness 160, 189
Mills River 50, 51, 95, 162, 169, 183
Mitchell, Elisha 144, 150
Morganton 79, 96
Mortimer 92, 97, 112, 113
Mountain Park Hotel 96
Mountains-to-Sea Trail 116, 147
Mount Craig 144
Mount Mitchell 26, 74, 88, 129
Mount Mitchell Game Refuge and Wildlife Management Area 92
Mount Pisgah 23, 25, 36, 85, 179
Muir, John 150

N

National Forest Reservation Commission 45, 71, 77
National Trails System Act 132
Nolichucky River 144
North Carolina Wildlife Resources Commission 83, 108, 115, 165

O

Old Fort 74, 78, 89, 97
Olmsted, Fredrick Law 34

P

Paint Rock 26, 138, 140
Patton, James 27, 138
peregrine falcons 108, 164, 183
Perley and Crockett 87, 147
Pigeon River 85, 167
Pinchot, Gifford 38, 49, 63, 68, 78, 85, 173, 177, 183
Pink Beds 38, 57, 92, 163, 177
Pink Beds Picnic Area 177

Pisgah Astronomical Research Institute (PARI) 169
Pisgah Center for Wildlife Education 159, 165
Pisgah Game Preserve 83, 87, 91
Pisgah Inn 179
Pisgah View Ranch 23, 42
Price, Overton 61, 74

R

Ray Mine 145
red spruce 147
Rhoades, Verne 61, 77, 86, 91, 105, 155, 174, 175
Rhododendron Festival 156
Rhododendron Gardens 149, 156
Rich Mountain Lookout Tower 140
Roan High Knob 156
Roan Mountain 26, 29, 129, 144, 149
Robertson,Reuben 167
Rockefeller, John D., Jr. 105
Roosevelt, Franklin D. 94
Roosevelt, Theodore 65, 68, 85
Rosman 72, 88, 96, 140, 170
Rowe, Art 161, 175
Rumbough, James H. 138

S

Schenck, Carl Alwin 38, 47
Shaffer, Earl 130, 133, 135, 141
Shining Rock Wilderness 187
Shortia (Oconee Bells) 122, 150
Shortoff Mountain 26, 102, 107, 108, 112
Sliding Rock 166, 174
Snowbird Mountain 132
Sondley, F.A 25
Southern Railway 28, 37, 85, 93, 124
Southern Research Station 132, 142, 160, 189
South Toe River 147
splash dams 51
Spruce Pine 146
Stackhouse 139
Stoney Fork 42

Stoney Fork School 43
Sunburst Campground 167, 189
Swannanoa River 45
Sycamore Flats 161

T

Tablerock Mountain 102, 107
Tennessee Eastman Hiking and Canoeing Club 144
Three-Day Camp 165
Toxaway Tanning Company 72
tuberculosis 26, 29, 69

U

Unaka National Forest 129
Union Tanning Company 79, 92

V

Vanderbilt, Edith 45, 74
Vanderbilt, George 33, 72, 146
Vanderbilt's Motor Road 42
Vines, Bill 97

W

Warm Springs 26, 138
Wayah Bald Game Preserve 92
Waynesville 23, 29
Weeks, John W. 71
Weeks Law 71, 72, 74, 75, 77, 78, 89
Weston, George 179
Wilder, John T. 155
Wilson Creek 92, 102
Wilson, Tom 144, 148
Wilson, Woodrow 72, 83
Wisemans View 107, 119
WLOS-TV 181
W.M. Ritter Lumber Company 105

Y

Yonahlassee Trail 105
Youth Conservation Corps (YCC) 162

ABOUT THE AUTHOR

After retiring as a nurse practitioner, Marci earned her certificate as a North Carolina environmental educator and a Blue Ridge naturalist. She is the author of *Clingmans Dome: Highest Mountain in the Great Smokies* and a soon-to-be released children's book based on a true story, called *Potluck, Message Delivered: The Great Smoky Mountains Are Saved!* She was a 2012 and 2013 finalist in a local publisher's short story contest.

Visit us at
www.historypress.net
..
This title is also available as an e-book

www.ingramcontent.com/pod-product-compliance
Lightning Source LLC
Chambersburg PA
CBHW070345100426
42812CB00005B/1434